THE TERESE AND ALVIN S. LANE COLLECTION

THE TERESE AND ALVIN S. LANE COLLECTION

TWENTIETH–CENTURY SCULPTURE AND
SCULPTORS' WORKS ON PAPER

ELVEHJEM MUSEUM OF ART
UNIVERSITY OF WISCONSIN–MADISON
1995

Catalogue of an exhibition at
the Elvehjem Museum of Art
University of Wisconsin-Madison
September 30–December 3, 1995

ISBN 0-932900-40-2

Edited by Patricia Powell
Designed by Earl J. Madden
Produced by University Publications
Printed by Straus Printing Co. Madison, WI

Library of Congress Cataloging-in-Publication Data
The Terese and Alvin S. Lane collection : twentieth-century sculpture and
sculptors' works on paper.
 p. cm.
Catalogue of an exhibition at the Elvehjem Museum of Art, University of Wis-
consin–Madison, September 30–December 3, 1995.
ISBN 0-932900-40-2
1. Sculpture, Modern—20th century—Exhibitions. 2. Artists' preparatory
studies—Exhibitions. 3. Lane, Terese—Art collections—Exhibitions. 4. Lane,
Alvin S.—Art collections—Exhibitions. 5. Sculpture—Private collections—
United States—Exhibitions. States—Exhibitions. 6. Drawing—Private collec-
tions—United States—Exhibitions.
I. Elvehjem Museum of Art.
NB198.3.L36T47 1995
734'.23'007477583—dc20 95-22245
 CIP

Cover: Claes Oldenburg (American, b. Sweden 1929),
Typewriter Eraser, 1977, pigment, concrete, aluminum rods, stainless steel, 32 ×
35 × 23 in.
Inset: *Seated Typewriter Eraser,* 1970, pencil and colored pencil on paper, $7\frac{7}{8}$ ×
$9\frac{3}{4}$ in.

CONTENTS

FOREWORD

When the Elvehjem Museum of Art first opened its
doors in 1970, its galleries were filled with works of art
that had been lent or donated by alumni of the University of
Wisconsin–Madison and friends of the new museum. Today,
twenty-five years later, that auspicious beginning is an established tra-
dition; the Elvehjem plays a vital educational role on campus and in the com-
munity thanks almost entirely to generous collectors who continue to share their treasures, their
expertise, and, last but not least, their passion for art.

The exhibition *The Terese and Alvin S. Lane Collection: Twentieth-century Sculpture and Sculptors'
Works on Paper* is the latest such kindness. After thirty-seven years of steady collecting, Mr. and
Mrs. Lane have selflessly denuded their home and sent over 300 works of art to the Elvehjem in
celebration of its twenty-fifth anniversary. This is a truly a generous act given that every piece is on
view; no work of art is ever stored in the Lane home.

I first met Alvin Lane, an alumnus of the University of Wisconsin–Madison class of 1940, in
1988. He had made several cash donations to the Elvehjem over the years. That spring, during
lunch at the Harvard Club, in response to my curiosity about him and his interest in art, he
extended a casual invitation to view his "modest" collection whenever I next came to New York
City. Little did I realize what an understatement that was.

The following autumn, my visit to the Lanes' home was truly, to borrow a term from a
younger generation, awesome. Not only did I have the pleasure of meeting the utterly charming
Mrs. Lane but I was overwhelmed by what I saw. Art, each piece of high quality, was installed in
every part of the house. The overall effect was tasteful and inspiring. Guided through the house by
my gracious and enthusiastic hosts, I learned how each piece had been located, researched, pur-
sued, acquired, and documented. I also learned about the care that had gone into the arrangement
of the pieces, works being juxtaposed primarily according to stylistic or conceptual considerations,
a living arrangement that changes as the collectors' understanding of the work evolves. I heard fas-
cinating anecdotes about the artists whom the Lanes befriended in pursuit of deeper understand-
ing of their work. It was an exciting and personal story about collecting modern art to which I was
being afforded an intimate view, a story that needed to be more widely told.

It is rare that an exhibition of thematic coherence and intellectual depth can be based on the
taste and aesthetic considerations of a single collector. Private individuals are seldom motivated by

educational goals. The Lanes' approach to collecting, however, was and still is a refreshing and fascinating exception. Their focus on twentieth-century sculpture and sculptors' works on paper has been very deliberate and, almost from the outset, was intended ultimately to provide opportunities for students of art and/or art history to explore the creative process itself. The seventy or so three-dimensional works in the collection, dating from around 1915 through the mid-1980s, represent a thoughtful though personal overview of sculpture in the twentieth century. Included are works by some of the most important artists of this period: Arp, Picasso, Storrs, Calder, Gabo, Noguchi, Nevelson, Smith, Oldenburg, among others. The accompanying works on paper were acquired because they have a direct relation to the sculptures; they are mostly preparatory drawings. It is the dynamic visual and intellectual exchange between sculpture and drawing that embodies the essence of the Lane collection.

Individual works of art from the Lane collection have been included in exhibitions organized by such prestigious institutions as the Whitney Museum of American Art, the Solomon R. Guggenheim Museum, and the Museum of Modern Art in New York City and have appeared in numerous catalogues and scholarly publications. Until now, however, the Lane collection has never been shown or published as a whole. The Elvehjem is indeed privileged to have been given the opportunity to present these wonderful works of art and to relate their story to a broader audience.

Exhibitions come about as the result of the diligence, resourcefulness, and dedication of many individuals. It is my pleasure to acknowledge here members of the Elvehjem and UW–Madison staff and others who have worked so hard during this past year to bring into being the present publication and the exhibition that it documents. Special recognition must be given first of all to Patricia Powell, our editor, for her research, organization, editing, and coordination of the myriad facts and materials that go into a publication of this scale and complexity; to Jerl Richmond, our preparator, for tasteful and effective exhibition installation; and to Lucille Stiger, our former registrar, for her excellent coordination of logistical and professional matters as well as the photography of the collection. I would also like to recognize Douglas Dreishpoon, curator of collections at the Weatherspoon Art Gallery, The University of North Carolina at Greensboro, for his informative essay; Gavin Ashworth, a freelance professional, for his excellent photography; and Earl Madden of the UW Publications Office for his creative and elegant catalogue design. Jill Nolan, graduate student in the department of art history at the UW–Madison and temporary coordinator of membership at the Elvehjem, provided valuable assistance with research of the collection.

To all of these, but especially to Terese and Alvin S. Lane, thank you for making this wonderful project a reality.

Russell Panczenko
Director, Elvehjem Museum of Art

MY PERSPECTIVE ON COLLECTING
ALVIN S. LANE

When my wife Terese and I started to buy art in the late 1950s, we never anticipated that we would some day have a collection that would be exhibited in a museum. We were merely looking for art to embellish our small apartment. In fact, it all started with a search for a painting to go on the empty wall over the couch. We were not focused on any particular artist, period, media, or art movement. On the other hand, we did not want anything that was merely decorative. In our spare time, usually on Saturdays, we meandered around the New York art galleries and auction houses like blind people in quest of the Holy Grail. We did not find that definitive painting, and after a few years, when we vacated our apartment, there still was an empty wall over the couch. We moved into a house with a living room that was large enough to place the couch in the middle of the room. That solved the problem of the proverbial picture over the couch by changing living rooms and thus eliminating the wall rather than pursuing the quintessential picture to go over the couch.

SCULPTURE RATHER THAN PAINTING

About the same time we went on vacation to Italy and were exposed to much great sculpture. In the midst of that trip I realized that I relate more strongly to sculpture than I do to paintings. I like form rather than the illusion of a three-dimensional subject on a two-dimensional canvas. I am tactile and like to touch the work and enjoy walking around the art object and seeing how the form changes and how the light plays on its surface.

Terese and I then agreed to concentrate on sculpture rather than paintings, which was fortunate because we both must enjoy our home decor. I usually found the art, but Terese and I had an understanding that both of us had to approve each purchase. Ninety-nine percent of the time we agreed.

The first sculpture that we purchased was José de Rivera's *Construction #46* (14.3). The de Rivera show at the Grace Borgenicht Gallery from November 8 to December 14, 1957 was very seductive for two neophyte collectors, since each piece was perfection. With our limited budget, we expressed an interest in the smallest piece in the show, but by the time we made a decision it had been sold. We then considered a slightly larger piece but that, too, was sold before we came to a decision. We finally bought *Construction #46* on June 10, 1958 about half a year after we first saw it. We placed it in the bay window in our living room. Because it was motorized by the artist, there was no necessity to walk around it. We got the same effect by standing in one place and watching it turn. It remained there until we acquired a piano, on which it has been ensconced ever since.

Construction #46 was forged from a bar of stainless steel that was heated and beaten thousands of times and then filed and rubbed with carborundum cloth of two hundred different degrees of fineness and finally polished with buffing rouge until it was like a large piece of beautiful jewelry revolving in space. I realize that today it is deemed demeaning to characterize art as beautiful, but that is what it is and that is what I like about it. I guess only a private collector can make that sort of a statement. De Rivera was a jeweler before he became a sculptor, which explains his meticulous craftsmanship and the sheer beauty of the piece.

There was a lot of good sculpture in New York in the fifties, sixties, and seventies, and once we made the decision, buying sculpture became relatively easy. This was facilitated by the fact that the cost of sculpture was, and is, much less than the cost of comparable paintings.

SCULPTORS' DRAWINGS

The purchase of Seymour Lipton's *Desert Briar* (32.18) on March 16, 1959 had a significant impact on our method of collecting because it was our first acquisition that had preliminary drawings, and as a lawyer, I am naturally interested in the background material and the creative process—the tangible evidence of creativity.

Desert Briar was illustrated on the cover of the catalogue for an exhibition entitled *Nature in Abstraction* in 1958 at the Whitney Museum of American Art, and that gave me a certain amount of confidence as I had no credentials or background in art. That confidence may have been mitigated by the fact that Lipton was a dentist with an office on the Grand Concourse in The Bronx which he also used as his studio. At the time that we purchased *Desert Briar*, he was in the process of giving up his dental practice and vacating his office. When we arrived to pick up the piece, his place was so chaotic that we felt fortunate that we were there to retrieve a piece of sculpture rather than to have any dental work done.

I asked Lipton whether he did any preliminary drawings for *Desert Briar*. He showed them to us (32.15, 32.16, 32.17). I naively told him that we would like to have the drawings as I thought they should go with the sculpture because they are part of its creative process. He agreed, but felt that I should pay for them. When I claimed that they were comparable to documents and not works of art per se, he reluctantly acquiesced. Years later, after I had taken a sculpture course with him at the New School for Social Research and we had become good friends, I confessed to Si that my conscience had been bothering me since I acquired those three drawings, as I realized that even though there was no real market for them at that time, I should have paid for them.

I told him that I would like to see all of his drawings and pick out those that were used in the creation of his major sculptures. I looked at hun-

dreds of his drawings, of which I purchased approximately sixty-five; fifty-three of those are in this show (32.1–32.14 and 32.19–32.57) and some of the others, of which we had duplicates, were given to museums that owned the related sculpture. These were the first drawings that he ever sold, and I believe he only first appreciated them as works of art when The Phillips Collection in Washington, D.C. borrowed ten of his drawings from us for their 1964 Seymour Lipton exhibition together with *Desert Briar,* which Albert Elsen described as "an aggressive, angular stance, defying death" in *Seymour Lipton* (New York: Harry N. Abrams, [1971], p. 40) and which Duncan Phillips referred to in the catalogue.

In 1969 the University of Wisconsin–Milwaukee borrowed twenty drawings (Drawings 7–31 in their catalogue checklist) from us for an exhibition from September 14 through October 26 (*Seymour Lipton: The Creative Process*).

We have always displayed the Lipton drawings as a group in a most conspicuous place in our home or in my office, and I probably have spent more time looking at those drawings than any other works of art. What I like most about them is their honesty. They were produced solely to translate his conceptions without any thought of marketability, and because I am familiar with almost all these sculptures, I can envision them emerging from these drawings.

Lipton's *Cerberus* (1947; 32.0), purchased on August 28, 1963, is not in the show because it is too fragile to transport. Lipton made these early pieces by building a core of plaster of Paris not reinforced by an armature and then covered with hammered lead approximately 1/8 of an inch thick. The surface, which looks like pewter, is aesthetically appropriate for his work. But he discovered, and I do not want to discover, that the work as constructed is so fragile that whenever he shipped a piece, it usually broke up. He later became a welder and brazier in order to make his work sturdy and portable. *Cerberus* is among the sculptures in Andrew Ritchie's illustrated book *Sculpture of the Twentieth Century,* the first art book that I used as a guide to determine in what areas of sculpture I wanted to acquire.

Although I always try to get preliminary drawings and drawings related to the sculpture that we acquire, this has proven at times to be dif-

ficult. To my knowledge, none of the artists in our collection who do assemblages with found objects, such as Lee Bontecou, Varujan Boghosian, Anthony Caro, John Chamberlain, Joseph Cornell, Louise Nevelson, David Smith, and Richard Stankiewicz do preliminary drawings for specific pieces of sculpture. This creates a void in our collection. But some of them have done drawings or prints that do relate to their generic work and certainly give some inkling of their conceptual and creative process. This is particularly true of David Smith.

The converse of this is Christo, who only leaves the models, photographs, and preliminary drawings (11.1–11.11) of his projects which are usually completely destroyed within three weeks of their completion.

Julio González also made thousands of drawings for sculptures of which we have seven (21.1–21.7). He, too, was only able to execute a few sculptures because he could not get the welding materials during the war and died in 1942. The bulk of his important sculptures, done directly in iron, are not readily available as they are in museums or owned by his daughter, and those that occasionally come on the market are usually casts, which I consider reproductions and would not buy.

Other sculptors such as Theodore Roszak made numerous sketches for specific sculptures. For *Flying Fish* (49.33) that was executed in 1959 and a monumental version entitled *Forms in Space* that was constructed in 1964–65 for installation in front of the Hall of Science at the New York World's Fair in Flushing Meadows, New York, he made at least eleven mechanical and conceptual drawings (49.21–49.32). Almost all of his other drawings in our collection relate to specific sculptures.

After buying *Flying Fish* we visited Roszak at his studio with our daughter Judy, who was nine at the time. As soon as we walked in, he said, "Wait a minute," and came back with two small drawings of a child playing store which he originally made for his daughter, Sara Jane, and gave to Judy who still treasures them. Roszak was a compulsive drawer. He even did drawings on the plaster walls near the telephone in his studio which were masterful doodles.

After we became friends, I was having a drink with him in his living room when I noticed over his

couch a drawing of *Study for "Spectre of Kitty Hawk"* (49.10). I was gauche enough to ask him whether he would sell it, and with slight reluctance he said he would. Shortly thereafter in a letter to me dated May 31, 1962, he wrote, "The drawing you have of *Kitty Hawk* was part of my 'own' private stock that I did not realize at the time I was relinquishing. However, I am satisfied and happy in the thought that it is in good hands." We hung it in our dining room. If we had a couch against a wall, it would undoubtedly have fulfilled our quest for that something-over-the-couch. It is unquestionably the most powerful piece of art that we have in our collection, and we have friends who will not sit opposite it when they are dining in our home because they find it too threatening.

The steel sculpture *Spectre of Kitty Hawk* is in the Museum of Modern Art. It is a metaphor for the bombing of civilian populations during World War II. Roszak envisions the bomber as a gnarled skeletonized monster with a bursting bomb causing cataclysmic destruction. He worked for Brewster Aircraft Corporation during the war and probably had second thoughts about the damage and death caused by planes that he may have worked on. I also bought two preliminary drawings for the *Study for "Spectre of Kitty Hawk,"* one in this exhibition (49.11) and another we gave to the Museum of Modern Art.

DOCUMENTATION AND CERTIFICATES OF AUTHENTICITY

Just as Lipton's *Desert Briar* influenced me always to seek preliminary and related drawings whenever we acquired a piece of sculpture, our purchase of Jean Arp's *Petite Torso* (3.1) taught me always to seek documentation with each purchase, particularly when the sculpture is a multiple. The saga of finally acquiring an authentic cast of *Petite Torso* in 1959 was described in a speech that I gave at the Conference on Arts and the Law held at the University of Chicago Law School on April 15, 1966 and published in the November 9, 1966 *New York Law Journal:*

It all started on a sunny Saturday afternoon in December, 1958. I was a neophyte collector of sculpture making my usual safari down Madison Avenue in quest of art treasure. I stopped off at

one of the more reputable galleries, currently a member of Art Dealers Association of America, Inc. While browsing, I came across a small bronze by Jean Arp. It was wonderfully sensuous and had all the whimsy that a dadaist-surrealist can impart to a piece of bronze. I immediately reacted to it and was delighted to learn that it was within my price range.

In a matter of minutes I had agreed to buy the Arp, which was the first bronze I had ever bought. The dealer gave me a bill of sale in which he set forth the name of the artist, the title of the work, the year it was executed, its approximate height and that it was 6/6, which means it was the sixth cast of a limited edition of six, and, of course, the price. I left with the Arp under my arm, gave it a place of honor in my living room and enjoyed it. After a few weeks I began to wonder how I could be sure that what I bought was an Arp. All I had received was a bill of sale. I returned to the gallery and spoke with the dealer, who advised me that the custom of trade with respect to contemporary bronzes is merely to give a bill. I advised the dealer that I am not a conformist in this respect, and would like a certificate signed by the artist on the back of a photograph, which should read approximately as follows:

"I certify that the sculpture of which this is a photograph was executed by me in 1930, is entitled *Petite Torso,* is approximately eleven inches in height, and is the sixth cast of a limited edition of six which was sold on December 29, 1958 by _____ gallery to Alvin S. Lane."

The dealer deemed me a bit eccentric, but not unreasonable, and assured me that he would use his best efforts. In about a month a certificate arrived and all was serene in the Lane household, particularly with respect to this little bronze.

After a few more weeks I started to wonder how Arp, sitting in Paris could determine from the photograph that a certain bronze located in New York was the sixth cast. How did he know it was not the third cast, or the first cast, or a cast from a cast? I decided to write to Arp, as I was planning a trip to Paris. I asked him to meet with me so that he could examine the bronze and verify its authorship. Unfortunately, Arp was out of town and I did not receive a reply until after I returned from Paris at which time a letter arrived from Madame Arp advising me that there appeared to be a discrepancy—Arp only made five casts of *Petite Torso.* You will recall that I was sold the sixth cast.

I hastened to send the certificate that I had received from the gallery to Arp. The next letter from France advised me that based on the photograph I had acquired a "good copy" although a forgery of Arp's *Petite Torso*. It went on to complain that the signature on the certificate was "crudely counterfeited." Armed with the correspondence I confronted the dealer. After gaining his composure, he advised me that the party from whom he acquired the work was beyond reproach, but he refused to name him, and I was therefore unable to investigate the matter further. Incidentally, this refusal of dealers to divulge their source is another custom of the trade. Often they claim that they do not want their competitors to know where they buy, and occasionally they give as their reason that the seller wishes to remain anonymous. But, unless the dealer buys directly from the artist or at public auction, he usually will not disclose the source.

The dealer was gracious enough to offer to refund the purchase price to me in exchange for the sculpture, and that is what most reputable dealers would do. I, of course, was willing to take back my money, but I refused to return the sculpture, unless it was first stamped "copy" or "reproduction." This was not acceptable to the dealer and the lawyers entered the picture.

It is not necessary to outline all the offers and counter-proposals. The matter was finally settled by the gallery refunding my money and the sculpture was held in escrow by one of the attorneys. The escrow agreement provided that if Arp, in writing, declared the sculpture to be authentic it would become the unencumbered property of the gallery. Otherwise, it was to be destroyed. Eventually a representative of the dealer did present the sculpture to Arp in France for authentication. He declared it to be a fake and by his droit de suite under the French law he seized the work.

The happy twist of this story is that Madame Arp, who became my pen pal during this episode, arranged for me to purchase the last of the authorized casts from [Galerie d'Art Moderne Bale] a Swiss gallery, for $200 less than I paid for the fake. This time I also received an authentic certificate from Arp.

As a result of the above experience, I decided that there should be a consumer protection law requiring art merchants to give to a purchaser a certificate of authenticity setting forth the pertinent facts when selling multiple sculpture. I started my campaign with many letters

and speeches, became the chairman of the Committee on Art of the Association of the Bar of the City of New York, wrote several articles, including an article for the October-November 1965 issue of *Art in America* entitled "The Case of the Careless Collector," and did a variation on the theme for *The Record*, vol. 20, no. 9 (December 1965), published by the above Bar Association entitled "How the Bar Can Assist the Art Community." All that agitation led to a series of hearings in 1966, conducted by Louis J. Leftkowitz, the Attorney General of the State of New York. Subsequently, I drafted proposed legislation in collaboration with various assistant attorney generals, but it was not until 1991 that the Sculpture Bill (Article 15 § 15.10 of the Consolidated Laws of New York) became law. My reward was a gift of a pen used by Governor Cuomo to sign the bill. It took over thirty years to enact this legislation because of the lack of support from the museum hierarchy and the strong opposition of the organized art dealers who looked askance at a lawyer trying to change the laissez-faire customs and mores of the art community.

Although the requirements of the Sculpture Bill are generally ignored by the art merchant and the public and private collector, and there is no effort to enforce it, I always try to get certificates, not only for multiples but for all artwork that I buy. I have no trouble if the artist is alive and very little trouble if he or she is dead as I approach the dealer or representative of the estate. Requesting such documentation had saved me from purchasing a small Picasso a few years ago that proved to be questionable.

Documentation can also generate pleasant surprises. For example, I purchased *Study for "The Rescue"* (31.4) at the April 5, 1967 auction of Parke-Bernet Galleries as one of an edition of seven according to the catalogue. Jacques Lipchitz in his certificate of authenticity added the following:

> In reality only one or maybe two bronzes of this sketch may exist because in my fire the plaster model was destroyed and I couldn't complete the edition.

I discovered that not only was the piece more rare than I thought but also that he had given it to the artist Lyonel Feininger, whose widow was the consignor.

Ideal examples to demonstrate the documentation of the creative process are the drawings of Tom Wessel-mann's laser-cut steel drawing entitled *Steel Drawing/Reclining Nude Edition* (58.5) as explained in the artist's statement, dated January 26, 1986, addressed to Carroll Janis, his dealer:

Jan 26 1986

Dear Carroll

For Mr Lane:

In 1983 or 84, I did a charcoal drawing from Amy, one of my *(which I am Retaining)* models. The drawing was so good and so right that it was my first choice for my newest idea, which was to make a drawing in steel, as though it were actually just drawn in steel, retaining the error lines, etc. But since it was a charcoal drawing, it had to be converted into a hard line, and simplified somewhat, especially since all lines must connect with some other lines, in order to hold the work together. The smaller pencil drawing was a first step in this process. The large ink drawing was the final step, where my final decisions as to the exact form, were made. This drawing was then photostated and from that the technical work was done to transfer the image to steel. That process was not simple, and the first method was rejected, the second method had shortcomings, and the third method was adopted. The drawing for this project was in full size, and was used for the large scale "Steel Drawing/Amy Reclining", which was done with ten variations. For the small scale edition of fifty, the computer was instructed to do the drawing at half size.

The drawing (58.3) that he states "I am retaining" was sold to me on March 1, 1988 after a considerable amount of persuasion over a two-year period and the certificate of authenticity for it reads:

 I certify that the pastel and pencil drawing on rag paper 23" x 28", of which this is a photograph, is entitled <u>Drawing for Amy Reclining</u>, was done in 1984, is the original conceptual drawing for the laser-cut steel drawing entitled <u>Steel Drawing Edition/Amy Reclining</u>, was signed by me at the bottom right and sold by me through the Sidney Janis Gallery to Alvin S. Lane on March 1, 1988.

Tom Wesselmann

April , 1988

He explains in his following letter to me why he chose that drawing.

Alvin Lane February 1988

Dear Alvin

The drawing for Amy Reclining was one of a number of random drawings from the model, all done months before. I thought of doing laser drawings.

When I had the idea of doing a drawing in steel, as though it had just been somehow miraculously drawn in steel, I looked through these drawings for the first candidate.

The Amy drawing seemed perfect, and, in fact, I regarded it as perhaps the best drawing I had ever done. I did a tracing of the drawing, in ink and enlarged it to full size. The biggest problem was in translation — converting the pastel pencil lines to solid black ones.

Sincerely

Tom Wesselmann

I acquired the drawing (58.2) which he describes as "a first step in this process" on January 21, 1986 and the certificate of authenticity reads:

> I certify that the pencil drawing on Bristol Board, which is 9-3/4" x 19-1/2", entitled <u>Drawing for Amy Reclining</u> and of which this is a photograph, was a working drawing for the laser-cut steel drawing entitled <u>Steel Drawing Edition/Amy Reclining</u> and was done by me in 1984, signed by me in the lower right corner and sold by me through the Sidney Janis Gallery to Alvin S. Lane on January 21, 1986.
>
> _April 16_ , 1986 Tom Wesselmann

I acquired the drawing (58.4) which he described as "the final step" on January 21, 1986. Wesselmann was very reluctant to sell this drawing because it showed all the corrections that he made before the image was transferred to the steel. However, I had indicated that it was those corrections that made it interesting for my purpose and that I have no intention to show it unless it is with the final work. That seemed to tip the scale. The certificate of authenticity reads:

> I certify that the marker drawing on paper which is 32" x 75", entitled <u>Study for Steel Drawing/Amy Reclining</u>, and of which this is a photograph, was the final drawing for <u>Steel Drawing/Amy Reclining</u>, a photostat of which was made from which the technical work was done to transfer the image to steel. This drawing was done and signed by me in 1984 and sold by me through the Sidney Janis Gallery to Alvin S. Lane on January 21, 1986.
>
> _April 16_ , 1986 Tom Wesselmann

Since we did not have the wall space for the large-scale *Steel Drawing/Amy Reclining,* on November 28, 1985, I bought the smaller one (58.5). This is the disadvantage of collecting within the confines of a comfortable house. The certificate of authenticity for it reads:

I certify that the laser-cut steel drawing, 13" x 33" , entitled Steel Drawing/
Reclining Nude Edition, of which this is a photograph, is the 5th of an edition
of 50 (plus proofs and unnumbered multiples not to exceed 10), was produced
from my ink drawing, and signed, numbered and dated in the lower right directly by
engraving done with my hand
and sold by me through Sidney SIDNEY JANIS GALLERY
Janis Gallery Editions to Alvin S. 110 W. 57 N. Y. 10019
Lane on November 29, 1985

[signature]

December 14, 1985

ARTIST Wesselmann
TITLE Steel Drawing Edition/ Amy Reclining Ed.50
MEDIUM Laser-cut stainless steel

The small colored drawing entitled *Open Ended Nude #147* (58.1) was purchased on May 8, 1990 merely to illustrate how Wesselmann used the demarcation of sun-tanned areas to tie the line together. The certificate of authenticity for it reads:

I hereby certify that the drawing entitled Open Ended ~~Reclining~~ Nude #147

Edition No. 147, of which this is a photograph, was produced by me

from watercolor and graphite on Bristol board 3-3/4 x 8-7/8 inches

and was signed and dated in pencil at the lower left "#147 Wesselmann 81"

by me and sold at Christie's Contemporary Drawings, Watercolors and

Collages auction (7092) on May 8, 1990 as item 246.

June 21 , 1990 *[signature]*

Tom Wesselmann

OVER THE YEARS THE DETAILS OF THE TITLE HAVE CHANGED - CURRENTLY
I TEND to USE OPEN ENDED NUDE # 147 (VARIABLE EDITION)

[signature]

COLLECTING RATHER
THAN ACQUIRING

After having bought a few pieces of art and done some reading beyond Andrew Ritchie's *Sculpture of the Twentieth Century,* I decided to collect rather than merely acquire art. Acquiring art is impulsively buying art that is aesthetically appealing. This can end up as a chaotic accumulation of the pieces which have no relationship to each other and is highfalutinly referred to as eclectic. Collecting, as I see it, is buying in accordance with a preconceived concept or plan. My hope is that our collection will have a harmony with complementary pieces that make it greater than the sum of its parts.

Because of my limited time and expertise, I narrowed the field that we collect to twentieth-century sculpture and sculptors' work on paper, and used the historical perspective approach as the acceptable criterion. My concern is whether the artist in some manner extends our way of seeing or thinking. Of course, I also wanted the art to add to the pleasurable decor of our home. Conforming to that double standard is sometimes difficult. For example, of the approximately 325 pieces of art acquired over the past thirty-seven years, we disposed of only four or five pieces, and the rest are all on display. However, one of the pieces that we sold was a construction by Jean Tinguely entitled *Variation Royal Constant* which was actually one of his least zany pieces. We did not question the importance of the artist or the relevance of the piece. Our problem was that it did not blend aesthetically into our home. It had a motor behind a concave black shield with tufts of rods protruding and a prong extending from the motor, terminating with a white crescent-shaped metal cutout that gyrated, causing the rods to jiggle and the prong to beat against them while the crescent spun around and created a jarring noise. I had envisioned connecting it to the doorbell instead of chimes. Terese vetoed that, and we are now without any sculpture of that important artist. We do have one of his drawings (57.1) which fortunately does not create any commotion.

In addition to finding art that is compatible with the decor of our home, we strived to buy art that we thought would be valid from a historical perspective for more than fifty years, and because of economic constraints we looked for art that was not in the mainstream of the art market. That meant discerning which artists who were not expensive were important because of the innovation and derivation of their work.

The artists that obviously fit our criteria and which we bought in depth during the late fifties and sixties were Louise Nevelson, Alexander Calder, and David Smith, whose work formed the early foundation of our collection.

LOUISE NEVELSON

When we started to buy Louise Nevelson's work many people regarded her as a bag lady who roamed the streets of lower Manhattan picking up debris and hauling it back to her studio. Although she dressed like a Bohemian with layers of colorful clothes, exotic scarfs wrapped around her head, and heavy makeup and eyelashes, she was actually a regal lady of great beauty with tremendous pride, energy, and confidence in her ability as an artist.

I first bought her work at Grand Central Moderns Gallery in January 1960, a small piece entitled *Moon Garden Plus One*, not in this exhibition because of its fragility. Her work indicated to me that it was an extension of analytical cubism. Approximately fifty years after Picasso and Braque invented cubism, mainly on two-dimensional canvases, Nevelson was developing three-dimensional cubistic architecture by scavenging from the streets of New York bed posts, picture frames, toilet seats, hat molds, and whatever other objects interested her; breaking them up; and then assembling the parts, usually contained in boxes or crates which became building blocks for creating walls and environments, which she called atmospheres.

Although analytical cubism, as the name implies, is cerebral, Nevelson allowed her mysticism to inculcate her work and give it a spiritual quality. Thus she took the debris of civilization and created her own ethereal world. But in spite of her inventiveness and importance from a historical perspective, she was not in the mainstream of the art market until after she joined The Pace Gallery in 1964 when she was sixty-five years old.

I believe the consensus today is that her greatest show was *Dawn's Wedding Feast*, which was installed at the Museum of Modern Art in New York in 1959. As the name suggests, the work was white, the first time she used a color other than black for her constructions. The viewer was engulfed in a magical environment consisting of

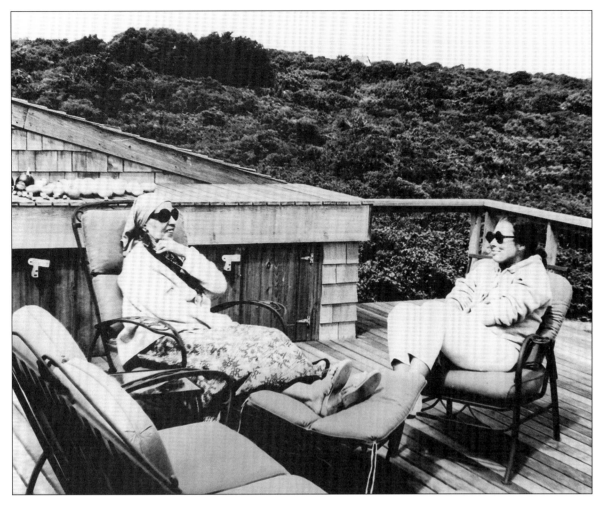

Fig. 1. Louise Nevelson (left) and Terese Lane relax at the Lanes' summer home

about eighty-five pieces that filled the entire gallery space. When the exhibition was over, only two minor pieces were acquired by the Museum of Modern Art, and a few other pieces were purchased by such sophisticated collectors as Nelson Rockefeller and Nevelson's dealer, Martha Jackson. Nevelson was anxious for the entire show to be kept intact and acquired by a museum or single collector in order to preserve the integrity of an environmental assemblage. Although she indicated that she was willing to give the entire show to any museum that would take it, none was interested. Because she was unable to store the whole show, she destroyed much of it and cannibalized some of it for future projects. This embittered Nevelson against the museum establishment for the rest of her life because they did not appreciate her work until years later when she became famous. If an artist could not give away her best show, she was not as yet in the art market mainstream, even if she received much acclaim from the critics. Martha Jackson bought *Dawn's Wedding Chest* (41.2)

which was a focal piece of *Dawn's Wedding Feast*, and I bought it from Ms. Jackson's estate.

In 1963 she had a show at a major New York gallery which consisted of her recent major wall constructions, none of which was sold, and because of a dispute between the dealer and the artist all of that work became unavailable. I happened to playing golf with Louise Nevelson's lawyer, Harris Steinberg, shortly thereafter when he asked me whether I would like to go to her studio and see what she had for sale. I, of course, agreed and found her very distraught and the studio in disarray. There were no walls or major pieces. I left without buying anything but returned a few months later. She had not been productive since I last saw her, but after looking around again I asked her whether certain odd pieces in the studio were of the same vintage and could be put together as a wall. When I showed her what I had in mind she said, "Take your coat off," and we started to assemble *Cathedral Garden #4* (41.4). After arranging the pieces, we decided it needed

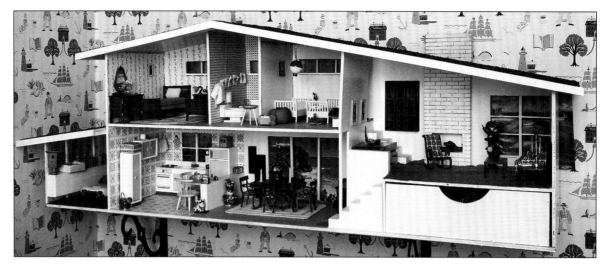

Fig. 2. Judy Lane's doll house with Louise Nevelson's wall to the left of the fireplace Below: Fig. 3 Nevelson's wall made for Judy's doll house

another box to give it the right proportions. Nevelson was not a carpenter so I went to my shop at home and made a box of the dimensions that she indicated, and she filled it with odds and ends to blend with the other twelve pieces. That is how *Cathedral Garden #4* was created. The box under the closet is the one that I made. Each segment of the wall is signed by her including the one on which I collaborated.

The following certificate indicates the various segments of the wall, and I do not think there is any question that the whole is more than the sum of the parts:

> This is to certify that the photo on the opposite side is that of an original work by Louise Nevelson, entitled *Cathedral Garden #4*, commissioned by Alvin S. Lane and completed in 1963. The wall unit consisting of 7 boxes, one column and one closet may be changed by interchanging the closet with any of the two standing columns that appear in this photo. The two columns are considered separate sculpture.
> s/Louise Nevelson
> January 23, 1964

After the metamorphosis of *Cathedral Garden #4*, Louise and my family became close friends. We socialized and dined together, and she spent a couple of long weekends with us at our seaside home (fig. 1). She had a grandmother-like relationship with our two daughters, and when I built a doll house for our daughter Judy, I asked Louise whether she would make a "wall" for it. She said she would be delighted to do it. I made ten tiny boxes out of cherry wood and cut up some old-

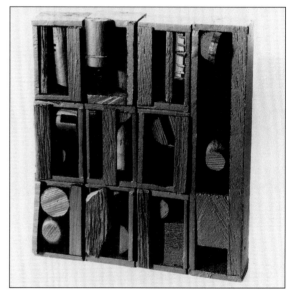

fashioned wooden clothespins at random with a band saw, took a few scraps from my shop floor and delivered them to her in a plastic bag with a tube of glue. About two weeks later she visited us to make the presentation. She wore black thermal underwear for a blouse, about a pound or so of bold necklaces that she apparently made, a colorful cape with a red lining, a black jockey cap, and space shoes that she sprayed with gold paint. My kids were enthralled with her gold shoes, but I was dumbfounded when I saw the 4 by 4-1/2 by 1 inch "wall." I could not help but realize that this was more than just a toy for a child's doll house (fig. 3). However, we did install it in the doll house with other miniature works by Lipton and Roszak. Judy, now age forty-one, still has and guards that doll house (fig. 2). I must confess from time to time I have tried without success to get that little Nevelson from her. The following certificate clearly indicated who the rightful owner is.

I certify that the photograph on the reverse side is that
of an original work executed by me in 1964. It is approx-
imately 4" x 4½" x 1" consisting of ten black wood boxes.
It is the first of the 1964 series of miniature works,
and was given by me to Judy Lane.

February 18, 1965

Louise Nevelson

Louise Nevelson

When Louise delivered the doll house wall early in 1964, she was excited as she told us that everyone who saw the doll house wall wanted to buy it. She was having her first show at The Pace Gallery in New York, and as a result of Judy's doll house wall, much of the show consisted of minia-tures in shadow boxes. The show was her first commercial success, and she frequently called me to tell me how the concept of the doll house wall changed her financial condition as she was selling the miniatures, as she said, as fast as she could make them.

She told me how she enjoyed making them after a hard day's work of lugging the larger pieces around in her studio because she could sit at her kitchen table and do them just like someone would do a doodle, but these became doodles that were selling for thousands of dollars. The show at Pace called *Diminishing Reflections, 1964* received rave reviews. Charlotte Willard in the November 29, 1964 issue of the *New York Post* said, "The small wall hangings she calls diminishing reflections are the compressed essence, the elixir of her art. A piece 20-½ by 16 inches contains all the elegance and mystery of one of her large walls."

John Canaday in the November 21, 1964 issue of *The New York Times* said:

> . . . as a creative artist she has never ridden so high as she does in her current show. Her work has had flair, spirit and the inexplicable quality called "presence," but it has never before been in addition so controlled, so disci-plined. There has been a suspicion that much of the impact of her art has come from the force of its architectural dimensions. But now she has some small wall panels and some standing pieces only a foot high that are as powerful in presence as the big constructions that take whole rooms themselves.

ALEXANDER CALDER

Alexander Calder is another cornerstone of our collection. When we started acquiring his work, he was perceived by the general public and the casual collector as a childlike man who fabricated inge-nious toys and liked to perform a miniature circus with his toys in Paris. That image impeded his entrance into the mainstream of the art market. Calder did sell quite a few pieces of sculpture but at very modest prices. He also was prolific, which in a supply-and-demand market tended to deflate further the price. But Calder was a very serious artist who was not just interested in entertaining people with his "toys." Those "toys" are derivative from Miró, a leading surrealist who took his dreams and fantasies and portrayed them visually in abstractions often consisting of such forms as circles and squares, half moons and triangles, squig-gly lines and biomorphic shapes. Calder cut similar forms out of sheet metal, usually painted them in primary colors as suggested by Mondrian, and carefully balanced them from attached wires. An engineer by training, Calder devised ingenious means by simple twists of the wire to control the movement of all the parts so that they glided with a certain harmony, and the movement of a seg-ment affected the movement of the other parts. Rarely is one segment askew. They are all con-trolled. They are Mirós that twist, turn, and float in space. He invented an area of art, and his crafts-manship was so meticulous that nobody has been successful in imitating him except the makers of ersatz Calders that are really toys and not art. He occupied the entire field, and there is no question that from a historical perspective he is important.

Alexander Calder's work always fascinated me. I do not believe you can have a modern col-lection of sculpture without at least one of his mobiles. He is the first artist that I bought in depth, not only because I thought his work was relevant but also because it gave our home a very

cheerful atmosphere. Five or six Calders in your house makes it like a nursery for adults. Terese and I were fortunate enough to know Calder, who was as much fun as his art.

Buying Calders is like eating peanuts: once you start, it is hard to stop. We purchased our first Calder in 1960, and we bought at least one of his sculptures or drawings during each of the next ten years. As the prices rose thereafter, our purchases became less frequent. By April 14, 1966 we already had acquired five Calders, and *Verticale hors de l'horizontale* (8.7), a major Calder, was coming up for sale at Parke-Bernet. I approached my partner Henry Klein to suggest that we buy it as joint owners. Since we were close friends, I knew that if my judgment proved wrong there would be no recrimination. I was building a summer home and realized how appropriate that Calder would look in a seaside house. Henry had a large house in Westchester where it would look equally handsome in the stairwell. We agreed that I would have it during July and August and he would have it the rest of the year. Neither of us had a large budget for acquiring art, but we successfully bid against Joseph Hirshhorn. Although the cost was modest by today's standards, it was at that time the highest price paid at auction for a Calder. Today it would cost at least thirty times as much as we paid for it.

Henry and I shuttled it back and forth between our houses taped to a sheet of heavy cardboard until unfortunately he died. I purchased his interest from his estate. It still travels each summer to and from our beach house, but I no longer have the ritual of raising and lowering the Calder with Henry over a glass of wine.

During 1966 the Helene Rubenstein collection was put up for sale at Parke-Bernet. One of the items in that sale was Brancusi's *Bird in Space*, which I consider the best piece of sculpture of the twentieth century and which I was very anxious to buy but could not afford. After the successful joint venture with the Calder I thought of putting a group of six people together who would jointly buy six sculptures to rotate every six months so that over a period of three years each of us would have had six important pieces of sculpture in our homes. *Bird in Space* was to be the first acquisition. But because I had no credentials, I decided it would be too risky to invest other people's money

in art. I abandoned the idea and thereby gave up the hope of getting *Bird in Space*.

The Guggenheim Museum had a marvelous Calder retrospective in 1976–77, entitled *Calder's Universe*. The interior of the Guggenheim is particularly suited for a Calder exhibition, and all the children playing with the sculptures made it even more festive. Signs throughout the museum read "please touch," the only time I have ever seen such a permissive invitation. During the Calder exhibition, I dropped into the Perls Galleries, which was usually one of my stops while doing a hop-skip-and-jump along Madison Avenue to see what they had, and to chat a little. Dolly Perls told me that there was a small Calder at the Guggenheim that she felt certain would interest me. Since I had bought most of our Calders from the Perls Galleries which was his dealer, she was well acquainted with my taste. While entering the Guggenheim, I met a man from the Southwest who apparently had never seen a Calder. He exclaimed how wonderful and stopped me to ask whether somebody could buy them. I told him there was probably a price list at the desk and then went on my way to see the piece that Dolly had suggested. She was right, and I called that afternoon to tell her I would take the piece, only to be advised that there was a man who looked like a rancher from the Southwest who had just been to her gallery and bought it. I told her that I thought she had reserved it for me and said that I would take the drawing entitled *Ben Hur* (8.1) instead. She explained that this was Calder's personal drawing and not for sale. She must have realized how disappointed I was since she called the next day to tell me that Calder would sell *Ben Hur* to me. I think it portrays one of the most charming orgies envisioned by a very mischievous and joyous artist. Needless to say, the Ben Hur in the leading chariot in the drawing has to be Calder, and you know he is going to win that race. As to the other revelers, I have no idea who they might have been.

Calder's boyish fun came through even in our correspondence. He would take an envelope that I sent to him and draw a personage with a very long arm and large hand indicating to the mailman that it should be returned to the sender. We had quite a correspondence because I bought many Calders and always requested a certificate of

authenticity signed by him. Although he complied with my wishes, he used to refer to me as "that crazy lawyer," as he apparently did not feel that documentation had anything to do with art.

My family and I visited with him and Mrs. Calder at their home in Woodbury, Connecticut in the mid-sixties when I was looking for a stabile. During a delightful afternoon, I had a chance to talk with him over a glass of wine. I reiterated my interest, not only in documentation but also in preliminary drawings. To the best of my knowledge there were very few, if any, preliminary drawings done by Calder that were on the market, but he was good enough when he did two for commissions to send the drawings to me as a present (fig. 4, is one of the two). I included one of them here to show that although his drawings usually have a flowing steady line, his preliminary drawings are sloppy scribbles.

Fig. 4. Alexander Calder, *Sketch for "The X and Its Tails,"* 1967, red marker on paper, 8½ x 11 in. A gift from the artist

DAVID SMITH

David Smith's work is the third and most substantial cornerstone of our collection, but it took me a long time to become enthusiastic about his sculpture, which I thought at first was crude and unresolved. I always liked his drawings, and my first purchase (51.31) was at his show at the Balin-Traub Gallery in May of 1963. He was in the gallery at that time and seemed to be indifferent toward collectors, or at least toward me. He was a gruff man, and I recall that he emphasized the fact that his gouaches were made with egg yolks and

ink but never tried to impress me with the artistic quality of his drawings.

I had seen the Julio González show at the Museum of Modern Art in New York in 1956 and had bought three Julio González drawings (21.2, 21.3, 21.5) in 1961 from the Gallerie Chalette, the first gallery in the United States to show his work. I merely mention this to show that I was familiar with González's work from which David Smith is derivative, and that derivation from González, and therefore from Picasso, gave him recognition from a historical perspective. My early rejection of his sculpture was obviously aesthetic rather than cerebral.

When David Smith died on May 23, 1965, I realized that whether I liked his work or not, he was a very important artist whose sculpture I should buy before the prices got out of my reach. I called Steven Weil, an acquaintance from the Committee on Art of the Association of the Bar of the City of New York, who was then the director of the Marlborough-Gerson Gallery, David Smith's dealer, and asked him to arrange for Terese and me to go to Bolton Landing, David Smith's home and studio, as I was interested in buying some of his work.

On a sunny Saturday we drove up to Bolton Landing. It felt like exploring the remains of a strange civilization. Except for the caretaker who greeted us there was no one in the area. Just beyond the entrance from the road there was a studio on the right. In the studio, which was like a large garage, were segments for a few pieces of sculpture that were arranged on large metal tables. These were subsequently welded together as posthumous pieces. Just beyond on the left was a small pond with some tall, lyrical pieces of sculpture around it. As we continued up the road beyond the pond toward the house, about thirty pieces of sculpture were on cinder blocks in straight rows. Many of these were painted white which I was later told was a rustproof undercoating which he intended to cover with various outdoor paints that he was experimenting with. To the right of the house was a field with about thirty monumental pieces of sculpture on cinder blocks arranged in a rather haphazard manner, and at the time appeared to me like an exotic pagan cemetery. As we examined each of the pieces, I was saddened to realize that they would not fit into the

modest colonial house that we had at that time. I would not consider putting one outdoors because many had started to rust, and some that were painted were starting to peel.

We entered the house constructed of cinder block which was rather crude and utilitarian. From its terrace there was a view of the meadow with all the sculpture, and I imagined David Smith standing there studying his pieces as an environment, but I am sure he saw it in a different context than I did. The decor of the house was simple with no frills and had a masculine quality. The only art on the walls was paintings and drawings made by his two young daughters, Rebecca and Candida, which were pinned on a bulletin board. On a book shelf were three small pieces of sculpture, one made with a lemon squeezer (51.29), another with a candle snuffer (51.28), and the third with a spoon and sardine can (51.30). The latter is the only piece that I know of that has been completely brazed with silver solder.

In the basement there seemed to be hundreds of pieces jammed together so that it was impossible to view them individually. We spent hours dragging a few small pieces out of the basement to view them better. In those few hours, I developed not only a healthy respect for these sculptures, but also a strong craving to own them.

We settled by buying *Albany VIIB* (51.32) and the three small pieces from the book shelf in his living room. It was a fruitful, exciting day that I will never forget. An aura of intense creativity and death permeated Bolton Landing that day for me.

According to the catalogue raisonné in Rosalind Krauss's *The Sculpture of David Smith*, he completed 676 pieces in his lifetime. I estimate that more than half of them were in the estate inventory when we were there.

Although Smith professed in his autobiography *David Smith by David Smith* to have done 300 to 400 large drawings a year, very few were sold during his lifetime, and for years after his death, none was offered for sale by the estate. With the exception of *Enamel Spray*, 1958 (51.31) we acquired all of our Smith drawings during the last twelve years.

All of his sketchbook drawings were given to the Archives of American Art, except one book from 1954 containing 100 drawings that David Smith gave to his friend Gloria Gil. She broke up the sketchbook, and I bought nine of the sketches

in 1987 from the Mekler Gallery in Los Angeles (51.16, 51.18–51.25). I bought a tenth (51.26) in 1993 at Christie's.

Although David Smith is probably the greatest twentieth-century American sculptor and received much recognition during his lifetime, his sculpture sold slowly and mainly to institutions. There was practically no market for his drawings during his lifetime.

RANDOM EXPERIENCES

I had never thought of using consultants or agents or other advisors to purchase art, with the exception, of course, of my wife, who not only has to live with me but also with the art I bring home. Much of the fun of collecting is the personal experience one encounters in searching for and buying art objects. Using a third party to acquire art insulates the collector from the excitement of the market place and the evolution of the decision-making process. The following are a few instances of the joy and frustration that I encountered.

In 1963 I went to my twentieth law school reunion in Cambridge, and rather than go to the football game on that Saturday, Terese and I decided to stroll down Newbury Street to see what the Boston galleries were showing. Most of the exhibitions were rather bland representational art in which I had no interest, but The Pace Gallery had a show of contemporary art that included a John Chamberlain sculpture. It seemed incongruous to see this show with parts of a crushed automobile—as so many people referred to them at the time—among the very conventional, genteel works that seemed to gravitate toward New England. As soon as we entered the gallery, I realized that I wanted this Chamberlain. It was *Nehoc* (10.5). I already had *E.D.* (10.3) and *El Reno* (10.4), but they were small and made from tin cans. I wanted one that better demonstrated the force of abstract expressionism made from crushing automobile parts.

The dealer was Eva Glimcher, the mother of Arnold Glimcher who owns The Pace Gallery in New York. Mrs. Glimcher was a plain, friendly lady who was not the personification of an art dealer. When I asked her for the price of *Nehoc*, she incredulously said: "Are you going to buy this?" When I answered in the affirmative, she said, "You

cannot be from Boston. Nobody in Boston would buy this." I told her she was right and that I was from New York. She nodded knowingly. I arranged to have the Chamberlain shipped to New York. I remember very little of my twentieth reunion, but the "negotiation" for the Chamberlain remains very vivid in my mind, making me smile every time I think of it.

In 1962 I was at a cocktail party in Westchester given by one of my Wisconsin classmates when I met Carlos Israel, a fellow lawyer. Terese and I had just come from our first visit to the Guggenheim Museum and were very excited about its concept and the marvelous space that it had to view art. When I expressed my enthusiasm, Carlos said in a stern manner, "My brother-in-law wouldn't set foot in there." I retorted, "Who the hell is your brother-in-law?" He said, "Naum Gabo." I said, "The sculptor?" He said, "Yes." I then told him that I always wanted to acquire a Naum Gabo but never saw any on the market and asked him whether he could arrange for me to meet with him. He did. The week before the scheduled meeting, however, I read that Gabo's brother, Antoine Pevsner, had died. I naturally called him to suggest a later date for the meeting. Gabo, a rather blunt man, said he would keep the appointment. He did not seem to be upset about his brother dying. In fact, he expressed some resentment about his brother copying his ideas. They both wrote the Constructivist Manifesto together, but Gabo did not seem to be the kind of man who would allow anyone to be an equal partner, not even his brother, from whom he carefully distinguished himself by changing his name.

We met with him and Mrs. Gabo (Carlos Israel's sister) at their house and studio in Middlebury, Connecticut, on April 21, 1962, having recently returned from a vacation in Russia. He had left Russia when the Bolsheviks took over, was *persona non grata*, and was anxious to talk about what was happening there. We talked for hours while sipping very hot tea from glasses, which after a while can blister your fingertips. He did not want to talk about his work except for a tirade about the people at the Guggenheim Museum who, without his authorization, reassembled some of his work which had fallen apart. He would not offer me any of the pieces he had in his studio unless I was interested in some of the enlargements that he was making of previous pieces, which did not

seem to have the same vitality. He finally offered me a woodcut (19.3) which I accepted against my better judgment. It was not until 1993 when I was fortunate enough to buy at auction his *Linear Construction in Space Number 2* (19.2) and *Esquisse* (19.1). Oddly enough, the woodcut that I bought has some resemblance to *Linear Construction in Space Number 2*, which now makes it more appropriate for our collection.

Because we bought most of our Christos directly from Christo, who does not have a regular dealer, we came to know him and his wife Jeanne-Claude, who does an exceptional job of marketing his work. We were out for dinner one night in 1982 when Christo mentioned that his brother, Anani Yavachez, who lives in Bulgaria, had gotten a visa to visit him in America for the first time. Christo was excited about this because he, as a former freedom fighter was *persona non grata* in Bulgaria, and he did not know when he would get another opportunity to see his brother. I asked Christo what he was planning to do with his brother, and he said he was going to show him Newport, Rhode Island. I said that Newport is hardly part of the United States and suggested he visit my house and then the White House, because as a Bulgarian, he probably could not envision people visiting the home of the president of our country. He took my advice and visited us with his wife, Jeanne-Claude, his brother and sister-in-law, and Jeanne-Claude's sister before going to the White House. During a festive afternoon I suggested to Christo that he wrap the Hudson River Palisades, which were clearly visible from the porch of our house. He showed no interest. As they left, Jeanne-Claude confided to me that Christo would never do the Palisades "because you suggested it. Christo has to conceive the ideas himself."

That same independence was evidenced by the signing of Christo's work when it consists of two panels. He would sign only the technical panel and not the major drawing because he wanted to make sure that the collector would show both sections of the work and not just the larger, more aesthetic drawing. I tried to induce him to sign the main panels for 11.7–11.11 to no avail. When I questioned why he refused, Jeanne-Claude said that is the artist's privilege. Years later when forgeries of his work began to appear, he eagerly agreed to sign the main drawings, but only on the back.

When I was a kid, going to an airport was an exciting experience even if I was not taking a plane or meeting someone. When I started to collect, going to an auction generated the same excitement, whether or not I bought anything. But after going to airports or auctions a few times, each became equally boring. Now I bid by phone.

My first auction was on February 27, 1963 when the proceedings were sluggish at Parke-Bernet galleries. When lot number 20 by Umberto Mastroianni entitled *Testa* (35.1) was being auctioned, I raised my hand, just once, merely intending to move proceedings along, but to my chagrin I bought lot number 20. That is the only explanation I have for its being in the collection.

Having not learned my lesson, I was at another auction at Parke-Bernet on November 28, 1966, held to benefit Channel 13, New York's public television station. I had previously purchased a Lee Bontecou drawing (6.4) at the Leo Castelli Gallery. There was a companion drawing (6.5) in the gallery, but Mr. Castelli said he could not sell it to me directly because it was committed to the Channel 13 sale. Thus I went to the auction at Parke-Bernet galleries. The auctioneer did not seem to look at the section of the room where I sat, and I kept waving my hand to get his attention, not realizing that a spotter on my side recorded each wave of my hand. As a result, I paid considerably more for that second drawing than for the first, but took solace from the fact that my extra hand waves benefited a good cause.

Of course, there are occasions when the weather is nasty and the reserve is low or non-existent, such as the evening of April 5, 1967 when I bought Jean Arp's *Constellation Expressive* (3.3) and Jacques Lipchitz's *Study for "The Rescue,"* (31.4) at what I believe were bargain prices.

REFLECTIONS AND ANTICIPATIONS

Collecting and living with a collection are exciting. The right time and place to find the sculpture and drawings that interested us were the fifties, sixties, and seventies in New York City. We were lucky to have that opportunity.

Unfortunately, today's art market is very different, and collectors will no longer find works comparable to those by Calder, Nevelson, and Smith at affordable prices. They will find that not only are the few important contemporary artists selling at astronomical prices, but also that many of the marginal and insignificant artists are demanding extravagant prices while they are temporarily elevated into the mainstream of the art market by sophisticated marketing techniques until their irrelevance is recognized and their appeal diminishes.

When the works for this exhibition are removed from our home and transported to the Elvehjem Museum, there will remain hundreds of nails, screws, and hooks protruding from the walls throughout our house. Portions of those walls that were not covered by drawings and other hangings will have faded. Chips of plaster that were covered by pictures will be exposed. I can fantasize that in the midst of that chaos someone, perhaps from SoHo, may visit us and exclaim that finally the Lanes are entering the twenty-first century with a declaration that this unique conceptual work of art, with its spatial configuration of nails and other protrusions, accented by delicate chipped plaster on a background of subtle gradations of painted surfaces, contunually flowing through five rooms of our house, is deemed to be a site-specific masterpiece to be preserved in perpetuity.

Returning to reality, we will use the period that our collection is in Wisconsin to repaint the walls so that the artworks can be reinstalled upon their return, and we will continue to collect and enjoy what we have collected in the past.

THE FAITH OF COLLECTING
DOUGLAS DREISHPOON

In a talk Alvin Lane gave on collecting art at the Riverdale Yacht Club in April 1991, he described various types of collectors:

> *There is the ostentatious collector who wants to put symbols of wealth on his walls; those who think they are going to get social recognition by collecting; those who use their collection as power; those who are merely acquisitive; and those who, as frustrated artists, compensate for their lack of creativity by developing curatorial skills.*

Lane offered these general categories as a way of introducing his topic. In the context of this essay, they offer perspective on his own involvement.

Lane and his wife, Terese, have been collecting twentieth-century American and European sculpture and sculptors' works on paper for the past thirty-seven years and during that period have amassed more than three-hundred objects. Most collectors begin collecting for specific reasons. The Lanes were no exception. They tell a story about wanting to fill an empty wall above the couch in their living room. While probably too modest but no less endearing, such an account is telling because a compatibility with their domestic environment became the central criterion for the Lanes' burgeoning collection. What began as a decorative impulse became a long-term commitment to beautifying their surroundings with works of art.

Private collectors can afford to take chances. Unlike museums or institutions, private collectors have no one to please but themselves. They can afford to be eccentric in their motivations. Their choices can be more whimsical without having to conform to a fixed agenda or collections policy. Although most private collectors develop a connoisseur's eye, the objects they purchase do not have to be masterworks, but can be things that move or astonish them in some unforeseen way. The psychology of the private collector thus varies from individual to individual.

The character of a private collection also depends on timing and circumstances. When the Lanes began collecting during the late 1950s, the art world was a very different place. One could still find notable works for relatively little money. And if one's area of interest was sculpture and sculptors' drawings, the possibilities were endless. Sculptors have always been the underdog when it comes to public recognition and the acquisition of their work. There seems to be something inherently threatening about sculpture's tangibility—its existence in real space—that makes most people think twice about having it in their home. The postwar period was a watershed for American and European sculpture. And yet a lot of important work was relegated to the background. Ad Reinhardt's adage, "sculpture is the thing you back into when you look at a painting," summed up the situation on a private as well as institutional level: during the 1950s sculpture was not only ranked second to painting but its in-your-space projection was considered by many to be an imposition.

According to Lane's own account, he gravitated to sculpture for the same reasons most people avoided it. His first acquisitions were made intuitively (in retrospect, the de Rivera *Construction #46* bought in 1958 was an auspicious start), and as time went on he became more focused. Some private collectors seek advice from others who might know the field better. Peggy Guggenheim, for example, when she began to collect earnestly for her Art of This Century gallery, recruited André Breton, Max Ernst, and Herbert Read as consultants. And Katherine Dreier, in formulating the superb collections of the Société Anonyme, sought out Marcel Duchamp and Man Ray, whose firsthand knowledge of vanguard art and artists was an invaluable boon. From the start, Lane's

methods were more empirical and self-motivated, even though he frequently bought directly from artists, many of whom became his friends. Once committed to sculpture, Lane began to read about it. He tells an anecdote about being a law student at Harvard and realizing that the endless minutiae found in various statutes and cases was relatively unimportant; what really mattered was the grand scheme of things—the big picture. And he took a similar approach to collecting. One of the first things he read was Andrew Ritchie's comprehensive survey of twentieth-century sculpture. He then filled in the gaps with contemporary periodicals and catalogues. Primed with this general overview, he literally hit the streets with Terese, making weekend jaunts to museums and galleries to study sculpture in the flesh.

The orientation of the Lane collection is curious in light of Alvin's status as an attorney. Lawyers are notorious sticklers for documentation. They have to be; it is a crucial aspect of their methodology. Early on Lane became intrigued by the creative process—the ways in which artistic ideas are conceived and realized. So it is not surprising that he gravitated to drawings. Over the past thirty-seven years he has solicited works on paper from any number of sources the same way an attorney gathers evidence for a case. In this case, the results represent, in his own words, "the tangible evidence of creativity." Alexander Calder once called Lane "that crazy lawyer" for his persistent requests. Granted, Lane's mania for documentation, which often includes proof of authenticity, could be an artist's worst nightmare. But such an unlikely preoccupation has yielded a treasure trove of two-dimensional sketches, notational studies, and personal statements. Just read Tom Wesselmann's description of the *Amy* project in Lane's introduction for this catalogue. It is an enlightening bit of correspondence.

Anyone who has ever worked with drawings knows their value as primary documents. The visual equivalent to an artist's handwriting, drawings tell us a great deal about the creative process. Drawings by sculptors constitute a unique genre. Freed from material constraints, sculptors use drawing to generate and stockpile ideas without having to worry about their physical realization. Some are unpretentious documents, abbreviated notations; others are independent works in their

own right. Unlike the finished sculpture, preliminary drawings can be full of fits and stops, mistakes and miscalculations absent in the final work. Drawing is the most expedient way for sculptors to get their ideas out and on to paper, and each artist develops a personal rapport with it, even while exploring various techniques and media—ink, pencil, charcoal, conté crayon, pastel, gouache, watercolor, and oil paint. The results, ranging from a unitary image or series of related images sketched on a single sheet to a highly finished composition, are a way to dream on paper.

Drawings make up a substantial part of the Lane collection and complement sculptures. Over the years, as the collection has grown, certain artists have been collected in greater depth, depending on personal preference, accessibility, and circumstances. While some artists—Alberto Giacometti, Raoul Hague, Barbara Hepworth, Conrad Marca-Relli, and Tony Smith—are represented by only one or two works, others such as Lee Bontecou, Calder, Christo, Gaston Lachaise, Seymour Lipton, Louise Nevelson, Claes Oldenburg, Theodore Roszak, David Smith, and John Storrs constitute impressive holdings. Chronologically, the collection begins with American and European modernism (i.e., Jean Arp, Alexander Archipenko, Lachaise, Elie Nadelman, Antoine Pevsner) then moves through the postwar period (1945–1959) and into the present, with works by Christo, Oldenburg, and John Chamberlain. The most comprehensive representation focuses on postwar drawings by Smith, Roszak, and Lipton.

POSTWAR TRANSFORMATIONS

David Smith was someone the Lanes knew they should collect. But it was only after the artist's death, in 1965, that they began to buy his work in earnest. Today, the collection includes a significant number of Smith's drawings, as well as several small-scale sculptures. Smith drew the way most people speak. It was a natural extension of himself, like breathing, and he did it religiously. He used drawing as an empirical means of tapping the subconscious—a way of bypassing conscious constraints that might otherwise deflect the graphic representation of a flash intuition or dream. Drawing enabled him to generate a steady stream of ideas; it was a reprieve from the blazing torch with

its spray of dangerous sparks, the Promethean struggle with heavy metals that took place in the Terminal Iron Works, that cinder-block edifice he called his studio.

Smith drew on all scales, from pocket-sized notepads and 8½-by-10-inch coil-ring notebooks (see 51.16, 51.18–51.26) to more expansive sheets of the finest Fabrico paper. Early on, during the 1930s and 1940s, he preferred graphite and ink, and in some of the 1940s notebooks he introduced brushes. His sketchbooks became a testing ground for various techniques—images could be gestural, tight and linear, modeled or crosshatched. He generally preferred brushes— soft sable or stiffer pig bristle—to pens, and his experimentation with black Chinese ink and egg tempera during the early 1950s was a natural outgrowth of his search for a medium responsive to the nuances of a spontaneously executed line, a dab or swirl, a blob or bleed. In many of Smith's postwar drawings, color became a significant element. By the late 1950s he was using enamel spray paint, a byproduct of his sculptural process, to create delicate silhouettes which he might then supplement with touches of pencil and ink (51.31, 51.33–51.42).

Smith's drawings are paradigmatic in the way they address central themes that preoccupied American sculptors from the 1930s on. This is particularly true of the figure, a leitmotif in many of the drawings, and something that had profound philosophical implications during the postwar period. At a time when many painters dismissed the figure as academic and retrograde, sculptors embraced its humanism and metaphorical potential. The figure was to sculptors what the loaded brushstroke was to abstract expressionist painters: a fundamental trope, a medium through which basic questions about the self and humankind could be expressed. Most sculptors refused to see abstraction and representation as diametrically opposed. The 1950s may have been a glorious decade for abstraction, but it was also a watershed for a new kind of figuration. The challenge was to find ways of using abstraction to reconfigure anatomy in order to make it contemporary.

Throughout his career Smith probed the gap between abstraction and representation, especially in his drawings. Works such as *Study for Sculpture* (1937; 51.2), Untitled (reclining figure) (1939–40; 51.3), and Untitled (Study for *Aftermath*

Figure) (1944; 51.4) are both an homage to the open and linear assemblages of Pablo Picassso and Julio González and an exploration of more biomorphic and surreal configurations, many of which were first developed in the *Metals for Dishonor* (1937–40). During and after the war, the figure became a cipher for some of Smith's most basic phobias. For him, drawing was an act of self-identification and abstraction, in some cases, a way of masking certain feelings within an image that might otherwise appear too obvious.[1] This seems true for a series of *Spectre* drawings executed between 1944 and 1946, as well as the few surviving studies for *The Hero* (1951–52; The Brooklyn Museum, New York), the most finished of which (51.6) was purchased by the Lanes.

The Hero, one of the most autobiographical of Smith's totemic sculptures, marks a transition from the volumetric and biomorphic work of the 1940s to the more reductive *Tanktotem* and *Agricola* series. Thematically, the hero had a poignant relevance for both American and European postwar sculptors. The hero's trials were metaphorically played out in the battlefield of the psyche. This psychological dimension made the hero a symbolic role model, an alter ego. Most sculptors saw the heroic act as a risk, an encounter with reality and with one's own irrational impulses, which required a journey beyond what was known and comfortable into foreign, even hostile terrain. The concept of the hero provided a visualization for an individual's confrontation with adversity and self-doubt. For sculptors, the hero signified a personage, a potent metaphor for a vulnerable and yet resilient spirit. While Smith was not the only sculptor who dealt with the hero in his work, his interpretation, both personal and archetypal, is by far one of the most original.[2]

Other drawings (51.8, 51.9, 51.12, 51.13) executed about the same time as *The Hero* are more abstract. Like his sculpture, Smith's two-dimensional work is distinguished by its stylistic breadth and experimental verve. Perhaps more than any of his peers, he constantly searched for ways to extend the medium. And his works on paper run the gamut from crisp and linear conceptions to painterly and calligraphic gesticulations. He seemed to navigate effortlessly between both extremes depending on his mood and circumstances. His production was protean. He was capable of turning out between two-and three-hundred drawings a year, and his sculptural output was just as impressive.

Early on, Smith singled out Julio González as one of his heroes. González, who had begun his career as a decorative metalsmith, found a collaborator in Picasso and between 1928 and 1931 changed the course of modern sculpture through an unprecedented series of direct-metal assemblages.[3] When Smith saw these in the early 1930s, first reproduced in the pages of *Cahiers d'Art* and subsequently at the home of his friend, the painter John Graham, they completely altered his perception of what sculpture could be. Seven González drawings (21.1–21.7) are included in the Lane collection. All date from the mid–1930s to the early 1940s. As an ensemble, they reflect some of the innovations that initially inspired Smith as well as other American sculptors—Herbert Ferber, Lipton, Isamu Noguchi, Roszak—who were then looking for a way beyond the monolithic figure.

González's conception of the figure was linear and open, like drawing in space. It jettisoned anatomical exactitude for expressive configurations constructed part to part, and it used the figure as a vehicle for more metaphorical interpretations. Several drawings that deal with the "cactus man" theme—a prickly and unapproachable entity—appear autobiographical. Another, the 1939 *Project for Sculpture* (21.5), with its aggressive and threatening head precariously perched atop a tear-shaped base, seems, in retrospect, like a premonition of war.

War can affect artistic perception. This was certainly the case with Theodore Roszak, whose work underwent a profound transition in the wake of World War II. Death, destruction, and the devastation of two Japanese cities revealed the darker side of technological progress. What previously had been a positivistic embrace of utopian systems was seriously questioned by the end of the war. Roszak's shattered faith in science and technology was replaced by a renewed faith in nature, in change and transformation, and in atavistic motifs that reaffirmed basic values. He wanted his work to ask questions (rather than posit definitive answers), to provoke, even rankle. He also wanted it to evoke archetypal themes and embody a life force that was destructive as well as constructive.

In the Lane collection, Roszak is represented by thirty-three drawings and one sculpture. The drawings range chronologically from early water-color, ink, and graphite studies for a Cubist head (49.1), an imaginary airport, and several constructions executed during the 1930s to larger ink-and-graphite studies for important postwar pieces, including *Recollection of the Southwest* (1948), *Sea Sentinel* (1956), *Spectre of Kitty Hawk* (1946–47), *Monument to an Unknown Political Prisoner* (1952), and *Night Flight* (1958–62). Roszak's sculptural process was inseparable from drawing, which became the backbone of his life's work and something he recalled doing by the time he was five or six. "Drawing was one of my earliest responses," he told Harlan Phillips, "it was automatic. It was simple to do. It was available. There was always paper and something to scratch with, and I began drawing very, very early in life."[4] For Roszak, the product of a lower-middle-class Polish family that immigrated to Chicago in 1909, drawing provided a creative outlet for many adolescent frustrations. At that time he must have realized its expressive potential; it functioned in a similar capacity until the end of his life.

The drawings Lane collected trace Roszak's development from a constructivist to an expressionist. The early *Study for "Airport"* (1933; 49.3) signals a time in his career when painting was as important as sculpture and reflects a visionary orientation and fascination with flight that persisted even after his postwar conversion. During the 1930s many graphpaper sketches for constructions (sheets full of spontaneous doodles, variations on ideas for free-standing "bipolar" forms and geometric reliefs) deal with sleek vertical monuments that recall contemporaneous lighter-than-air dirigibles (49.2, 49.4). As a result of the war, the theme of flight underwent a dramatic metamorphosis. What had been a positivistic projection in earlier constructions, when chromium finish and stream-lined torsos signified a progressive machine-age culture, the discovery of new planets and galaxies took on more sinister connotations. The *Spectre of Kitty Hawk* drawings (49.10, 49.11) not only mani-fest Roszak's rage, but his response to the spirit of flight as a death-dealing instrument, an archetypal incarnation of the prehistoric pterodactyl, and a mythical phoenix that rose from the ashes of atomic fallout.[5] They are also one aspect of a spec-

tral image which reconciled male and female prin-ciples in the final sculpture.[6] A preoccupation with flight culminated during the 1950s and early 1960s in *Night Flight* as well as numerous graphite studies for the *Flying Fish* (49.21–49.32), which subse-quently became the basis for *Forms in Space*, a monumental outdoor sculpture commissioned for the 1964 World's Fair and installed in front of the Hall of Science, Flushing Meadow, Queens, where it still stands today.

Roszak's studies for *Spectre of Kitty Hawk* and *Sea Sentinel* have a strong figurative bias that epito-mizes his postwar sensibility. These images, like many of their expressionist analogues, embody an amalgam of personal and collective experiences; they reflect a cross-fertilization of ideas—from mythology and literature to poetry and anthropol-ogy—and a comprehensive overview of art, seen as a continuum extending backward and forward; and they reaffirm the primacy of the psyche as the ultimate source of visual ideas. Roszak, like other such sculptors as Smith, Lipton, Ferber, Noguchi, Louise Bourgeois, Germaine Richier, César, and Ossip Zadkine, set out after the war to revitalize monumental figurative sculpture.[7] The new figura-tion, however, had a disquieting edge and asked difficult questions. It also challenged sculptors to find new ways of combining abstraction and repre-sentation without compromising the work's humanism and formal integrity.

Seymour Lipton, like González, Smith, and Roszak, believed in the continuation of a figurative tradition. He also realized that for such a tradition to survive it had to change with the times. The émigré sculptor Jacques Lipchitz described this phenomenon—the importance of seeing one's work within a greater continuum—as "the Great Stream,"[8] and in his own work, which underwent a radical transformation in the late 1930s and early 1940s after his immigration to the United States (31.3, 31.4, 31.6), he maintained this historical per-spective. Lipton recorded his own thoughts about the same phenomenon in a statement he wrote to Lane: "The sense of historic continuity and of dis-continuity of newness, invention, and spontaneity enter into the awareness of image creativity as an inseparable unity."[9] What came to preoccupy Lip-ton from the late 1930s until his death in 1986 was a conception that acknowledged the underlying humanism of traditional western sculpture but

stretched, even violated, its canons of beauty and perfection. He wanted his work to be contemporary, to function dialectically as a forum for opposing principles—male/female, life/death, organic/technological. Abstraction enabled him to warp natural forms into multivalent configurations. A "nonanatomical humanism" was the term Lipton coined to describe an aesthetic that drew from various sources—the tortured forms in Hieronymus Bosch's painting, pre-Columbian, Cycladic, Oceanic, and African sculpture—in an attempt to resuscitate figurative art.

Lipton used drawing to record his first sculptural impulses and develop their formal variations. He had never thought of selling this preliminary aspect of his work, that is, until Lane convinced him to part with about sixty-five images. These track the evolution of Lipton's work between 1951 and 1963 and form the backbone of Lane's postwar holdings. There are studies for *The Cloak* and *Mephisto* (1951; 32.1–32.2, 32.4), *Sanctuary* and *Storm Bird* (both 1953; 32.6–32.9), *Desert Briar* (1955; 32.15–32.18), *Sorcerer* (1957; 32.28, 32.30, 32.32, 32.31), *Manuscript* (1960; 32.48, 32.49), *Gateway* (1963), and a host of other seminal pieces.

The drawn image had a very specific place in Lipton's creative process, as the first step in what was usually a three-step progression. The second step was a small maquette, which led to a large-scale welded and brazed sculpture (see, for example, the final version of *Desert Briar*, 32.18). There is a certain predictability to these sketches; they do not extend the medium or take chances in the same way drawings by Smith or Roszak do. Lipton, it seems, saw drawing primarily as an expedient means of investigating an idea's formal extensions. Time and time again he explored the serial permutations of an image using the same size paper (usually an 11-by-8½-inch sheet of typing bond), pencil or ink (in earlier drawings), conté crayon (after about 1951), and a format in which each sculptural motif is rendered against a stark background articulated by a single horizon line or several perspective lines that suggest an interior space. Strong contours delineate most configurations. While earlier drawings are filled in with cross-hatching, in later conté crayon works, subtle modeling is used. In their emphatic emphasis on a discrete image,

Lipton's drawings offer a nuanced record of an idea's sequential development.

MODERN PROTOTYPES

Some of the same issues that preoccupied postwar American and European sculptors—the viability of the human form, balancing representation and abstraction, and the reciprocity between painting and sculpture—were already part of a modernist discourse by the 1920s. It is easy to forget that even by this time abstraction still required justification, a philosophical defense. Some, like the painter Wassily Kandinsky in his 1910 *On the Spiritual in Art*, offered a musical analogy. Others, like the poet-painter Jean Arp, deferred directly to nature. Believing that "art is a fruit that grows in man, like a fruit on a plant, or a child in its mother's womb,"[10] Arp looked for abstract analogues to suggest nature's complexity and underlying unity. As early as 1915 he began to investigate the characteristics of natural forms in drawings he made of branches, roots, grass, and stones. His *concretions humaines*, or "stones produced by human hand," developed out of these early drawings, as did his dada woodcuts and reliefs executed during the 1910s and 1920s. Described by the artist as objects that "fit naturally into nature," these concretions extended his preoccupation with organic growth and morphology. Arp's notion of concrete, a term he and Kandinsky rescued from Theo van Doesburg's earlier—formalist—definition, united aspects of geometric abstraction and surrealism. Arp was skeptical of art that imposed stylistic limitations and proposed definitive answers to spiritual questions. Concrete art was his way of hedging dogmatic assertions, humoring the unknown, and reaffirming humanity's vital connection to nature.

Arp's biomorphs—*Petite Torso*, *Pierre païenne*, and *Constellation Expressive* (3.1–3.3)—are poetic equivalents for natural forms that imply simultaneously everything and nothing. Early on each object was an empirical investigation of material—plaster, wood, marble, and granite—that developed heuristically into organic configurations. Arp's interest in cellular morphology and undifferentiated levels of animal development was not only compatible with a vanguard aesthetic, but also reflected his deeper search for universal generative principles.[11]

Whereas Arp's work focused almost exclusively on natural forms, John Storrs also embraced machines for their potential as form generators. Storrs has nine works in the Lane collection (55.1–55.9). These include an early 1918 polychromed *Madonna*, a 1920 pen-and-ink isometric drawing of industrial forms, two oil paintings from 1931 and 1937, as well as several graphite drawings, a silverpoint study, and a bronze "window" piece from the 1930s. In many of these the figure is a central theme. Throughout his career, Storrs maintained a flexible approach to the figure, which he rendered academically or abstracted in more experimental ways. (The same could be said of Elie Nadelman, another American modernist whose early ink-and-wash drawings from the 1910s [39.1] and later *papier-mâché* figurines [39.2–39.4] combined aspects of American folk art with more reductive and, in the case of the figurines, suggestive presentations.) Storrs's interpretations were highly subjective for their time. Some (55.5) recall the streamlined contours of Art Deco or the armored and mechanistic overtones of Umberto Boccioni's 1913 *Unique Forms of Continuity in Space*. Others, emulating the organic undulations of a botanical or human anatomy, are more abstract.

Although better known during his lifetime for his futuristic "forms in space" and public architectural commissions, Storrs never gave up painting. Indeed, his painted tableaux and figures posed in nondescript spaces are some of the most eccentric things he did. Painting, it seems, allowed him to stretch his imagination in ways sculpture could not. It also sustained him in lean times, when sculptural materials were scarce and hard to come by. Never one to limit his extensions, Storrs drew from all available sources. The results seem as innovative today as they did when conceived.[12]

One could say that Gaston Lachaise was obsessed with the attributes of the female figure. He spent the better part of his career sculpting and drawing the female form, rendering it from every conceivable angle and posture. That his model was, in most cases, his wife adds a certain charm to the story. Mrs. Lachaise inspired an ongoing series of drawings, eight of which (28.1–28.8) were purchased by the Lanes. She not only became her husband's muse but a kind of Ur-woman. Sometimes she is depicted as a goddess, regal and imposing; other times her aggressive and threatening demeanor makes her look more like a temptress. The Lanes' selection covers the gamut of Lachaise's involvement with this motif. All are linear conceptions sketched on-the-spot or from memory. Drawing was a way for the artist to train his eye and imagination at the same time. Whereas some works depict the body as an elegant and classical entity, others exaggerate its contours to the point of caricature; some present the body in full view, standing or reclining with arms and legs in various positions, while in others the body is cropped to isolate and emphasize specific parts of its anatomy. Perhaps more than any other American sculptor, with the possible exception of David Smith, who persistently rendered the female nude throughout his career,[13] Lachaise made the female form the central focus of his sculptural investigations.

COLLECTING CALDER

Alexander Calder's work had immediate appeal for the Lanes. He was one of their first acquisitions, in 1960, and someone they continued to collect. When Lane says that "buying Calders is like eating peanuts; once you start it is hard to stop," he is not kidding. Between 1960 and about 1970, the Lanes bought an impressive number of sculptures and drawings. They chose wisely: several stabiles—*Bird* (1939; 8.4), *Orange and Black Waves* (1954; 8.11), *Snowy Sky over the Steeple* (1965; 8.15)—and mobiles, including the gem of this sculptural ensemble, *Verticale hors de l'horizontale* (1950; 8.7); three pen-and-ink drawings from 1931 (8.1–8.3); a gouache from 1945–46; and two ink studies (a single sheet with numerous thumbnail sketches for specific pieces) for upcoming exhibitions during the 1950s. While the 1931 contour drawings, based on Calder's famous *circus* and the wire sculptures he made in Paris during the 1920s, reflect the artist's whimsical and humorous side, the postwar *Moon and Stars* (8.6) is more disturbing in its apocalyptic overtones. Having been initially trained as an engineer, Calder always maintained a interest in science, technology, and space exploration. Some of his earliest works from the 1930s functioned as metaphors for planetary models, and the possibility of extraterrestrial existence continued to fuel his imagination late into life. Principles of tension, sus-

pension, and balance, implicit in his mature work, especially the mobiles and stabiles, were not only inherent aspects of constructional design, but part of a worldview in which humor tempered existential musings.

ASSEMBLAGE

In my conversations with Lane, he emphasized his interest in assemblage. An art based on recycling found materials, assemblage constitutes the strongest sculptural tenet in the collection. The roots of this scavenger aesthetic can be traced to Picasso's constructions from the 1910s, Duchamp's readymades, and Kurt Schwitters's Hannover *Mertzbau*, begun in 1920. And the impulse, which continues to be a vital expression today, assumes many incarnations in the Lane collection: Joseph Cornell's 1956 *Sun Box* (12.1) as well as other "boxes" by Varujan Boghosian (5.1–5.4) and Lanny Lasky (29.1), several painted metal pieces by John Chamberlain (10.3–10.5), one of Richard Stankiewicz's figurative works from 1960 (54.1), and a more recent abstraction by Anthony Caro titled *Writing Piece "Knob"* (9.1).

Louise Nevelson had her own unique approach to assemblage. Lane sensed this early on, in 1960, when he bought *Moon Garden Plus One*, and over the next eleven years he continued to purchase her work. He also developed a lively relationship with the sculptor, who on several occasions visited the Lane's at their summer home, and even designed a miniature piece, the prototype for a subsequent series of small-scale bas-reliefs, for the interior of their daughter's artsy doll house.

Nevelson's notion of assemblage had strong poetic and spiritual overtones. It was also ambitious, given its monumental dimensions and installational extensions. Her sculptural rooms had the impact of theater. They transformed space, as any effective installation should, but they also projected a level of mystery that left an unforgettable impression on the spectator. Seminal works such as *The Royal Voyage (of the King and Queen of the Sea)* (1956), *Sky Columns Presence* (1959), and *Dawn's Wedding Feast* (1959–60) were environments constructed out of detritus that functioned metaphorically as personal tableaux. Not surprisingly, the work, with its monochromatic skin bathed in light, maintains its sense of mystery even as a discrete object.

From 1959 to 1972 Lee Bontecou produced a remarkable series of assemblages, which were widely exhibited in America at the Leo Castelli Gallery, New York, and in Europe at various galleries and museums.[14] Over the course of only twelve years, she developed a singular aesthetic. Using the oxyacetylene torch to construct a thin-gauge membranous scaffolding on which she stretched canvas and felt, Bontecou transformed a postwar heavy-metal ethos into a unitary image (her signature "black hole") with multivalent associations. What began as a promising career, however, ended in the late 1970s when the artist stopped exhibiting and withdrew from the art world.

Obscurity is one thing, self-imposed exile another. Bontecou fled the limelight at an auspicious juncture. Though not unparalleled, hers is a curious situation. Marcel Duchamp, for instance, gave up painting in 1923 to devote more time to chess. But his decision, though philosophically motivated, did not preclude his continued visibility in art circles. Bontecou has maintained a marginal profile for the past twenty years. And yet the work she produced from the late 1950s until 1972, when she exhibited vacuum-formed plastic flowers and fishes at Castelli's, still elicits adulation from younger artists and museum curators who hope that someday she will reenter the arena.[15]

The Lanes bought Bontecou's work during the salad days of her career. They own a cross-section, including an early cast bronze *Bird* from 1958 (6.1), two metal and canvas constructions from 1959–60 (6.2, 6.3), and several graphite and soot drawings from the mid-1960s (6.4–6.7). They also own a page from one of the artist's sketchbooks (6.8a, 6.8b), something Bontecou tore out during a studio visit and gave to them as a gift. The bird sculpture, reproduced by Donald Judd in his 1965 article on Bontecou for *Arts Magazine*, reflects a more traditional orientation—the product of her earlier studies with William Zorach and John Hovannes at the Art Students League, in 1952–1955, and a subsequent trip to Italy in 1957–1959. The other sculptures and drawings represent her mature work.

Bontecou's work from the 1960s gravitates between images of lightweight orifices and fuse-

lages and metallic facades full of threatening teeth. Natural forms—shells, craters, flowers, claws—become metaphors for bipolar states of being—social/asocial, vulnerability/impenetrability—and their conflation with machine-made forms, such as airplanes and gas masks, suggests a tension between nature and technology. Her drawings explore terrains that are both familiar and fantastic. And the serial transformation of forms meticulously rendered on sheets of graphpaper suggests an unlikely marriage between a constructivist and surrealist sensibility.

REDEFINING THE SCULPTURAL ARENA

A preference for sculpture made from recycled materials also explains the Lanes' interest in Claes Oldenburg's work. Since he created *The Store* in his lower East Side New York studio in 1961, Oldenburg has redefined what public sculpture could be by reconfiguring its content and context. The Lanes own two drawings from this earlier period, *Giant Soft Sculpture Visualized in Green Gallery, Cone, Sandwich, Hat* (1962; 44.1) and *Proposed Colossal Monument for Lower East Side: Ironing Board* (1965; 44.2), as well as several drawings and sculptures from the 1970s, including *Typewriter Eraser* (1977; 44.11), accompanied by two preliminary sketches, and *Soft Screw* (1975; 44.6).

Oldenburg questioned fundamental issues that had characterized American and European sculpture during the postwar years. Instead of glorifying the figure, he simulated edibles and inanimate goods. What humanism had been for Lipchitz, Smith, Roszak, and Lipton, commercialism became for Oldenburg, who preferred the sociopolitical implications of store-bought readymades. Instead of grand figurative monuments, he endowed a hamburger, baked potato, or ironing board with heroic dimensions.

Oldenburg stripped postwar sculpture of its metaphysical veneer just as Jasper Johns and Robert Rauschenberg stripped abstract expressionism of its existential pretensions. At the same time he questioned the way in which art is made and presented to the public. (His early "Happenings" can be seen an extension of this critique.) He developed an iconography more responsive to contemporary issues and, in doing so, created a new arena for sculpture.

Christo's notion of sculpture, like Oldenburg's, is contingent on context. Most of Christo's projects involve the alteration of a particular site for a short period of time. Site selection is crucial and demands a great deal of time and research. A diplomat in artist's clothing, Christo often embarks on projects that require years of negotiation before they are realized. In its conceptual stages, his work often elicits strong reactions from officials and local populations. Politics becomes an inevitable part of his creative process. So does constructive dialogue—the matrix through which controversial ideas, initially dismissed, are ultimately understood and supported.

In Christo's scheme, the sculptural object is a transient entity. Projects exist for two or three weeks before they are disassembled and the site restored to its former condition. Given the ephemeral nature of this enterprise, what survives, and in many cases helps to finance an idea, are preliminary studies: elaborate collages that map out various aspects of an undertaking, including its location, treatment, and materials. Christo's works on paper occupy a central place in the Lane collection. Major projects are represented, from the early *Store Front Project* of 1964 to the more recent *Umbrellas* exchange between Japan and the United States. There are also studies for *Valley Curtain* and *Running Fence*, as well as the *Reichstag* and *Biscayne Bay* wraps. These two-dimensional works are part of an ongoing documentation process that also includes film and still photography. While these are not the materials of a traditional sculptor, in Christo's hands they become the basis for sculpture conceived within an expanded field.

In the Lane collection certain sculptors are represented by only one or two works. Some of these are gems and deserve to be mentioned. There is a lovely walnut sculpture, *Echo Notch Walnut* (24.1), by Raoul Hague; a Barbara Hepworth "string" piece from 1957 (25.2); a 1968 painted cast polyester resin sculpture by Jean Dubuffet (16.2); a 1961 monofilament construction by Naum Gabo (19.2); a stainless steel abstraction by Tony Smith from 1962 (52.1); and two Miró sculptures (in ceramic and bronze) from 1956 and 1973–81 (37.1, 37.2). There are also notable drawings by Alberto Giacometti, Ibram Lassaw, Henry Moore, Reuben Nakian, Antoine Pevsner, and Jean Tinguely. These objects can be seen as bright spots outside more comprehensively collected areas.

Collecting can be a capricious undertaking. There is no way of knowing whether one's choices will turn out to be sound investments. Perhaps it does not matter. Some collectors collect just because they want to and because what they collect gives them pleasure. This has been the Lanes' modus operandi for the past thirty-seven years. All pleasure aside, though, it is easy to get fanatical. Once you start collecting it is often hard to stop, even after all your walls are covered and all your closets full. As this catalogue was in its final stages of production, objects were still being added to the checklist. With the exhibition finally installed and many of the walls in the Lane's home empty, another phase of collecting may well begin.

Douglas Dreishpoon
Curator of Collections
Weatherspoon Art Gallery
University of North Carolina at Greensboro

NOTES

1. It was Dorothy Dehner who suggested that "abstraction appealed to Smith as a way of making use of his deepest feelings without revealing himself completely"; see Karen Wilkin, "David Smith: The Sculptor and His Drawings," *The New Criterion* 8 (March 1990), p. 16.

2. For a more detailed discussion of Smith's *The Hero*, see my essay in *Between Transcendence and Brutality: American Sculptural Drawings from the 1940s and 1950s*, exhibition catalogue (Tampa, Fla.: Tampa Museum of Art, 1994), pp. 19–23.

3. For more information on González's life and work, see Margit Rowell, *Julio González: A Retrospective*, exhibition catalogue (New York: The Solomon R. Guggenheim Foundation, 1983).

4. Harlan B. Phillips, "Theodore Roszak Reminisces: As Recorded in Talks with Dr. Harlan B. Phillips," 1964, transcript, pp. 1–5, Theodore Roszak estate.

5. The iconographic parameters of Roszak's sculpture, which were fairly well established by the mid-1950s, are discussed in detail in Joan Seeman Robinson, "The Sculpture of Theodore Roszak: 1932–1952," Ph.D. diss., Stanford University, 1979. Robinson, pp. 102–08, discusses the affinity of Roszak's *Spectre of Kitty Hawk* with contemporary war planes and primordial beasts.

6. See Dreishpoon, *Between Transcendence and Brutality*, p. 46.

7. For a more recent study of issues in postwar American and European sculpture, see the essays in "Sculpture in Postwar Europe and America, 1945–59," *Art Journal* 53, no. 4 (Winter 1994), Mona Hadler and Joan Marter, eds.

8. James Johnson Sweeney, "An Interview with Jacques Lipchitz," *Partisan Review* 1 (Winter 1945), p. 83.

9. Seymour Lipton, "Statement," January 13, 1962, Alvin Lane Papers.

10. Jean Arp, "Art Is a Fruit," *Arp on Arp: Poems, Essays, Memories*, ed. Marcel Jean (New York: Viking Press, 1972), p. 241.

11. Harriet Watts, "Arp, Kandinsky, and the Legacy of Jakob Böhme," in *The Spiritual in Art: Abstract Painting, 1890–1985*, exhibition catalogue (New York: Abbeville Press and Los Angeles County Museum of Art, 1986), pp. 239–55.

12. For a monograph on Storrs's work, see Noel Frackman, *John Storrs*, exhibition catalogue (New York: Whitney Museum of American Art, 1986).

13. This aspect of Smith's work, neglected during his lifetime, only recently has been reassessed; see Paul Cummings' essay in *David Smith: Drawings and Paintings from 1927–1964*, exhibition catalogue (New York: Knoedler, 1990).

14. For two essays that address Bontecou's life and work from the late 1950s and 1960s, see Mona Hadler, "Lee Bontecou—Heart of a Conquering Darkness," *Source* 12 (Fall 1992), pp. 28–44, and "Lee Bontecou's 'Warnings,'" *Art Journal* 53, no. 4 (Winter 1994), pp. 56–61.

15. Bontecou's most recent enticement came from Klaus Kertess, adjunct curator of drawing at the Whitney Museum of American Art, who asked her to participate in the 1995 Biennial. After many solicitous letters, she politely declined; see Paul Goldberger, "The Art of His Choosing," *The New York Times Magazine*, February 26, 1995, p. 39.

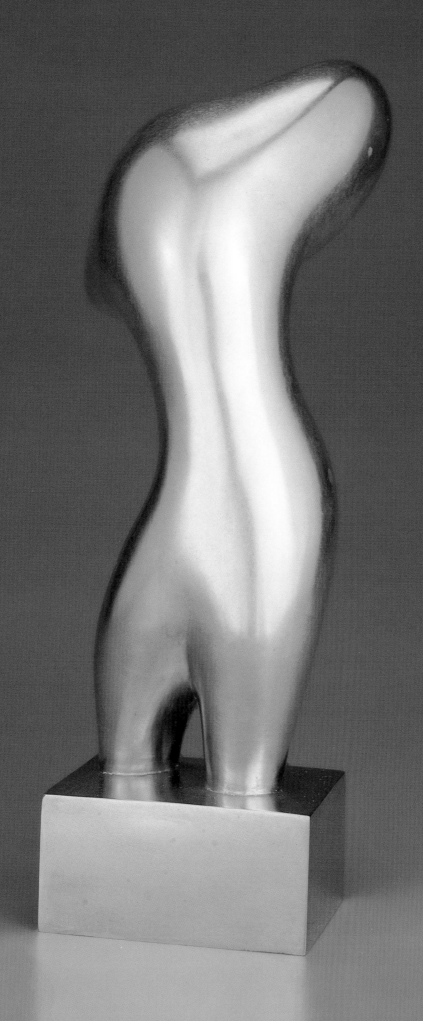

Plate 1 (cat. 3.1)
Jean (Hans) Arp
Petite Torso, 1930

37

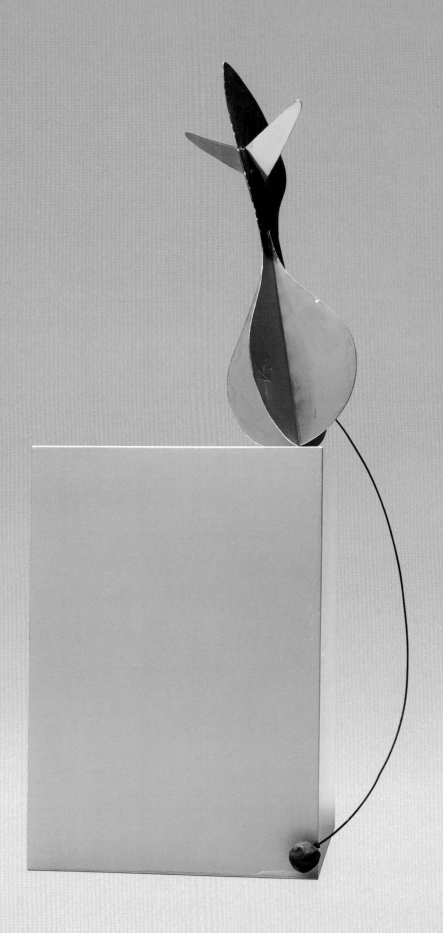

Plate 2 (cat. 8.4)
Alexander Calder
Bird, 1939

38

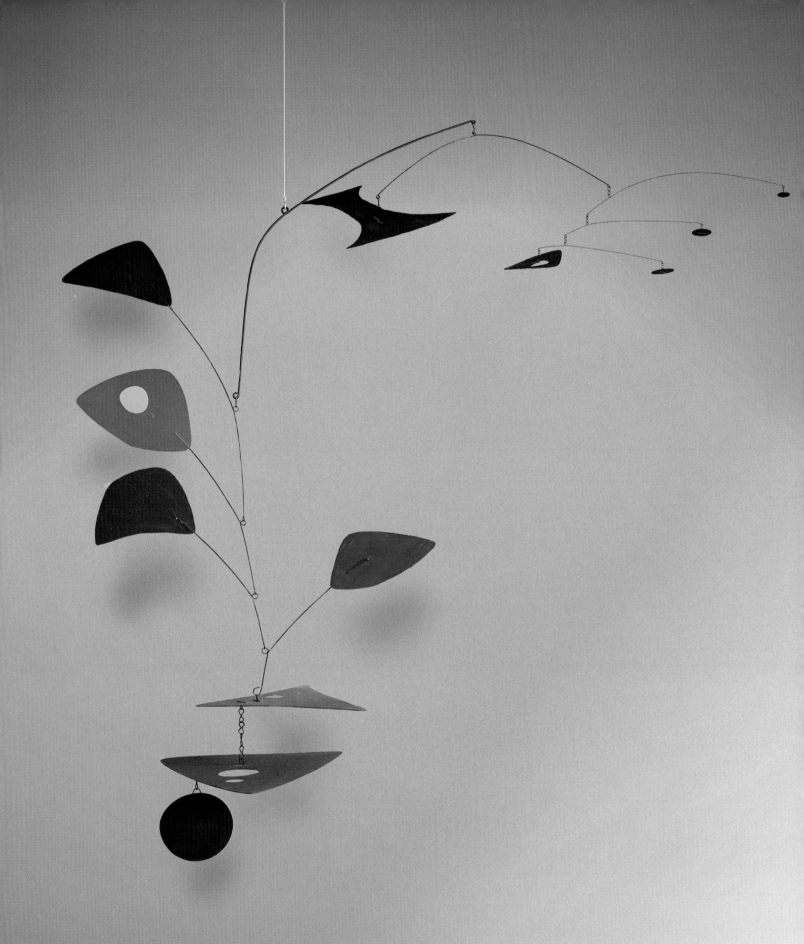

Plate 3 (cat. 8.7)
Alexander Calder
Verticale hors de l'horizontale, 1950

39

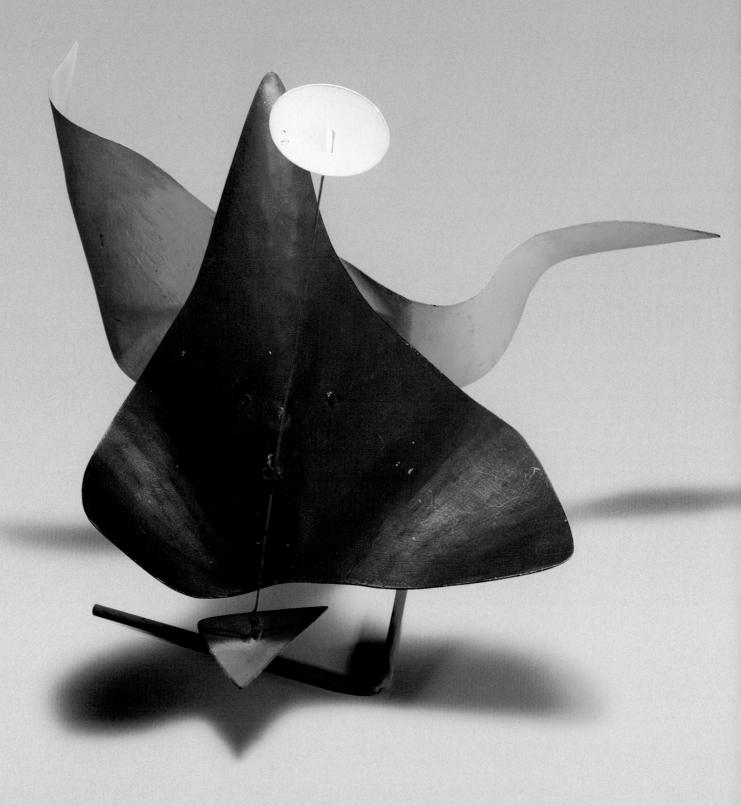

40

Plate 4 (cat. 8.11)
Alexander Calder
*Orange and Black
Waves*, 1954

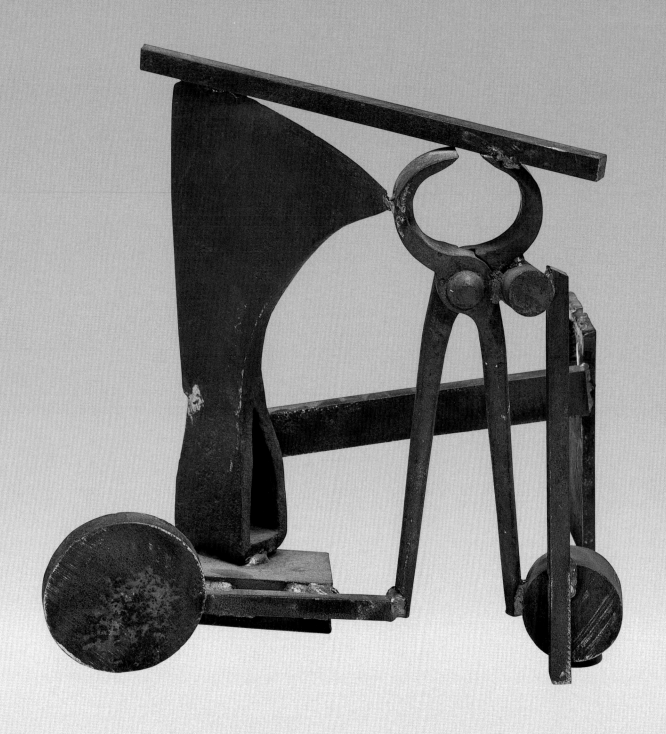

Plate 5 (cat. 9.1)
Anthony Caro
Writing Piece
"Knob," 1979

41

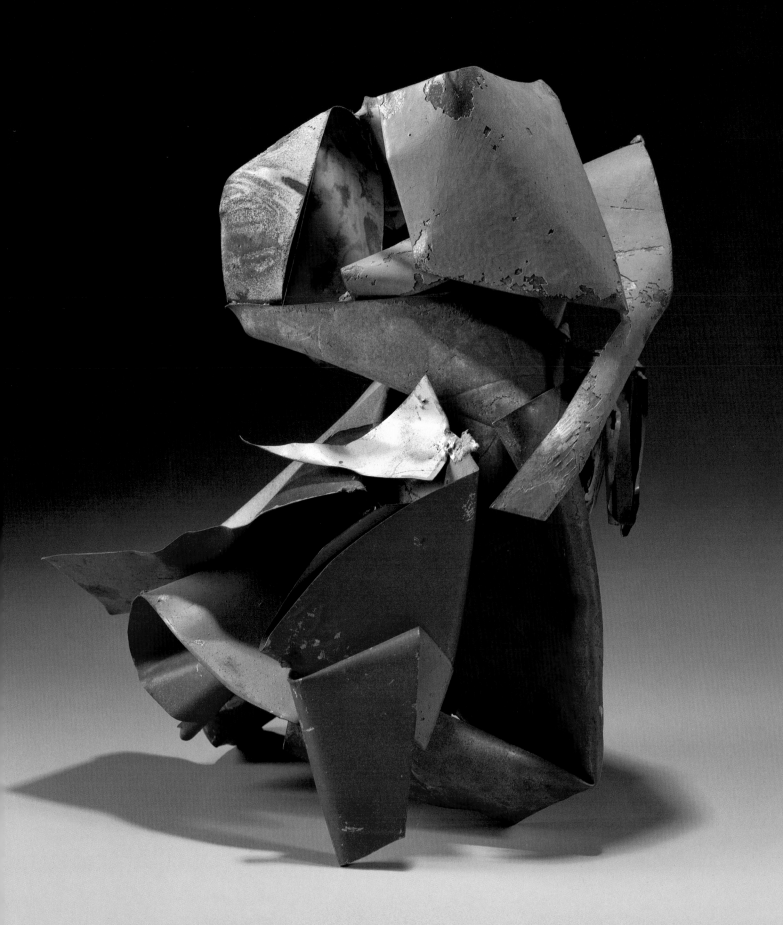

Plate 6 (cat. 10.4)
John Chamberlain
El Reno, 1962

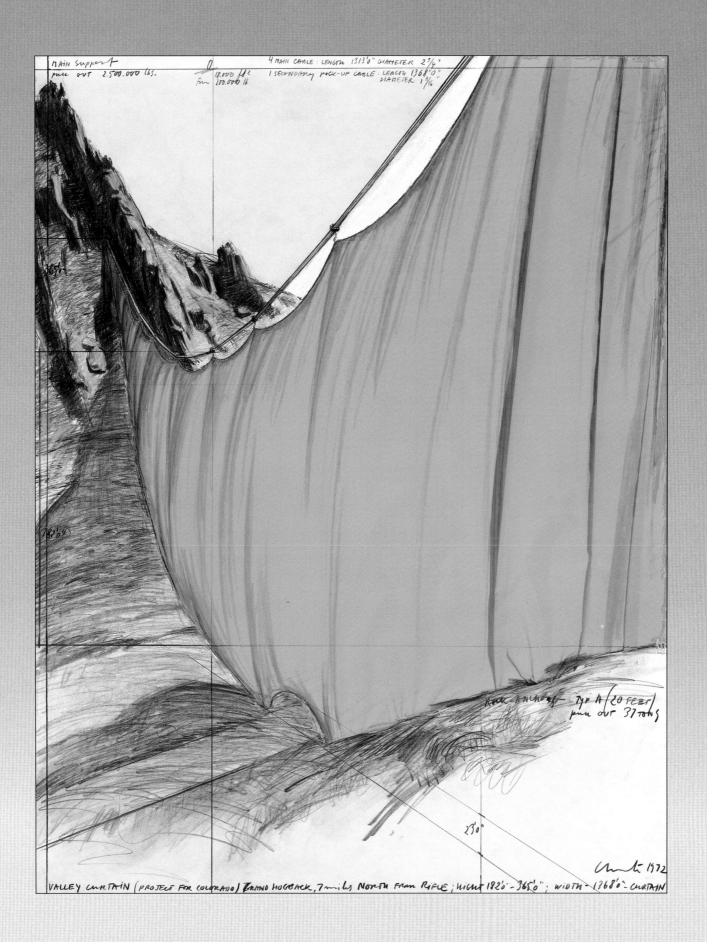

VALLEY CURTAIN (PROJECT FOR COLORADO) GRAND HOGBACK, 7 miles NORTH FROM RIFLE; HIGHT 1820'-365'0"; WIDTH - 1368'0"- CURTAIN

Plate 7 (cat. 11.5)
Christo
Valley Curtain (Project for Colorado), 1972

43

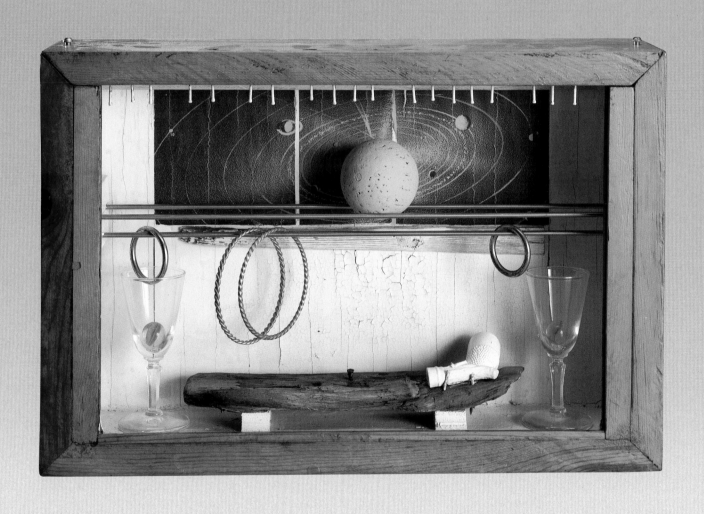

Plate 8 (cat. 12.1)
Joseph Cornell
Sun Box, 1956

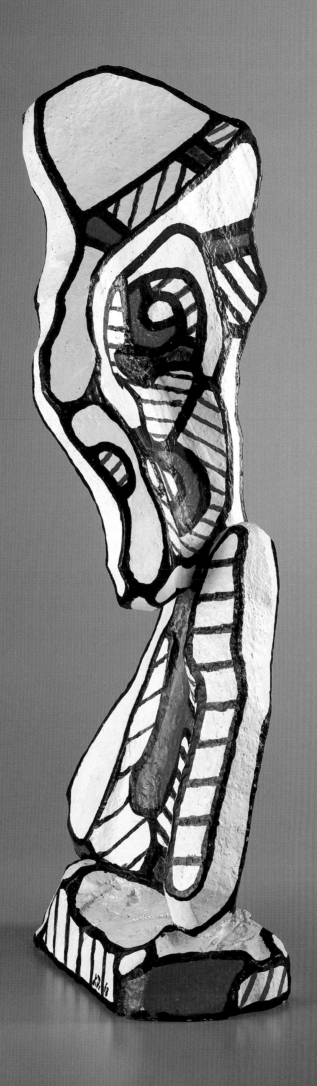

Plate 9 (cat. 16.2)
Jean Dubuffet
*Buste au visage en
lame de couteau II,*
1968

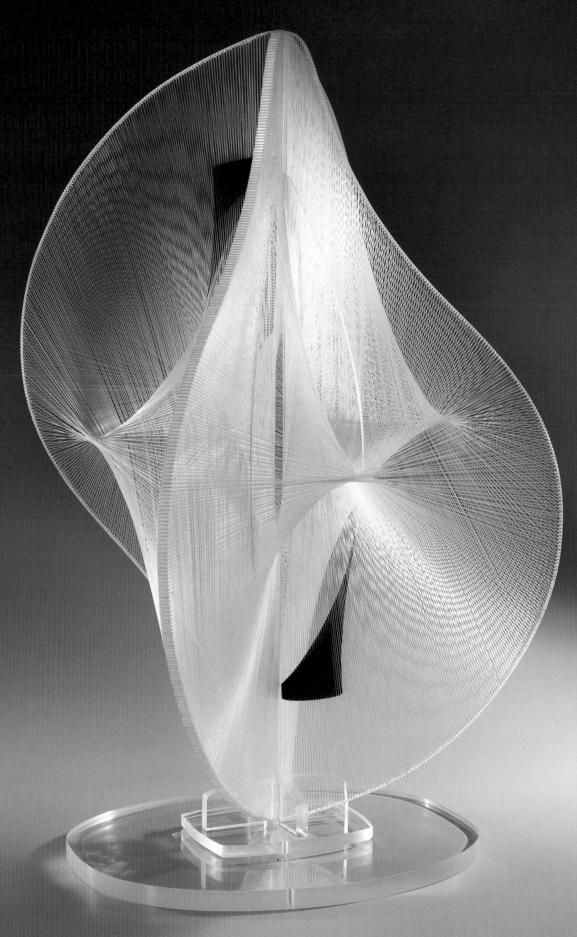

Plate 10 (cat. 19.2)
Naum Gabo
Linear Construction in Space Number 2, 1961

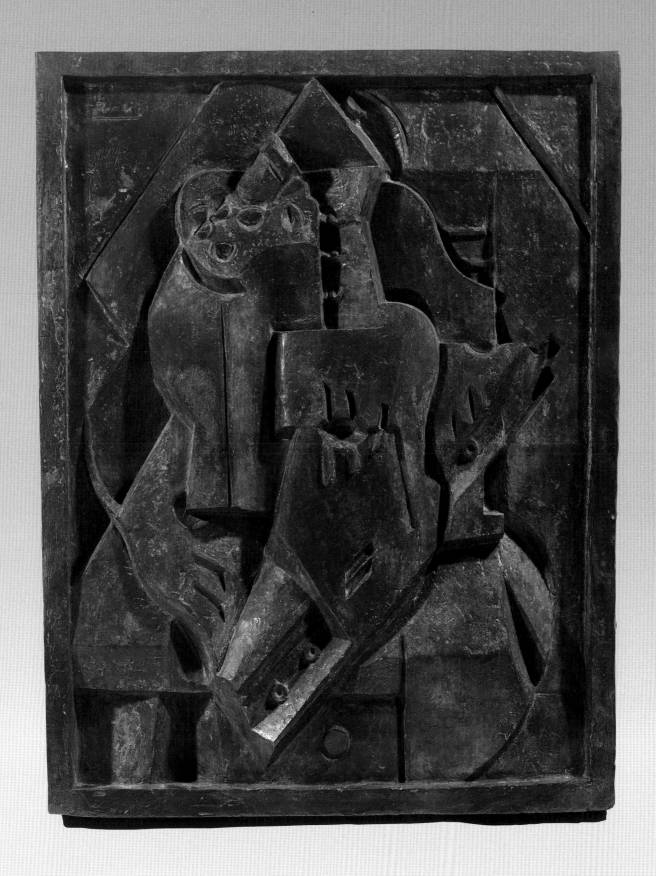

Plate 11 (cat. 31.1)
Jacques Lipchitz
Nature morte (Still-life), 1918

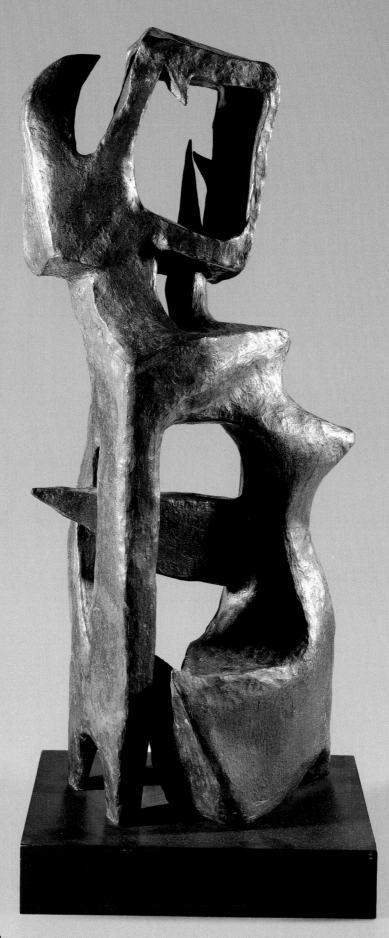

Plate 12 (cat. 32.0)
Seymour Lipton
(not in exhibition)
Cerberus, 1947

48

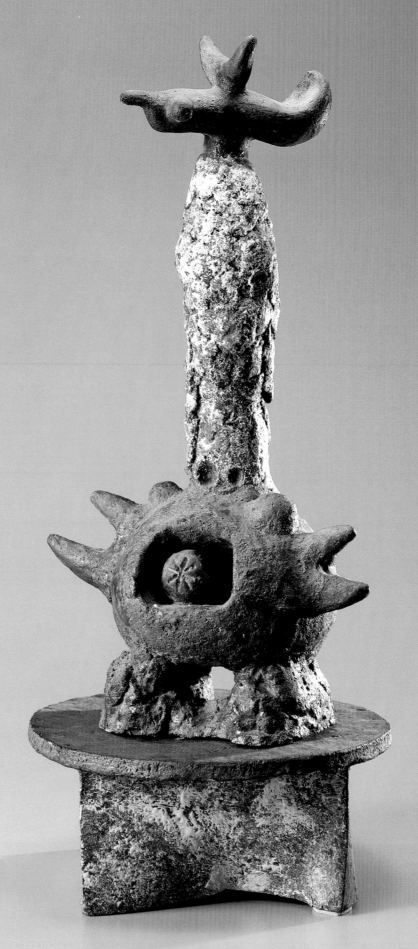

Plate 13 (cat. 37.1)
Joan Miró
Monument, 1956

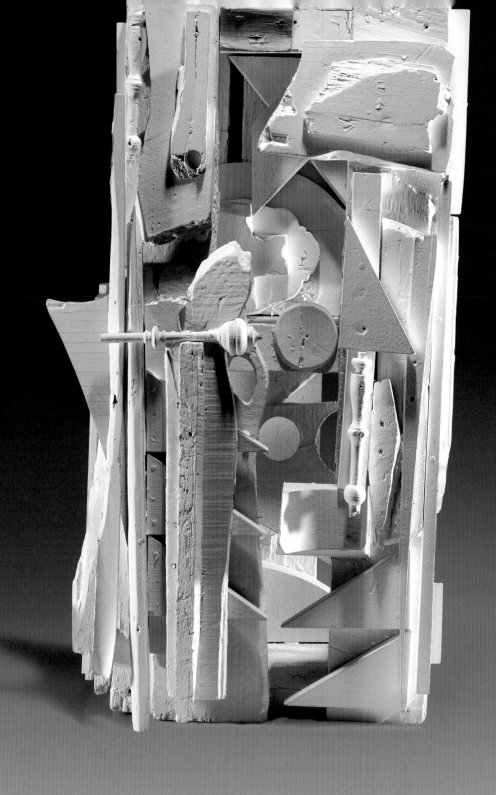

Plate 14 (cat. 41.2)
Louise Nevelson
*Dawn's Wedding
Chest*, 1959

50

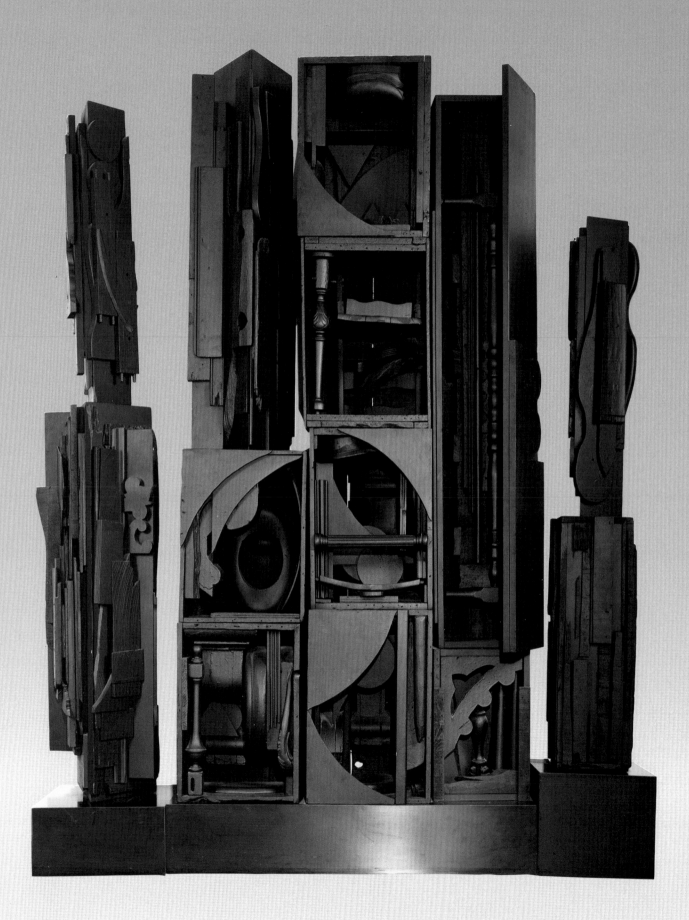

Plate 15 (cat. 41.4)
Louise Nevelson
Cathedral Garden #4, 1963

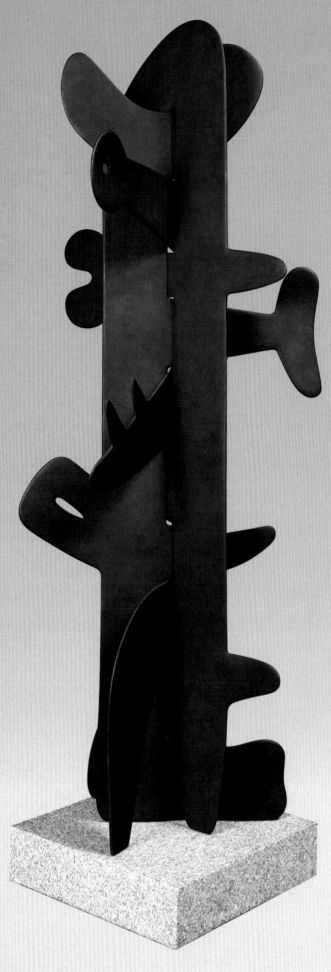

Plate 16 (cat. 42.1)
Isamu Noguchi
Trinity (Triple), 1987 from a prototype of
1945

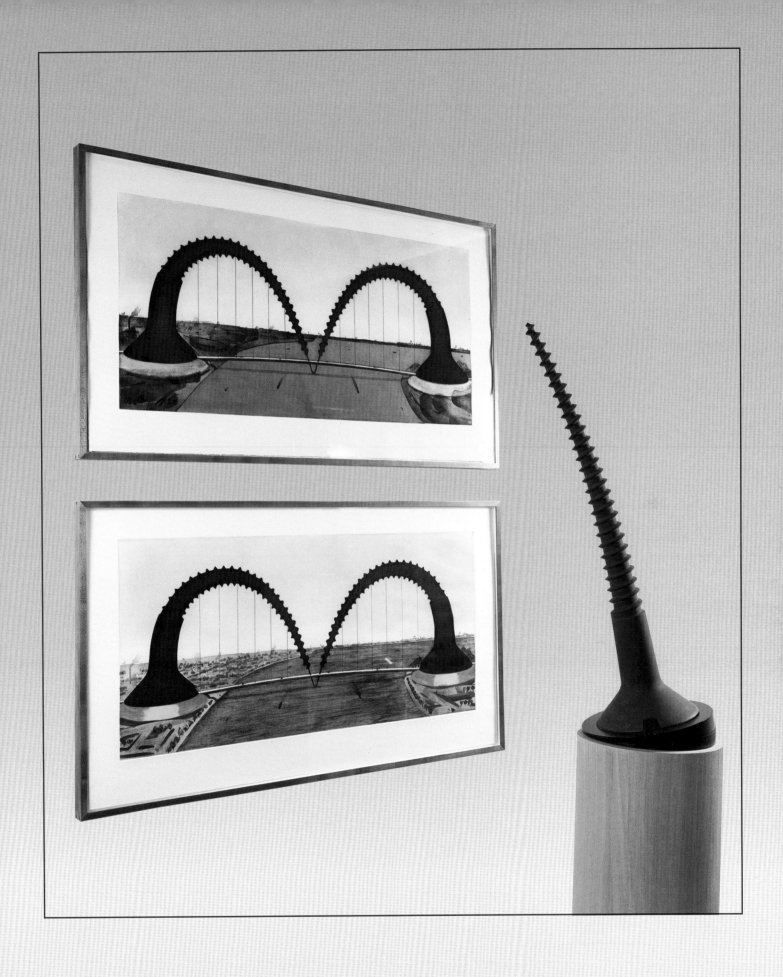

Plate 17 (cat. 44.6, 44.7, and 44.8)
Claes Oldenburg
Soft Screw, 1975
Double Screwarch Bridge, State II, 1981
Double Screwarch Bridge, State III, 1981

53

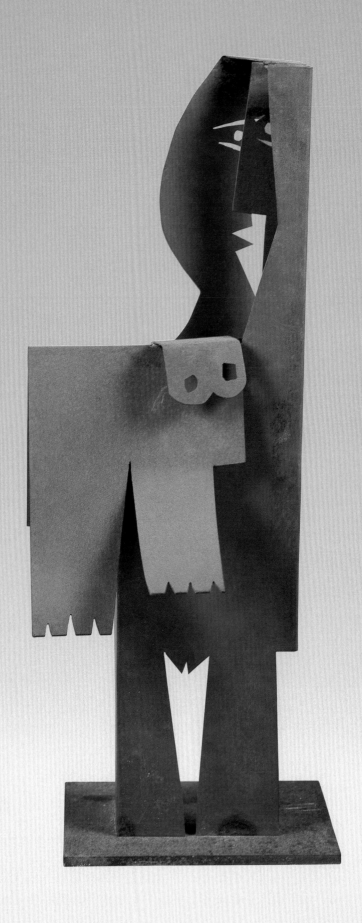

Plate 18 (cat. 47.2)
Pablo Picasso
Femme debout, 1961

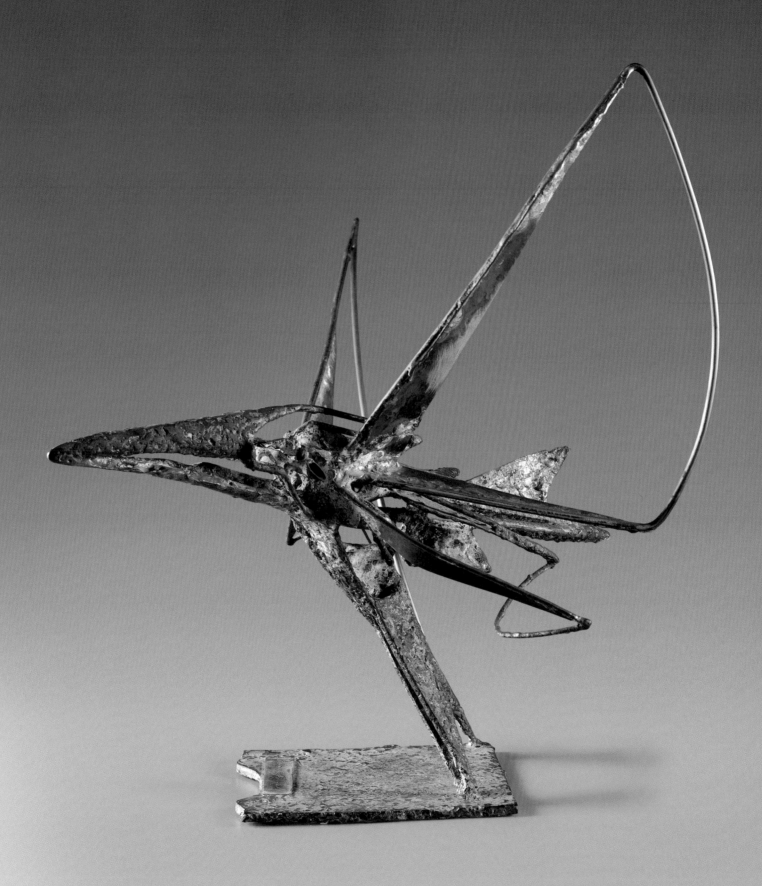

Plate 19 (cat. 49.33)
Theodore Roszak
Flying Fish, 1959

55

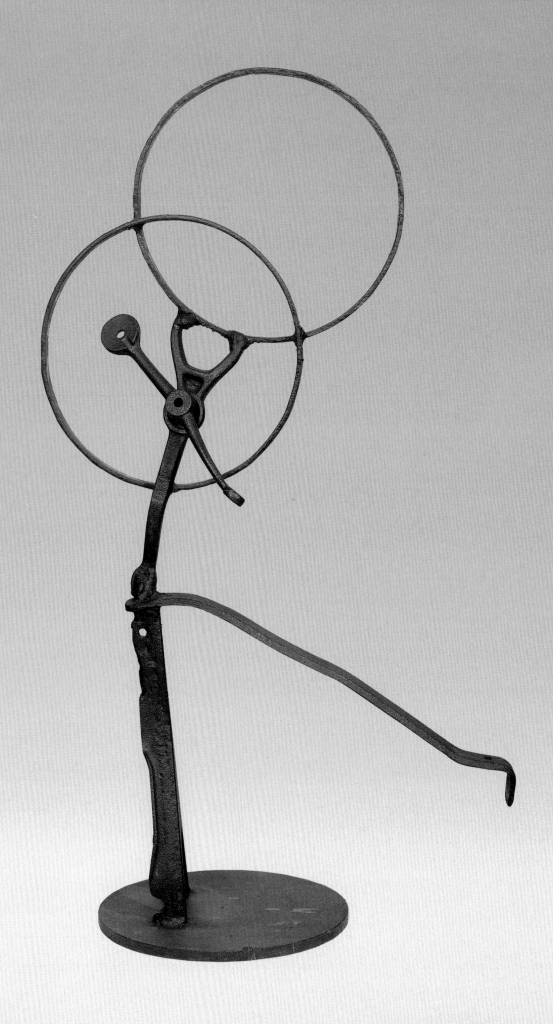

Plate 20 (cat. 51.7)
David Smith
Untitled, 1951

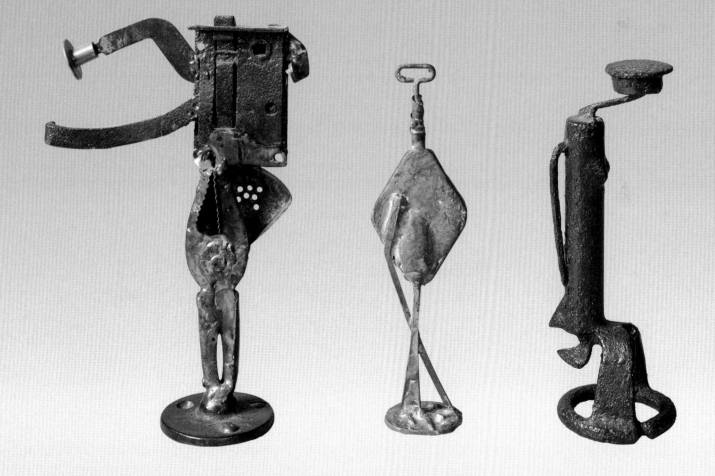

Plate 21 (cat. 51.28–30)
David Smith
Untitled, ca. 1956
Untitled, ca. 1956
Untitled, ca. 1956–1959

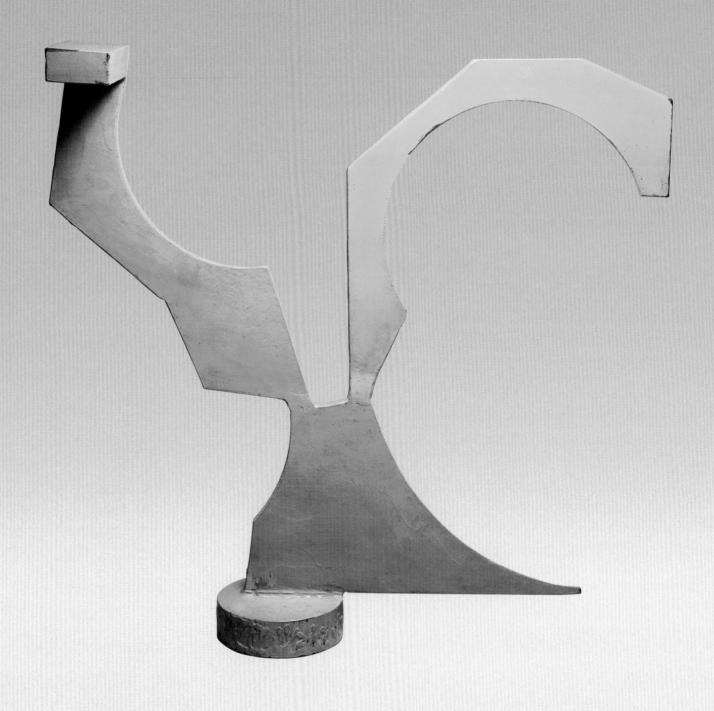

Plate 22 (cat. 51.32)
David Smith
Albany VIIB, ca. 1959

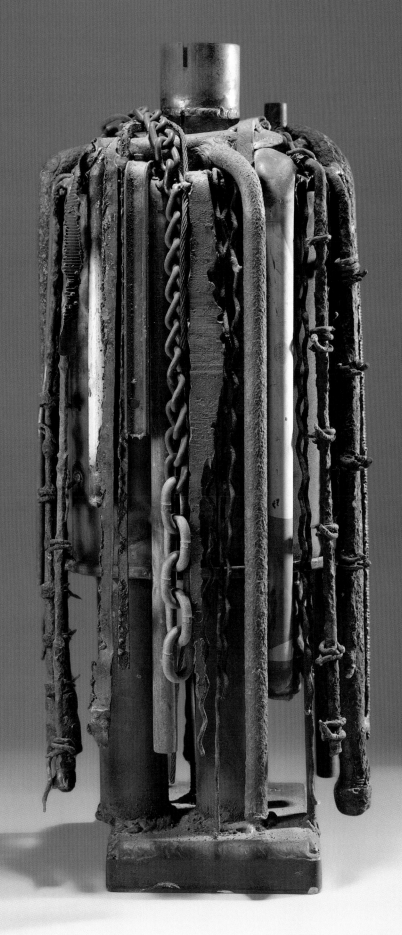

Plate 23 (cat. 54.1)
Richard Stankiewicz
Chain People, 1960

59

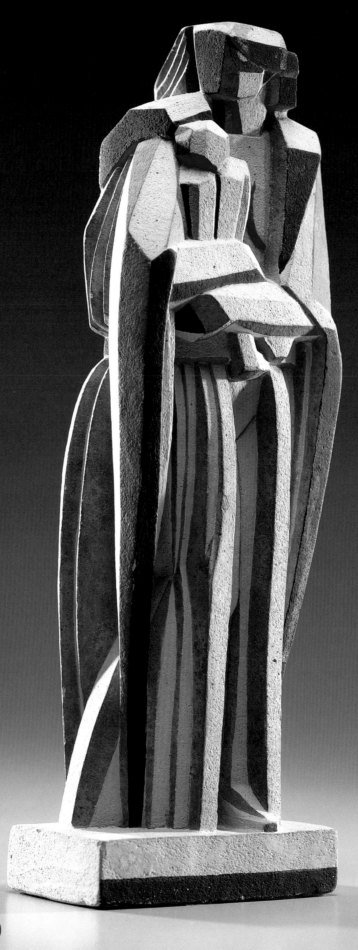

Plate 24 (cat. 55.1)
John Storrs
Modern Madonna,
1918

60

ARTISTS IN THE EXHIBITION

1. Peter Agostini (American, 1913–1993)

2. Alexander Archipenko (Russian, worked in U.S. after 1923, 1887–1964)

3. Jean (Hans) Arp (French, 1887–1966)

4. Leonard Baskin (American, b. 1922)

5. Varujan Boghosian (American, b. 1926)

6. Lee Bontecou (American, b. 1931)

7. Fritz Bultman (American, 1919–1985)

8. Alexander Calder (American, 1898–1976)

9. Anthony Caro (American, b. 1924)

10. John Chamberlain (American, b. 1927)

11. Christo (American, b. Bulgaria 1935)

12. Joseph Cornell (American, 1903–1972)

13. José de Creeft (American, b. Spain, 1884–1983)

14. José Ruiz de Rivera (American, 1904–1985)

15. Mark di Suvero (American, b. 1933)

16. Jean Dubuffet (French, 1901–1985)

17. Herbert Ferber (American, 1906–1991)

18. Elisabeth Frink (British, b. 1930)

19. Naum Gabo (American, b. Russia, 1890–1977)

20. Alberto Giacometti (Swiss, 1901–1966)

21. Julio González (Spanish, 1876–1942)

22. Sidney Gordin (b. Russia 1918, worked in U.S. since 1937)

23. Dimitri Hadzi (American, b. 1921)

24. Raoul Hague (American, b. Turkey, 1905–1993)

25. Barbara Hepworth (British, 1903–1975)

26. Rudolf Hoflehner (Austrian, b. 1916)

27. Gabriel Kohn (American, 1910–1975)

28. Gaston Lachaise (American, b. France, 1882–1935)

29. Lanny Lasky (American, b. 1927)

30. Ibram Lassaw (American, b. Egypt 1913)

31. Jacques Lipchitz (French, b. Lithuania, 1891–1973)

32. Seymour Lipton (American, 1903–1986)

33. Aristide Maillol (French, 1861–1944)

34. Conrad Marca-Relli (American, b. 1913)

35. Umberto Mastroianni (Italian, b. 1910)

36. Bernard Meadows (British, b. 1915)

37. Joan Miró (Spanish, 1893–1983)

38. Henry Moore (British, 1898–1986)

39. Elie Nadelman (American, b. Poland, 1885–1964)

40. Reuben Nakian (American, 1897–1986)

41. Louise Nevelson (American, b. Russia, 1899–1988)

42. Isamu Noguchi (American, 1904–1988)

43. Toshio Odate (American, b. Japan 1930)

44. Claes Oldenburg (American, b. Sweden 1929)

45. Alfonso A. Ossorio (American, b. Philippines, 1916–1990)

46. Antoine Pevsner (Russian, 1884–1962)

47. Pablo Picasso (Spanish, 1881–1973)

48. Ivan Puni (Jean Pougny) (French, b. Russia, 1894–1956)

49. Theodore Roszak (American, b. Poland, 1907–1981)

50. Julius Schmidt (American, b. 1923)

51. David Smith (American, 1906–1965)

52. Tony Smith (American, 1912–1981)

53. Francesco Somaini (Italian, b. 1926)

54. Richard Stankiewicz (American, 1922–1983)

55. John Storrs (American, 1885–1956)

56. George Sugarman (American, b. 1912)

57. Jean Tinguely (Swiss, 1925–1991)

58. Tom Wesselmann (American, b. 1931)

59. Fritz Wotruba (Austrian, 1907–1975)

ILLUSTRATED CHECKLIST OF THE EXHIBITION

The following abbreviations are used in checklist for exhibitions and publications which occur more than three times; otherwise complete information is given with each entry.

Constructivist
Theodore Roszak: Constructivist Works, 1931–1947, Hirschl & Adler Galleries, New York, February 20–April 11, 1992. Exhibition catalogue by Douglas Dreishpoon

Elsen
Seymour Lipton. Text by Albert Elsen. New York: Harry N. Abrams, [1971]

Hirshhorn
Edward F. Fry and Miranda McClintic, *David Smith: Painter, Sculptor, Draftsman*, Hirshhorn Museum and Sculpture Garden, November 4, 1982–January 2, 1983. Traveled to San Antonio Museum of Art. Exhibition catalogue published by George Braziller in association with Hirshhorn Museum and Sculpture Garden, 1982

Krauss
Rosalind E. Krauss, *The Sculpture of David Smith: A Catalogue Raisonné.* New York: Garland, 1977

New Dimensions in Drawing
New Dimensions in Drawing 1950–1980, The Aldrich Museum of Contemporary Art, Ridgefield, Conn., May 2–September 6, 1981

Phillips
Seymour Lipton: A Loan Exhibition. The Phillips Collection, Washington, D.C., January 12–February 24, 1964. Exhibition catalogue text by Duncan Phillips

Smith Drawings
David Smith: The Drawings, Whitney Museum of American Art, New York, December 5, 1979–February 10,1980. Traveled to The Serpentine Gallery, London. Exhibition catalogue text by Paul Cummings, 1979

Smith Sprays
David Smith Sprays from Bolton Landing, Anthony d'Offay, London, July 3–August 24, 1985. Exhibition catalogue

Storm
David Smith: Drawings for Sculpture: 1954–1964, Storm King Art Center, Mountainville, New York, May 19–October 31, 1982. Exhibition catalogue

Storrs
John Storrs. Whitney Museum of American Art, New York, December 11, 1986–March 22, 1987. Traveled to Amon Carter Museum, Fort Worth, Texas; J.B. Speed Museum, Louisville, Kentucky. Exhibition catalogue, 1986

UW–Milwaukee
Seymour Lipton: The Creative Process, University of Wisconsin–Milwaukee, September 14–October 26, 1969. Exhibition catalogue introduction by Tracy Atkinson

Dimensions list height first, width, depth. D. = diameter

1. PETER AGOSTINI
(American, 1913–1993)

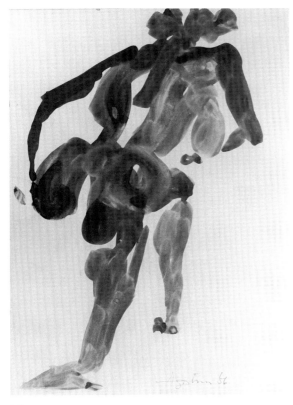

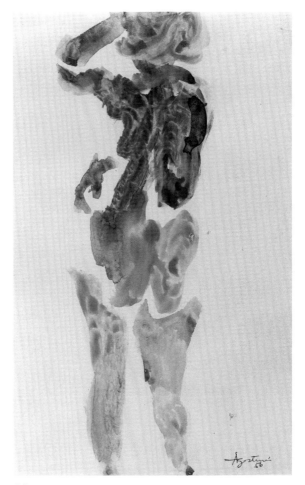

1.1
Kneeling Figure, **1956**
Watercolor, 12 x 9 in.
Signed and dated LR: Agostini '56
Photo: Gavin Ashworth
Provenance: [Stephen Radich Gallery, New York, February 26, 1963]

1.2
Nude with Arm Raised, **1956**
Watercolor, 12 x 9 in.
Signed and dated LR: Agostini '56
Photo: Gavin Ashworth
Provenance: [Stephen Radich Gallery, New York, November 23, 1965]

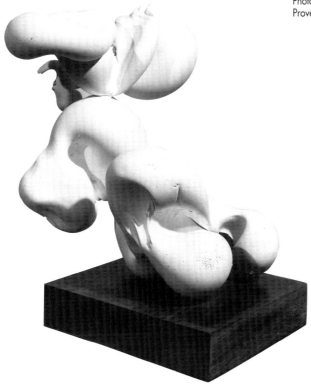

1.3
Summer Cloud, **1962**
Plaster, 10 in. H.
Photo: Eric Pullitzer
Exhibition: Solo exhibition, Stephen Radich Gallery, New York,
April 1964
Provenance: [Stephen Radich Gallery, New York, April 7, 1964]

2. ALEXANDER ARCHIPENKO
(Russian, worked in U.S. after 1923, 1887–1964)

2.1
Etude de nu debout, **ca. 1920**
Red, black, and white pencil drawing, 11⅝ x 9¼ in.
Signed LL: Archipenko; LR: 45
Photo: Gavin Ashworth
Provenance: [Perls Galleries, New York, October 12, 1962]

2.2
Femme nue, **ca. 1925**
Pencil on buff paper, 18½ x 11¾ in.
Signed LL: Archipenko
Photo: Gavin Ashworth
Provenance: (Christie's, New York, October 8, 1987, lot 75)

2.3
Reclining Nude, **n.d.**
Pencil and colored pencil on
paper, 11 x 15 in.
Signed LR: Archipenko
Photo: Gavin Ashworth
Provenance: (Sotheby's, New
York, February 24, 1994, lot 56);
ex coll.: Margot Gottlieb

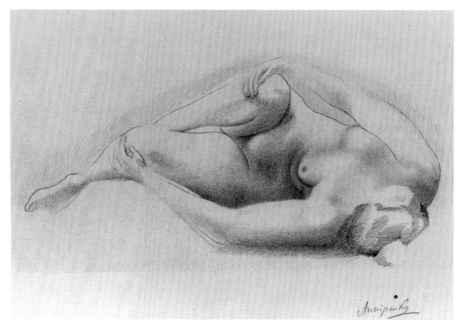

3 JEAN (HANS) ARP
(French, 1887–1966)

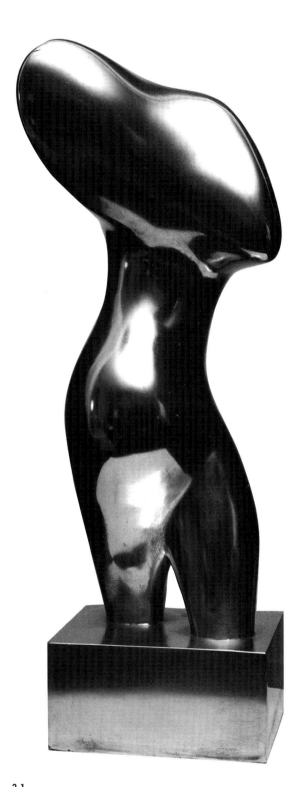

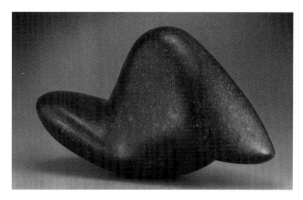

3.2
Pierre païenne (Pagan Stone), 1942
Black granite, 5 ⅞ x 10 ½ x 4 ¾ in.
Photo: Gavin Ashworth
Exhibition: *Jean Arp*, Buchholz Gallery, New York, January 18–February 12, 1949
Publication: Ionel Jianou, *Jean Arp*. Paris: Arted, Editions d'Art, 1973, p. 70, cat. 68 (not illus.) // Carola Giedion-Welcker, *Hans Arp*. Stuttgart: Verlag Gerd Hatje, 1957, p. 110, cat. 68; p. 65, illus. // *Jean Arp*. New York: Buchholz Gallery, 1949, cat. 22 // P. G. Bruguière, "Arp," *Cahiers d'Art* 22 (1947), p. 267, illus.
Provenance: [Parke-Bernet, New York, February 26, 1970, lot 75]

3.1
Petite Torso, 1930
Bronze, 12 ¼ x 4 ¾ x 3 ¾ in.
Edition: 5/5
Photo: John A. Ferrari
Publication: Ionel Jianou, *Jean Arp*. Paris: Arted, Editions d'Art, 1973, p. 66, cat. 5 (not illus.)
Provenance: [Galerie d'Art Moderne Bale, Basle, Switzerland, October 1960]

3.3
Constellation Expressive, 1958
Painted wood relief, 39 ⅜ x 31 9/16 in.
Signed on reverse
Provenance: [Parke-Bernet Galleries, New York, April 5, 1967, lot 53]; ex coll.: Mrs. Henry (Ethel Steuer) Epstein; [Sidney Janis Gallery]

4 LEONARD BASKIN
(American, b. 1922)

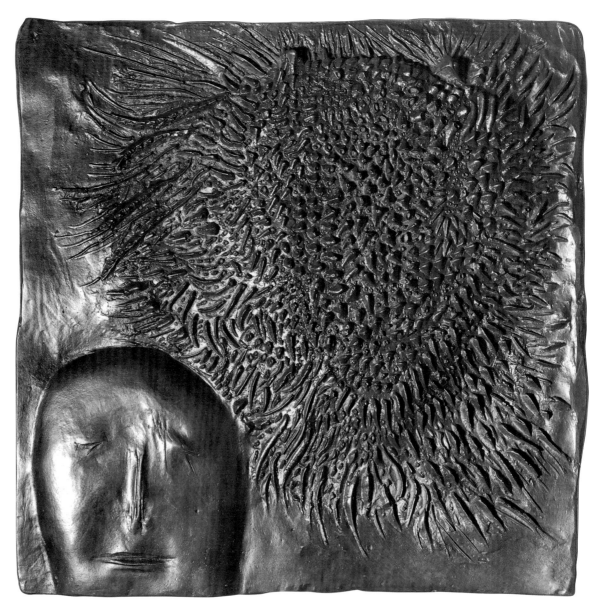

4.1
***Homage to Un-American Activities Committee,* 1959**
Bronze bas-relief, 11¼ x 12 x 1 in.
Edition of twelve known, number of this work unknown
Photo: John A. Ferrari
Exhibition: *Leonard Baskin,* The Museum of Modern Art, New York,
May 7–July 2, 1961. Traveled to Museum Boymans-Van Beuningen,
Rotterdam; Amerika Haus, West Berlin; Centre Culturel Americain,
Paris // Irma B. Jaffee, *The Sculpture of Leonard Baskin,* New York:
The Viking Press, 1980 // *Leonard Baskin: Drawings and Sculpture,*
Grace Borgenicht Gallery, New York, March 15–April 2, 1960
Publication: *Leonard Baskin.* New York: The Museum of Modern Art,
1961, cat. 18, illus. // *Leonard Baskin: Drawings and Sculpture,* New
York: Grace Borgenicht Gallery, 1960. (checklist) cat. 16, illus. n.p. //
"Reviews and Previews," *Art News* 59, no. 3 (May 1960), p. 16, not
illus.
Provenance: [Grace Borgenicht Gallery, March 15, 1960]

4.2
***Howling Bird,* 1959**
Ink on paper, 31 x 22 in.
Signed and dated in ink LR in duplicate: Baskin 1959
Photo: Gavin Ashworth
Provenance: [Grace Borgenicht Gallery, November 1, 1962]

5 VARUJAN BOGHOSIAN
(American, b. 1926)

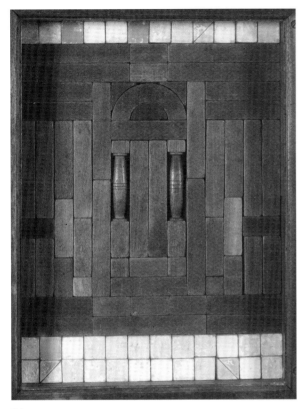

5.1
Remembrance, **1969**
Wood, paint, plate glass, 16 x 12¼ in.
Exhibition: Cordier & Ekstrom, New York, October 9–November 6, 1971
Publication: *Varujan Boghosian.* New York: Cordier & Ekstrom, 1971, illus. cover.
Provenance: (Sotheby's, New York, February 17, 1988, lot 151); [Cordier & Ekstrom, New York, 1978]

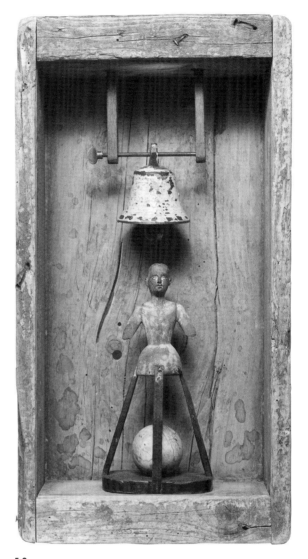

5.2
Untitled, 1971
Wooden doll's torso, beads, string, bell, plate glass, 19 ¾ x 10½ x 5 in.
Photo: Geoffrey Clements
Exhibition: *Varujan Boghosian,* Cordier & Ekstrom, New York, October 9–November 6, 1971
Publication: *Varujan Boghosian.* New York: Cordier & Ekstrom, 1971, illus. n.p.
Provenance: [Cordier & Ekstrom, November 16, 1971]

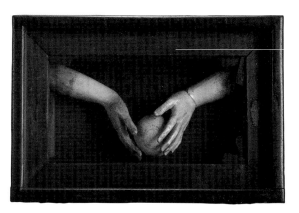

5.4
The Offering, 1973
Marble, wood construction, 11¼ x 17 x 12 in.
Photograph: Gavin Ashworth
Photo: Gavin Ashworth

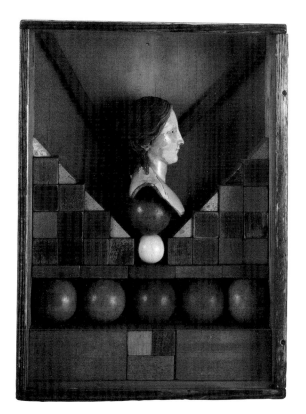

5.3
Cameo, 1973
Wood and composition construction, 14½ x 10¾ x 3¾ in.
Photo: Gavin Ashworth

6 LEE BONTECOU
(American, b. 1931)

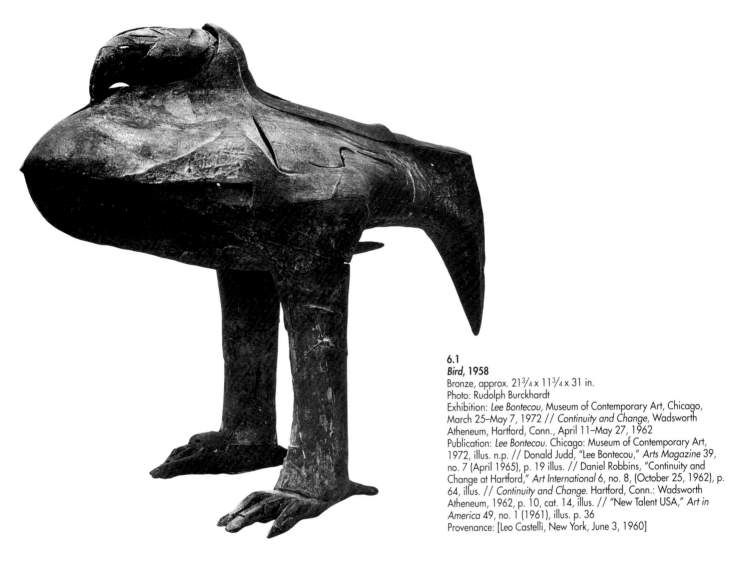

6.1
Bird, 1958
Bronze, approx. 21¾ x 11¾ x 31 in.
Photo: Rudolph Burckhardt
Exhibition: *Lee Bontecou*, Museum of Contemporary Art, Chicago,
March 25–May 7, 1972 // *Continuity and Change*, Wadsworth
Atheneum, Hartford, Conn., April 11–May 27, 1962
Publication: *Lee Bontecou*. Chicago: Museum of Contemporary Art,
1972, illus. n.p. // Donald Judd, "Lee Bontecou," *Arts Magazine* 39,
no. 7 (April 1965), p. 19 illus. // Daniel Robbins, "Continuity and
Change at Hartford," *Art International* 6, no. 8, (October 25, 1962), p.
64, illus. // *Continuity and Change*. Hartford, Conn.: Wadsworth
Atheneum, 1962, p. 10, cat. 14, illus. // "New Talent USA," *Art in
America* 49, no. 1 (1961), illus. p. 36
Provenance: [Leo Castelli, New York, June 3, 1960]

6.2
Untitled (#4), 1959
Welded metals and canvas relief, 36 x 39½ in.
Signed and dated LR: Bontecou 59
Photo: John A. Ferrari
Provenance: [Leo Castelli, New York, February 3, 1960]

6.3
Untitled (#10), 1960
Welded metal, canvas, 28 x 28 in.
Signed and dated LR: Bontecou 60
Photo: John A. Ferrari
Provenance: [Leo Castelli, New York, March 29, 1960]

6.4
Untitled, 1965
Pencil and soot on paper, 22½ x 28½ in.
Signed and dated LR: Bontecou 1965
Photo: Gavin Ashworth
Exhibition: *A World of Visual Metaphors: Drawings and Etchings from the 60's by Lee Bontecou*, Neuberger Museum, State University of New York at Purchase, December 3, 1989–February 11, 1990 // *Lee Bontecou*, Museum of Contemporary Art, Chicago, March 25–May 7, 1972
Publication: *Lee Bontecou*. Chicago: Museum of Contemporary Art, 1972, checklist
Provenance: [Leo Castelli, New York, November 9, 1966]

6.5
Untitled, 1966
Pencil and soot on paper, 20½ x 27½ in.
Signed and dated LR: Bontecou 1966
Photo: Gavin Ashworth
Exhibition: *A World of Visual Metaphors: Drawings and Etchings from the 60's by Lee Bontecou*, Neuberger Museum, State University of New York at Purchase, December 3, 1989–February 11, 1990 // *Lee Bontecou*, Museum of Contemporary Art, Chicago, March 25–May 7, 1972 // *Lee Bontecou*, Stadtisches Museum of Leverkussen, March 11–April 7, 1968. Traveled to Museum Boymans-Van Beuningen, Rotterdam and Geselleschaft für Bildende Kunst, Berlin
Publication: *Lee Bontecou*. Chicago: Museum of Contemporary Art, 1972, checklist // *Lee Bontecou*. Leverkussen: Stadtisches Museum, 1968, no. 32, illus., n.p.
Provenance: (Channel 13, New York, November 28, 1966); [Leo Castelli Gallery]

6.6
Untitled, 1966
Pencil on graph paper, 17 x 22 in.
Signed and dated LR: Bontecou 1966
Photo: Gavin Ashworth
Provenance: [Leo Castelli, New York, October 20, 1966]

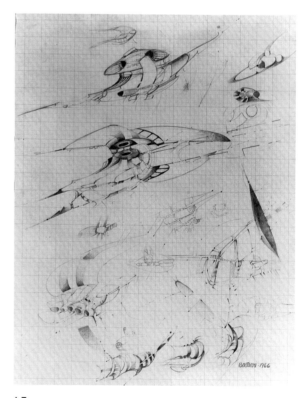

6.7
Untitled, 1966
Pencil on graph paper, 22 x 17 in.
Signed and dated LR: Bontecou 1966
Photo: Gavin Ashworth
Provenance: [Leo Castelli, New York, October 20, 1966]

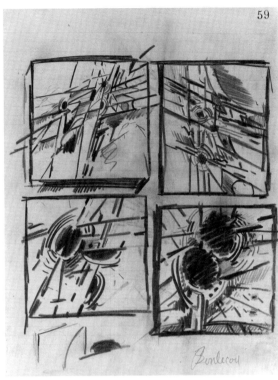

59

6.8a (recto)
Untitled, n.d.
Pencil on graph paper, 11³/₁₆ x 8 in.
Signed in pencil LR: Bontecou; stamped UR: 59
Photo: Gavin Ashworth
Provenance: gift from the artist, 1960

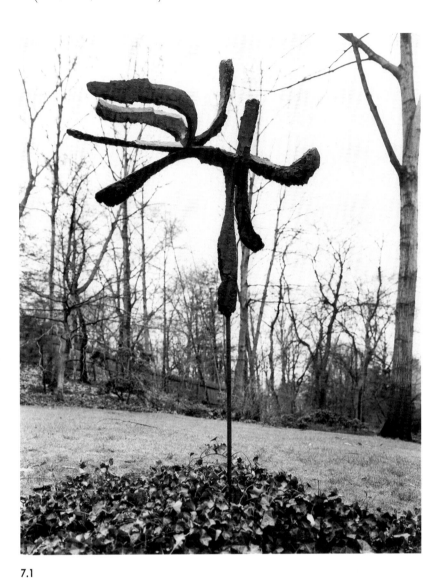

7.1
Azores, 1959
Bronze, 41¹/₂ x 45¹/₂ in.
Edition: 1/4
Photo: John A. Ferrari
Provenance: [Gallery Mayer, New York, March 18, 1960]

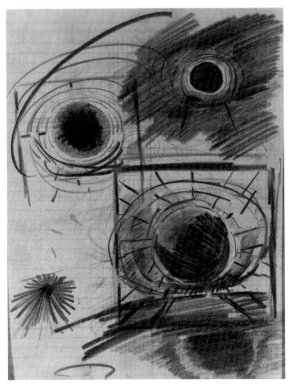

6.8b (verso)
Untitled, n.d.
Pencil on graph paper, 11³/₁₆ x 8 in.
Photo: Gavin Ashworth
Provenance: gift from the artist, 1960

8 ALEXANDER CALDER
(American, 1898–1976)

8.1
Ben Hur, 1931
Pen and ink drawing, 22³/₄ x 30³/₄ in.
Signed LR: Calder; titled LC: Ben Hur
Photo: Gavin Ashworth
Exhibition: *Alexander Calder Memorial Exhibition*, American Academy and Institute of Arts and Letters, New York, November 14–December 30, 1977 // *Alexander Calder: A Retrospective Exhibition*, Solomon R. Guggenheim Museum, New York, November 1964–January 1965. Traveled (in altered form) to Milwaukee Art Center; Washington University Art Gallery, St Louis; Des Moines Art Center; and Art Gallery of Toronto, 1965 // *Calder*, Musée d'Art Moderne, Paris, July-October, 1965
Publication: Roger Winter, *Introduction to Drawing*. Englewood Cliffs, NJ: Prentice Hall, 1983 // H. H. Arnason and Pedro Guerro, *Calder*. New York: Van Nostrand, 1966, pp. 156–57, illus. // Thomas Messer, *Alexander Calder: A Retrospective Exhibition*. New York: Solomon R. Guggenheim Museum, 1964, p. 29, illus. // *Alexander Calder: A Retrospective Exhibition*. Toronto: Art Gallery of Toronto, 1965, cat. 5 illus. // *Calder*. Paris: Musée d'Art Moderne, 1965, cat. 62
Provenance: [Perls Galleries, New York, December 5, 1964]

8.2
Pyramid (Tumbling Family), 1931
Pen and ink drawing, 22³/₄ x 30³/₄ in.
Signed and dated LR: Calder 1931
Photo: Gavin Ashworth
Exhibition: *Calder's Universe*, Whitney Museum of American Art, New York, October 14, 1976–February 6, 1977. Traveled to The High Museum of Art, Atlanta; Walker Art Center, Minneapolis; Dallas Museum of Fine Arts
Publication: Jean Lipman, *Calder's Universe*. New York: The Viking Press in cooperation with the Whitney Museum of American Art, 1976, p. 93, illus.
Provenance: [Perls Galleries, New York, October 8, 1964]

8.3
Tumblers, 1931
Pen and ink on paper, 22³/₄ x 30³/₄ in.
Signed and dated LR: Calder 1931
Photo: Gavin Ashworth
Exhibition: *Olympics In Art*, Munson-Williams-Proctor Institute, Utica, NY, January 13–March 2, 1980 // *Calder's Universe*, Whitney Museum of American Art, New York, October 14–February 6, 1977. Traveled to The High Museum of Art, Atlanta; Walker Art Center, Minneapolis; Dallas Museum of Fine Arts // *Alexander Calder: The Circus*, Whitney Museum of American Art, New York, April 20–June 11, 1972
Publication: Rita Gilbert, *Living With Art*. New York: McGraw-Hill, 1991. 3rd ed. // *Olympics In Art*. Utica, N.Y.: Munson-Williams-Proctor Institute, 1980, p. 105, no. 47, illus. // Jean Lipman, *Calder's Universe*. New York: The Viking Press in cooperation with the Whitney Museum of American Art, 1976. p. 99, illus. // Jean Lipman and Nancy Foote, eds. *Calder's Circus*. New York: Dutton with the Whitney Museum of American Art, 1972, p. 61, illus. (detail) // Cleve Gray, "Calder's Circus," *Art in America* 52, no. 5 (1964), p. 34 illus.
Provenance: [Perls Galleries, New York, October 8, 1964]

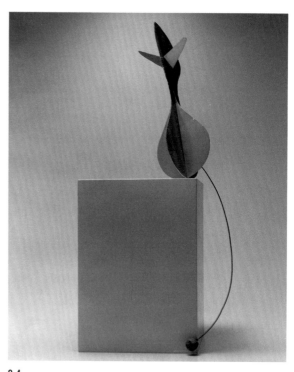

8.4
Bird, 1939
Sheet aluminum, steel wire, lead ball, 12 x 4¹/₂ x 4¹/₂ in.
Inscribed AC
Photo: Gavin Ashworth
Provenance: [Perls Galleries, New York, December 19, 1967]

8.5
***Pregnant Black Woman*, 1946**
Gouache, 27¼ x 19 in.
Signed and dated LR in black gouache: Calder 46
Photo: Gavin Ashworth
Provenance: [Perls Galleries, New York, March 23, 1969]

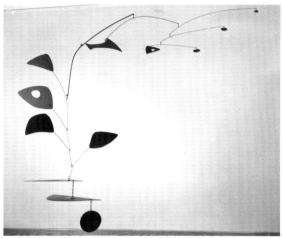

8.7
***Verticale hors de l'horizontale*, 1950**
Painted sheet metal and wire cord, 67 in. H.
Exhibition: *Brandeis University Creative Art Awards 1957–66*, The
Larry Aldrich Museum, Ridgefield, Conn., April 17–July 3, 1966 //
Dusseldorf and Basel, 1961 // Municipal Van Abbemuseum, Eind-
hoven, 1954 // Musée Municipal, Amsterdam, 1954 // *La Reserve*,
Knokke-le-Zoute, Belgium, 1952 // *Calder: Mobiles et Stabiles*,
Galerie Maeght, Paris, June 30–July 27, 1950
Publication: *Brandeis University Creative Art Awards 1957–66*. Ridge-
field, Conn.: The Larry Aldrich Museum, 1966, cat. 44 // *Time Maga-
zine* (April 23, 1965), p. 66, illus. // "The Market," *International Art
Market 5*, no. 4 and 5 (June and July 1965), p. 110 // *Calder:
Mobiles et Stabiles*. Paris: Galerie Maeght, 1950,no. 32
Provenance: owned jointly with Henry Klein [Parke-Bernet Galleries,
New York, April 14, 1965]; [Galerie Maeght, Paris]; ex coll.: Philippe
Dotremont

8.6
***Moon and Stars*, 1947**
Watercolor and gouache, 23 x 31 in.
Signed and dated UL: Calder Eastham '47
Photo: Gavin Ashworth
Provenance: [Parke-Bernet Galleries, New York, June 7, 1962, lot 134]

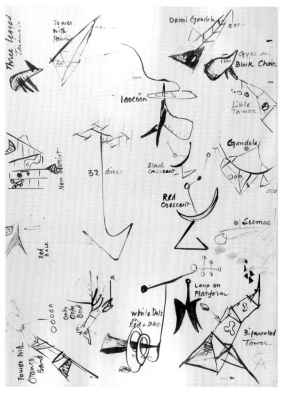

8.8
Study for an Exhibition Announcement, ca. 1951
India ink, red crayon, and collage on board, 20 x 15 in.
Inscribed LR: AC
Provenance: [Stephen Radich Gallery, New York, December 27, 1963, lot 123]

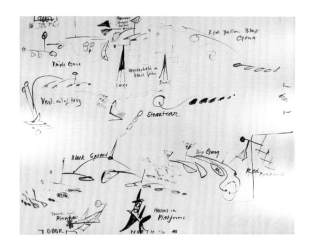

8.9
Study for an Exhibition, ca. 1951
Ink and watercolor on paper, 15 x 20 in.
Signed LR: Calder
Provenance: (Sotheby's, New York, April 25, 1986); ex coll.: Dr. Jacob B. Freedman (1971 bought); [Parke-Bernet Galleries, New York]

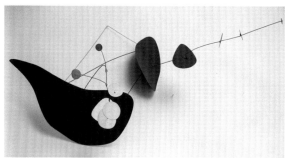

8.10
Escutcheon III, 1952
Sheet metal, steel wire, paint, 27 x 56 in.
Photo: Gavin Ashworth
Provenance: [Perls Galleries, New York, October 24, 1968]

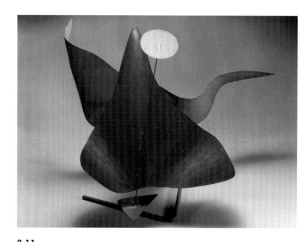

8.11
Orange and Black Waves, 1954
Sheet metal and steel wire, 22 x 15 x 19 in.
Inscribed AC
Photo: Gavin Ashworth
Exhibition: *Brandeis University Creative Art Awards 1957–66*, The Larry Aldrich Museum, Ridgefield, Conn., April 17–July 3, 1966 // *Alexander Calder: Sculpture, Mobiles*, The Tate Gallery, London, July 3–August 12, 1962
Publication: *Brandeis University Creative Art Awards 1957–66*. Ridgefield, Conn.: The Larry Aldrich Museum, 1966, cat. 42 illus., n.p. // *Alexander Calder: Sculpture, Mobiles*. London: The Tate Gallery, 1962, cat. 52 // *Art in America* 48, no. 2 (1960), illus. cover as *Black Wave/ Orange Wave*
Provenance: [Perls Galleries, New York, February 8, 1961]

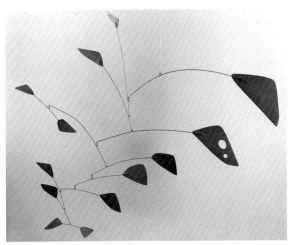

8.12
Sumac Fall, **1960**
Sheet metal, steel wire, 43 x 50 in.
Inscribed: AC
Photo: Gavin Ashworth
Provenance: [Perls Galleries, New York, January 4, 1961]

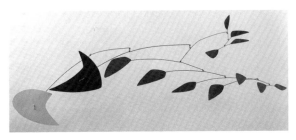

8.13
White Moon, Red Moon, **1961**
Sheet metal, steel wire, 26 x 71 in.
Inscribed: AC 61
Exhibition: *Art and Visual Perception,* Museum of Art, Science and
Industry, Bridgeport, Conn., July 15–September 22, 1969
Photo: Gavin Ashworth
Provenance: [Perls Galleries, New York, April 18, 1964]

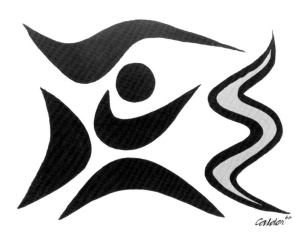

8.14
Abstraction, **1966**
India ink and watercolor on paper, 22³⁄₄ x 31 in.
Signed and dated LR: Calder 66
Photo: Gavin Ashworth
Provenance: [Parke-Bernet Galleries, New York, May 14, 1970]

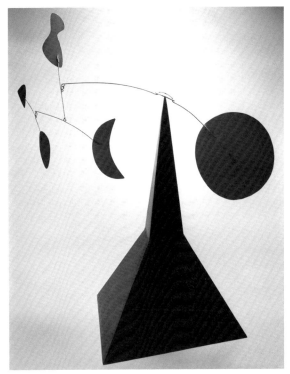

8.15
Snowy Sky over the Steeple, **1965**
Sheet metal and steel wire, 32 x 38 in.
Inscribed on base: AC 65
Photo: Gavin Ashworth
Provenance: [Perls Galleries, New York, March 1, 1965]

8.16
Contour Plowing, **1976**
Lithograph on Arches paper, 26³⁄₈ x 30 in.
Signed LR: Calder
Edition: 5/80
Photo: Gavin Ashworth
Provenance: Whitney Museum of American Art, November 1976]

9 ANTHONY CARO
(English, b. 1924)

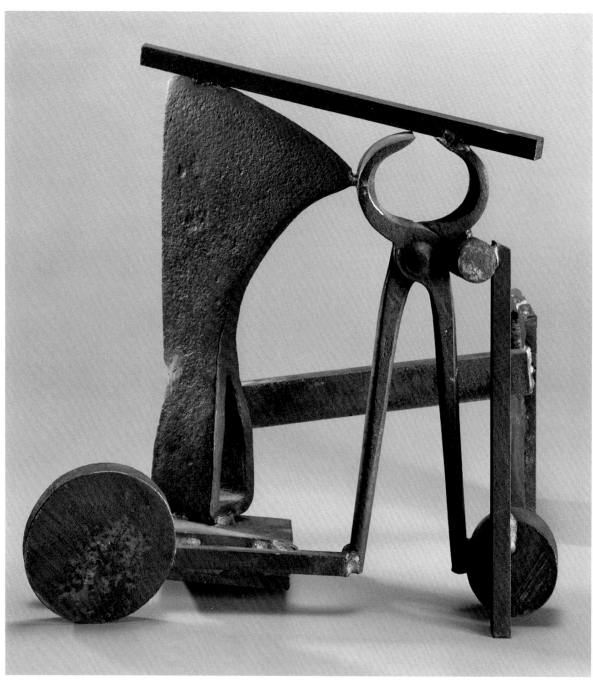

9.1
***Writing Piece "Knob,"* 1979**
Welded steel, 14$^1/_2$ x 16 x 10$^1/_2$ in.
Photo: Gavin Ashworth
Exhibition: *Anthony Caro "Writing Pieces,"* André Emmerich Gallery,
New York, November 10–December 1, 1979
Publication: Dieter Blume, *Anthony Caro: Table and Related Sculptures
1979–1980, Miscellaneous Sculptures 1974–1980, Bronze Sculptures
1976–1980: A Catalogue Raisonné.* Cologne: Verlag Galerie Wentzel,
1981, vol. II, p. 127, cat. 524
Provenance: (Christie's, New York, May 11, 1994, lot 164); (Janie C.
Lee Gallery, Houston, Tex.); (André Emmerich Gallery, New York)

10 JOHN CHAMBERLAIN
(American, b. 1927)

10.1
Untitled, 1958
Oil on paper, 13⁷/₈ x 16⁷/₈ in.
Signed and dated LL: CHAMBERLAIN '58
Photo: Gavin Ashworth
Provenance: (Christie's East, New York, May 3, 1994, lot 13); Allan Stone Galleries, New York

10.2
Untitled, 1958
Oil on paper, 13¹/₄ x 17 in.
Signed and dated LR quadrant: CHAMBERLAIN '58
Photo: Gavin Ashworth
Provenance: (Christie's East, New York, November 1, 1994, lot 18); from the artist

10.3
E.D., 1960
Painted tin with wood base, 7³/₄ x 6¹/₂ x 5 in.
Photo: Gavin Ashworth
Publication: Julie Sylvester, *John Chamberlain: A Catalogue Raisonné of the Sculpture 1954–1985*. New York: Hudson Hills Press in association with The Museum of Contemporary Art, Los Angeles, 1986, p. 54, cat. 44, illus.
Provenance: [Martha Jackson Gallery, New York, March 22, 1960]

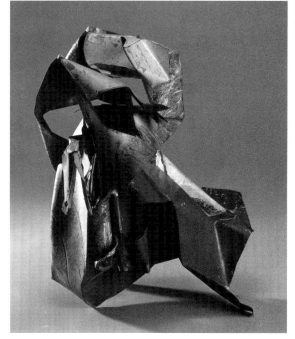

10.4
El Reno, 1962
Painted sheet metal, 11 x 9 x 8 in.
Photo: Gavin Ashworth
Exhibition: *John Chamberlain: A Retrospective Exhibition*, Solomon R. Guggenheim Museum, New York, December 23, 1971–February 20, 1972
Publication: Julie Sylvester, *John Chamberlain: A Catalogue Raisonné of the Sculpture 1954–1985*. New York: Hudson Hills Press in association with The Museum of Contemporary Art, Los Angeles, 1986, p. 68, cat. 113, illus. // Diane Waldman, *John Chamberlain*. New York: Solomon R. Guggenheim Museum, 1971, p. 60, cat. 35 // Donald Judd, "Chamberlain—Another View," *Art International* 7, no. 10 (January 1964), pp. 38–39, illus. p. 39 // *Metro International 1964 Directory of Contemporary Art*. Milan: Editoriale Metro, 1964, illus. pp.76–77.
Provenance: [Leo Castelli, New York, January 10, 1962]

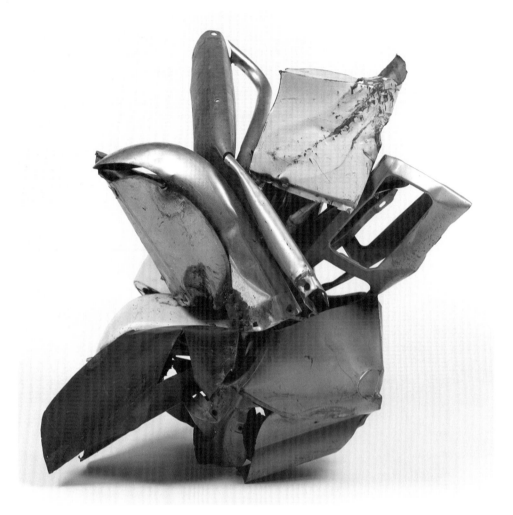

10.5
Nehoc, **1962**
Painted sheet metal, chrome automobile bumper, 33 x 32 x 27 in.
Photo: Gavin Ashworth
Publication: Julie Sylvester, *John Chamberlain: A Catalogue Raisonné of the Sculpture 1954–1985.* New York: Hudson Hills Press in association with The Museum of Contemporary Art, Los Angeles, 1986, p. 70, cat. 124, illus.
Provenance: [The Pace Gallery, Boston, November 9, 1963]

10.6
View from the Cockpit Series #72, **1976**
Dye and enamel on paper, 7 3/8 x 3 1/4 in.
Signed and dated LR: Chamberlain '76
Photo: Gavin Ashworth
Exhibition: *Contemporary Sculptors' Drawings,* Rice University, Houston, 1981 // Albright-Knox Member's Gallery, 1980 // Group exhibition of drawings, Margo Leavin Gallery, 1977
Provenance: [Leo Castelli, New York, October 6, 1993]

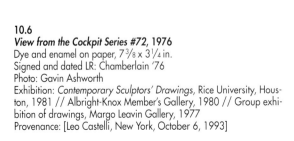

11 CHRISTO
(American, b. Bulgaria 1935)

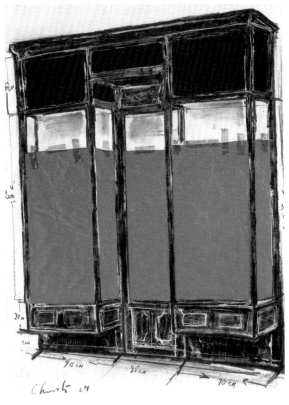

11.1
Store Front Project, 1964
Collage: enamel, charcoal, paper, and cellophane tape on paper
mounted on panel, 26¼ x 26 in.
Signed and dated LL: Christo 64
Provenance: (Christie's, New York, October 4, 1989, lot 41); [Minami
Gallery, Tokyo]

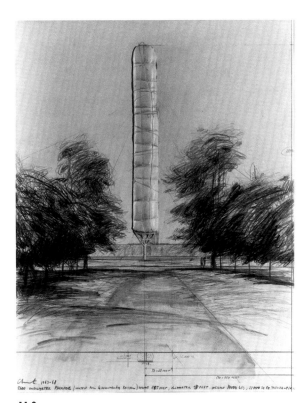

11.2
5600 Cubicmeter Package, Project for Kassel, 1967–1968
Collage: plastified fabric, twine, cardboard, pencil, charcoal mounted
on cardboard, 28 x 22 in.
Signed and dated LL: Christo 1967–68
Exhibition: *Christo: Works on Paper*, Library of the Boston Athenaeum,
September 10–October 10, 1984
Provenance: from the artist 1982

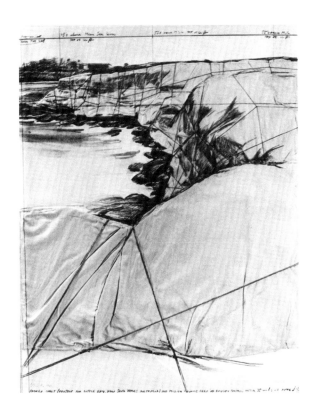

11.3
*Packed Coast, Project for Little Bay, New South Wales, Australia,
1969*, 1969
Collage, pencil, charcoal, twine, fabric, and staples mounted on
board, 28 x 22 in.
Signed and dated LL: Christo 1969
Photo: André Grossmann
Exhibition: *New Dimensions in Drawing*
Provenance: [Allan Frumkin Gallery, New York, December 29, 1972]

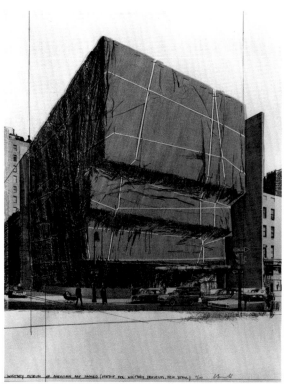

11.4
Whitney Museum of American Art, Packed, Project for New York,
1971
Lithograph on BFK Rives and special Arjomari paper, 28 x 22 in.
Signed LR: Christo; LC: 11/100
Edition: 11/100
Photo: André Grossmann
Provenance: [Allan Frumkin Gallery, New York, November 15, 1972]

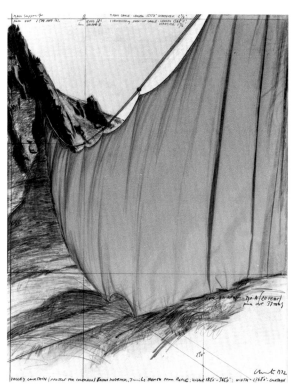

11.5
Valley Curtain (Project for Colorado), **1972**
Collage: pencil, fabric, pastel, charcoal, and crayon, 28 x 22 in.
Signed and dated LR: Christo 1972
Photo: André Grossmann
Exhibition: *New Dimensions in Drawing*
Provenance: [Allan Frumkin Gallery, New York, November 11, 1972]

11.6
*Running Fence, Project for
Sonoma and Marin Counties,
CA, 1975*
Collage: fabric, photostat,
pastel, charcoal, pencil,
crayons, 22 x 28 in.
Signed and dated LL: Christo
1975
Exhibition: *New Dimensions
in Drawing*
Provenance: from the artist
November 17, 1980

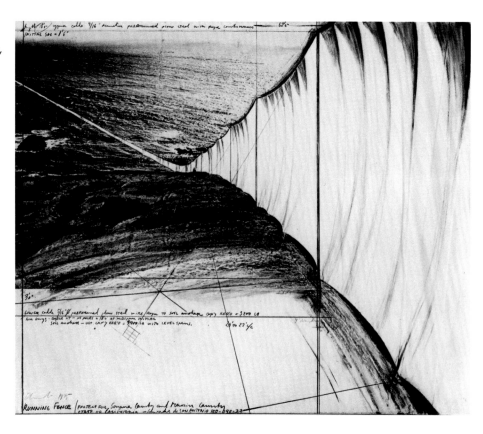

80

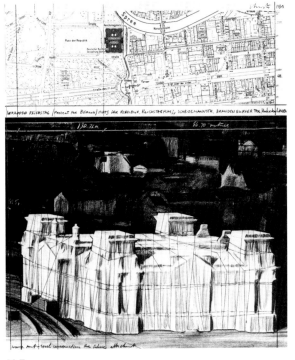

11.7
Wrapped Reichstag, Project for Berlin, 1980
Collage in two parts: fabric, twine, pastel, charcoal, pencil, and map on board, 11 x 28 in.; 22 x 28 in.
Signed and dated UR of 11 x 28 in. panel and on back of 22 x 28 in. panel: Christo 1980
Exhibition: *New Dimensions in Drawing*
Provenance: from the artist November 17, 1980

11.9
Surrounded Islands, Project for Biscayne Bay, Greater Miami, Florida, 1983
Collage in two parts: pencil, fabric, pastel, charcoal, enamel paint, aerial photograph, 11 x 28; 22 x 28 in.
Signed and dated UR pf 11 x 28 in. panel and on back of 22 x 28 in. panel: Christo 1983
Photo: André Grossmann
Provenance: from the artist February 13, 1983

11.8
The Pont Neuf Wrapped, Project for Paris, 1982
Collage in two parts: fabric, twine, pastel, charcoal, pencil, crayon, and technical data, 28¼ x 11⅜ in.; 28 x 22¼ in.
Signed and dated LR of 28 x 11 in. panel and on back of 28 x 22¼ in. panel: Christo 1982
Photo: Gavin Ashworth
Provenance: from the artist December 1982

 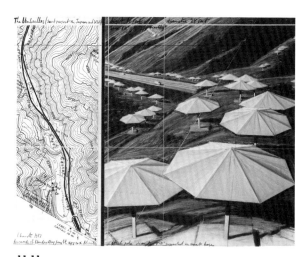

11.10
The Umbrellas, Joint Project for Japan and USA, 1987
College in two parts: pencil, charcoal, crayon, fabric, pastel, map,
enamel paint on board, 30^1/$_2$ x 12; 30^1/$_2$ x 26^1/$_4$ in.
Signed and dated LL and on back of 30^1/$_2$ x 26^1/$_4$ in. panel: Christo
1987
Photo: Eeva-Inkeri
Provenance: from the artist October 1987

11.11
The Umbrellas, Project for Japan and Western USA, 1987
Collage in two parts: pencil, charcoal, crayon, fabric, pastel, map
enamel paint, 30^1/$_2$ x 12 in.; 30^1/$_2$ x 26^1/$_4$ in.
Signed and dated LL and on back of 30^1/$_2$ x 26^1/$_4$ in. panel: Christo
1987
Photo: Eeva-Inkeri
Provenance: from the artist October 1987

12 JOSEPH CORNELL
(American, 1903–1972)

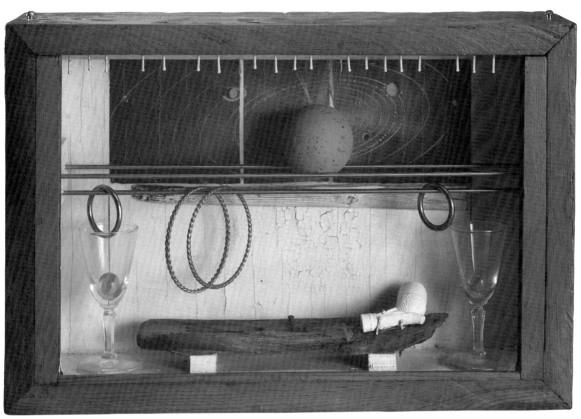

12.1
***Sun Box*, 1956**
Metal, glass, cork, driftwood, clay, 10⅛ x 15¼ x 3⅓ in.
Signed in reverse on the back
Photo: Gavin Ashworth
Exhibition: *Joseph Cornell*, The Museum of Modern Art, New York,
November 17, 1980–January 20, 1981 // *Joseph Cornell*, Solomon
R. Guggenheim Museum, New York, May 4–June 1967
Publication: Darwin Reid Paune, *Materials and Craft of the Scenic
Model*. Carbondale, Ill.: Southern Illinois University Press, 1976, illus.
58// *America Illustrated*, Soviet issue no. 149, (March 1969), p.49
illus., Poland issue no. 122, p. 49, illus. // *Joseph Cornell*. New York:
Solomon R. Guggenheim Museum, 1967, p. 46, illus.// Jack Kroll,
"Paradise Regained," *Newsweek* (June 5, 1967), p. 86, illus. // Hilton
Kramer, "The Poetic Shadow-Box World of Joseph Cornell," *The New
York Times*, May 6, 1967, P27 illus. // David Bourdon, "Imagined
Universe," *Life Magazine* (December 15, 1967), p. 52
Provenance: [Jane Wade, New York, May 1964]; ex coll.: Frederick
Weisman; [Felix Landau Gallery, Beverly Hills, Cal.]

12.2
***Cerubino: Prism Version Variant*, ca. 1960–1965**
Paper collage on masonite, 12¼ x 9⅞ in.
Signed and titled on back; inscribed on frame: "To Skip 3/11/67"
Provenance: (Sotheby's, New York, November 2, 1994, lot 134);
[Douglas Drake Gallery, New York]; (Sotheby's, New York, November
9–10, 1983, lot 98); [Barbara Mathes Gallery, New York]; ex coll.:
private collection, Boston

12.3
Untitled [Hotel du Nord], 1972
Heliogravure (screenprint), 21 x 16¼ in.
Signed LR: Joseph Cornell; LL 2/125
Edition: 2/125
Photo: Gavin Ashworth
Publication: *Prints for Phoenix House*. New York: Brooke Alexander,
April 1973, illus. n.p.
Provenance: [Brooke Alexander, New York, March 14, 1983]

13.1
Le Coif, 1917
Pencil on paper, 8½ x 5 in.
Signed LC: José de Creeft
Photo: Gavin Ashworth
Exhibition: *José de Creeft 1917–1940*, Childs, New York, October
1989
Publication: *José de Creeft 1917–1940*. New York: Childs, 1989, p.
11, illus.
Provenance: [Childs Gallery, New York, November 22, 1989]

12.4
**Untitled [How to Make a
Rainbow], 1972**
Screenprint, 19½ x 15½
in.
Signed LR: Joseph Cornell
LL: 4/125
Edition: 4/125
Publication: *Prints for
Phoenix House*. New York:
Brooke Alexander, April
1973, illus. n.p.
Provenance: [Brooke
Alexander, New York,
March 14, 1983]

14 JOSÉ RUIZ DE RIVERA
(American, 1904–1985)

14.1
Untitled Study, ca. 1930
Pastel drawing, 17 x 17 in.
Photo: Gavin Ashworth
Provenance: [Richard Gray Gallery, Chicago, October 2, 1991]

14.2
Untitled Study, ca. 1930
Pastel on paper collage, 17³/₈ x 17¹/₂ in.
Photo: Gavin Ashworth
Provenance: [Richard Gray Gallery, Chicago, October 2, 1991]

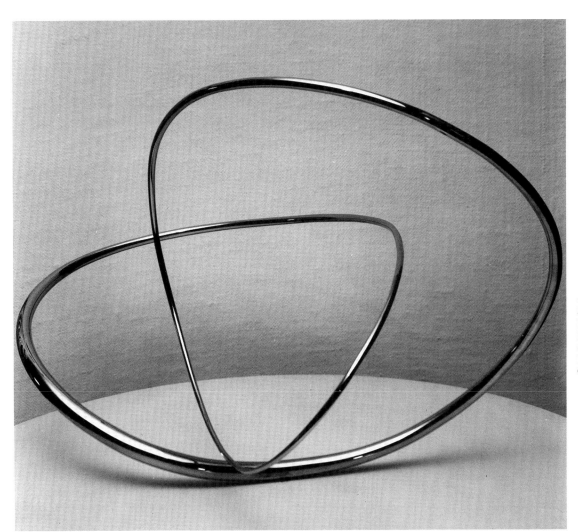

14.3
Construction #46, **1957**
Stainless steel, 14¹/₂ x 22¹/₂ in.
Exhibition: *José de Rivera,* Grace
Borgenicht, New York, November
8–December 14, 1957
Provenance: [Grace Borgenicht
Gallery, New York, June 10, 1958]

15 MARK DI SUVERO
(American, b. China 1933)

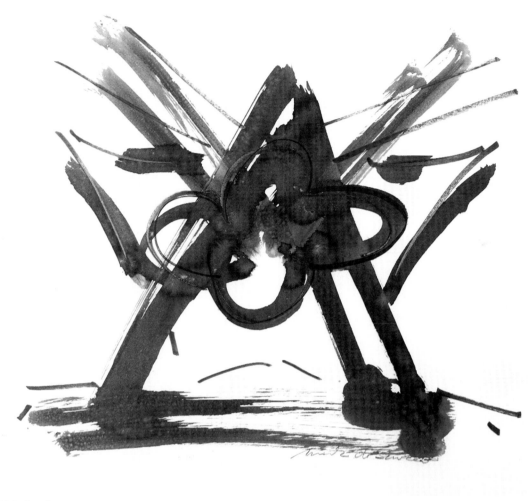

15.1a (recto)
***Studies for Isis: A Pair of Drawings,* probably before 1977–78**
Ink wash and brush on paper, 19 x 24 in.
Signed: LC: Mark di Suvero

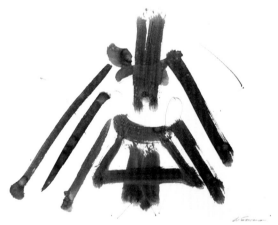

15.1b (verso)
***Studies for Isis: A Pair of Drawings,* probably before 1977–78**
Ink wash and brush on paper, 19 x 24 in.
Signed: LR: di Suvero
Provenance: (Sotheby's, New York, October 6, 1987, lot 239)

16 JEAN DUBUFFET
(French, 1901–1985)

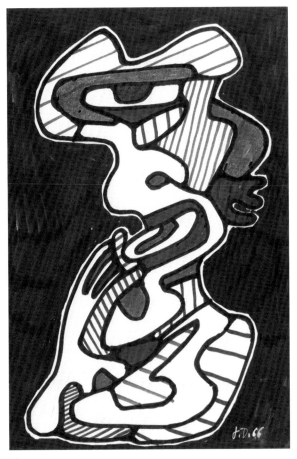

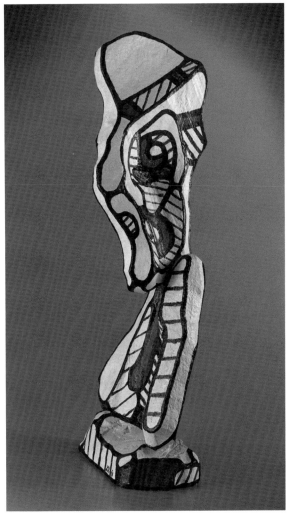

16.1
Le Convive (The Guest), 1966
Colored felt-tipped pens on paper, 9³/₄ x 6¹/₂ in.
Initialed and dated LR: J.D. 66
Exhibition: *Jean Dubuffet*. Galeries Nationales du Grand Palais, Paris,
September 28–December 20, 1973 // *Jean Dubuffet: A Retrospective*,
Solomon R. Guggenheim Museum, New York, April 26, July 29, 1973
Publication:*Jean Dubuffet*. Paris: Galeries Nationales du Grand Palais
and Weber, 1973, cat. 321b (not illus.) // Margit Rowell, *Jean Dubuf-
fet: A Retrospective*. New York: Solomon R. Guggenheim Foundation,
1973, cat. 232b // *Catalogue des travaux de Jean Dubuffet: Cartes,
Ustensiles*, vol. 22, Max Loreau, comp. Paris: Pauvert, 1972, p. 18,
fig. 21
Provenance: (Christie's, New York, October 5, 1990, lot 30); ex coll.:
Frederic Mueller; [The Pace Gallery, New York]

16.2
Buste au visage en lame de couteau II, 1968
Cast polyester resin, paint, 24¹/₄ in. H.
Initialed and dated: J.D. '68
Photo: Gavin Ashworth
Publication: *Catalogue des travaux de Jean Dubuffet*, vol. 24, Max
Loreau, comp. Paris: J. J. Pauvert, 1974, p. 40, illus. no. 30
Provenance: [Sotheby Parke Bernet, New York, November 10, 1979];
[The Pace Gallery, New York]

17 HERBERT FERBER
(American, 1906–1991)

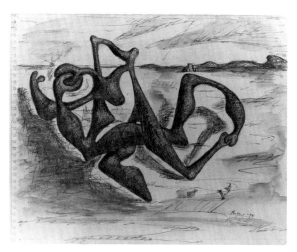

17.1
Study for "Act of Agression" (Number 5), 1946
Ink and wash, 11 x 13³/₄ in.
Signed and dated LR: Ferber 46
Photo: Gavin Ashworth
Exhibition: *Herbert Ferber Retrospective Exhibition*, Whitney Museum
of American Art, New York, April 3–May 19, 1963
Provenance: Whitney Museum of American Art, New York, April 29,
1963

18 ELISABETH FRINK
(British, b. 1930)

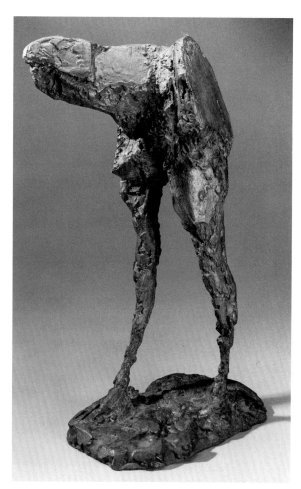

18.1
Harbinger Bird III, 1960
Bronze, 18 x 7¹/₂ x 12 in.
Edition: 4/9
Photo: Gavin Ashworth
Exhibition: *Elisabeth Frink*, Bertha Schaefer Gallery, New York, October 30–November 18, 1961
Publication: *Elisabeth Frink*. New York: Bertha Schaefer Gallery, 1961,
(checklist) illus. n.p.
Provenance: [Bertha Schaefer Gallery, New York, August 8, 1962]

19 NAUM GABO
(American, b. Russia, 1890–1977)

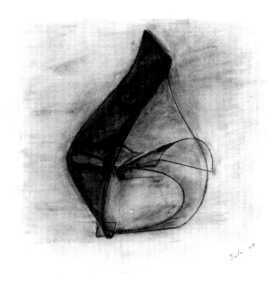

19.1
Esquisse, 1940
Charcoal and colored crayon on paper, 16⅛ x 18¾ in.
Signed and dated LR: Gabo 40
Exhibition: *Naum Gabo Retrospective*, The Dallas Museum of Art, September 29–November 17, 1985. Traveled to Art Gallery of Ontario, Toronto; Solomon R. Guggenheim Museum, New York; Akademie der Kunste, West Berlin; Kunstsammlung Nordrheim-Westfalen, Dusseldorf; The Tate Gallery, London // *Naum Gabo: The Constructive Process*, The Tate Gallery, London, November 3–December 12, 1976 // *Naum Gabo*. Exhibition traveled from 1970–1972 to Louisiana Museum, Humlebaek; Nasjonal Galeriet, Oslo; National Galerie, Berlin; Kunstverein, Hanover; Musée de Peinture et de Sculpture, Grenoble; Gulbenkian Foundation, Lisbon; Musée National d'Art Moderne, Paris
Publication: Steven Nash, Jorn Merkert, Christina Lodder, *Naum Gabo: Sixty Years of Constructivism*. Munchen: Prestel, 1986, p. 179, no. 121, illus. // *Naum Gabo*. Grenoble, France: Musée de Peinture et de Sculpture, 1972, no. 32.
Provenance: (Sotheby's, London, March 25, 1992, lot 163); [Annely Juda Fine Art, London]; family of the artist, Humlebaek

19.2
Linear Construction in Space Number 2, 1961
Perspex and nylon monofilament on a Perspex base, 32¼ x 16¼ x 16⅛ in.
Signed and dated on top at intersection of planes: Gabo, 1961 and N.G. on edge of base
Photo: Gavin Ashworth
Exhibition: *Naum Gabo*. Exhibition traveled from 1970–1972 to Louisiana Museum, Humlebaek; Nasjonal Galeriet, Oslo; National Galerie, Berlin; Kunstverein, Hannover; Musée de Peinture et de Sculpture, Grenoble; Gulbenkian Foundation, Lisbon; Musée National d'Art Moderne, Paris
Publication: *Naum Gabo: Sixty Years of Constructivism*. Munchen: Prestel, 1985, p. 237, cat. 55.1 9 (contains catalogue raisonné of the constructions and sculptures, comp. Colin Sanderson) // Hannover: Kunstverein, 1971, figs. p. 73, 35 detail // Humlebaek, Denmark: Louisiana Museum, 1971, no. 12, fig. 2 // *Louisiana Revy*, no. 11, (November 1970)
Provenance: (Sotheby's, New York, November 8, 1993, lot 327); ex coll.: private collection, England (ca. 1970); Bo Boustedt, Sweden (1968)

19.3
Untitled, n.d.
Woodcut in brown ink, 11 x 7⅞ in.
Signed LR: Gabo; Inscribed LL: N12 op3
Provenance: from the artist 1962

20 ALBERTO GIACOMETTI
(Swiss, 1901–1966)

20.1
Four Figures Seated, 1951
Pencil on paper, 15¼ x 22 in.
Signed and dated LR: Alberto Giacometti 1951
Photo: Gavin Ashworth
Exhibition: *New Dimensions in Drawing // Giacometti Retrospective*,
The Tate Gallery, London, July 13–August 30, 1965. Traveled to
Louisiana Museum, Humlebaek, Denmark // Pierre Matisse Gallery,
New York, March 1964
Publication: *Giacometti Retrospective*, introduction by David Sylvester.
London: The Tate Gallery, 1965. // Catalogue text by James Lord.
New York: Pierre Matisse Gallery, 1964, cat. 17, illus.
Provenance: [Pierre Matisse Gallery, New York, March 25, 1965)

20.2
Heads, 1962
Black and brown ink on paper, 7½ x 3¾ in.
Exhibition: *New Dimensions in Drawing*
Provenance: [Galleria Odyssia, New York, December 20, 1969]; ex
coll.: James Lord

21 JULIO GONZÁLEZ
(Spanish, 1876–1942)

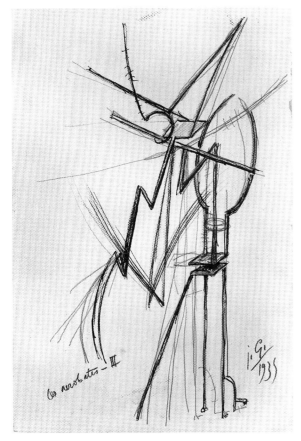

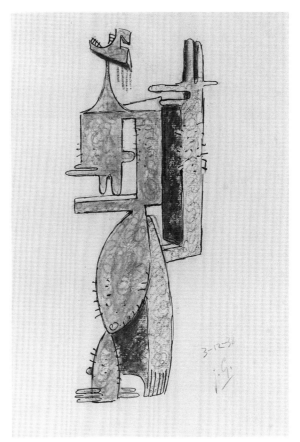

21.1
Les Acrobats III, 1935
Ink and pastel on gray paper, 10¹/₂ x 7 in.
Initialed LR: J.G./1935; titled LL: Les Acrobats III
Exhibition: *Julio González 1876–1942: Plastiken, Zeichnungen, Kunstgewerbe*, Solomon R. Guggenheim, New York, March 11–May 8, 1983. Traveled to Stadtische Galerie im Stadelsches Kunstinstitut, Frankfort am Main; Akademie der Kunste, Berlin
Publication: *Julio González 1876–1942: Plastiken, Zeichnungen, Kunstgewerbe*. Berlin: Akademie der Kunste, 1983, cat. 215, p. 132
Provenance: [Hirschl & Adler Galleries, New York, February 29, 1988]; ex coll.: Jeffrey Hoffeld & Company, New York; estate of the artist

21.2
Study for "Cactus Man 1," 1938
Crayon and ink on paper, 12 x 7⁷/₈ in.
Initialed and dated LR: 3–12–38 J.G.
Photo: Gavin Ashworth
Publication: Josephine Withers, *Julio González: Sculpture in Iron*. New York: New York University Press, 1977, p. 89, fig. 112
Provenance: [Galerie Chalette, New York, October 28, 1961]

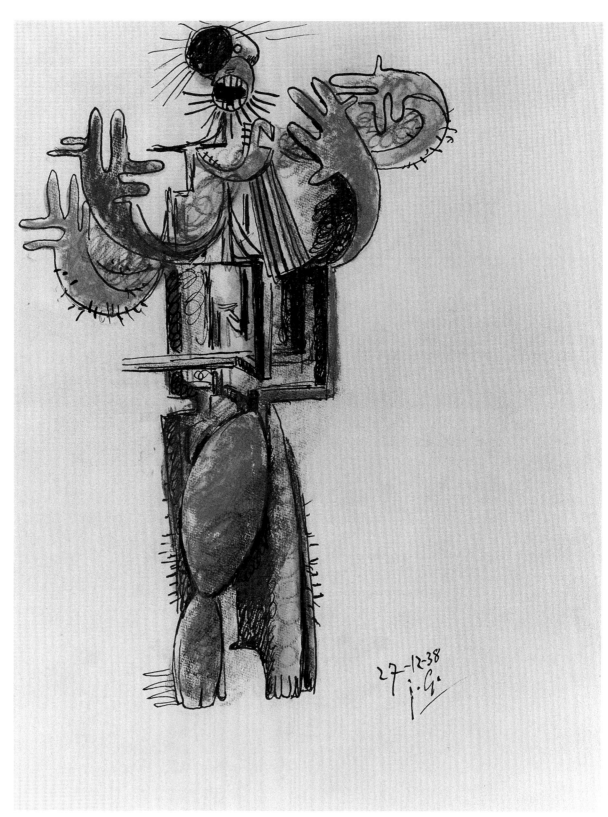

21.3
Drawing for Sculpture 1938, 1938
Crayon and ink on gray paper, 12⁷/₈ x 10 in.
Initialed and dated LR: 27–12–38 J.G.
Publication: Josette Gilbert, *Julio González: Dessins,* vol. 9, *Projects pour sculptures: Personnages.* Paris: Carmen Martinez, 1975, p. 79
Provenance: [Galerie Chalette, New York, October 28, 1961]

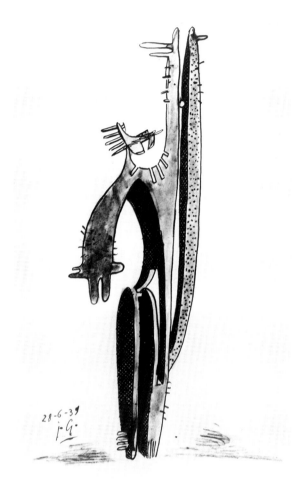

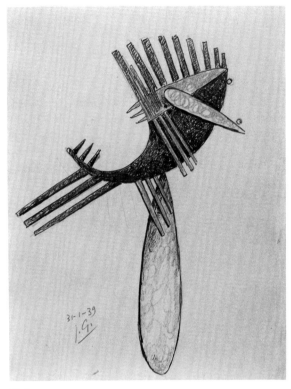

21.4
Homme cactus bras levé, 1939
Ink and wash on paper, 12^1/$_8$ x 7^7/$_8$ in.
Initialed and dated LL: 28–6–39 J.G.
Exhibition: *Westkunst,* Museen der Stadt, Koln, May 30–August 16, 1981
Publication: Laszlo Glozer, *Westkunst,* Koln: Museen der Stadt, 1981, p. 359, cat. 148 // Josette Gilbert, *Julio González: Dessins,* vol. 9, *Projects pour sculptures: Personnages.* Paris: Carmen Martinez, 1975, p. 87
Provenance: [The Pace Gallery, New York, November 9, 1981]; estate of the artist

21.5
Project for Sculpture, 1939
Crayon and ink on gray paper, 12^3/$_4$ x 9^7/$_8$ in.
Initialed and dated LR: 31–1–39 J.G.
Photo: Gavin Ashworth
Exhibition: *Julio González,* Galerie Chalette, New York, October 16–November 28, 1961. Traveled to San Francisco Museum of Art; Cleveland Museum of Art; Munsen-Williams-Proctor Institute, Utica, NY; Albright-Knox Gallery, Buffalo, NY; Montreal Museum of Fine Arts; National Gallery of Canada, Ottawa
Publication: Josette Gilbert, *Julio González: Dessins,* vol. 2, *Scènes paysannes.* Paris: Carmen Martinez, 1975, p. 342 // Hilton Kramer, *Julio González.* New York: Galerie Chalette, 1961, p. 47, no. 82, color illus.
Provenance: [Galerie Chalette, New York, October 28, 1961]

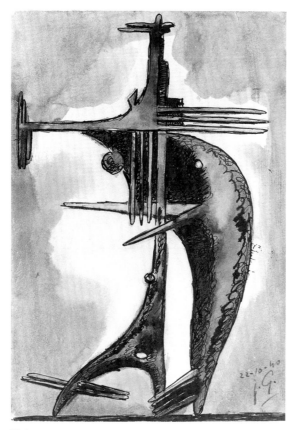

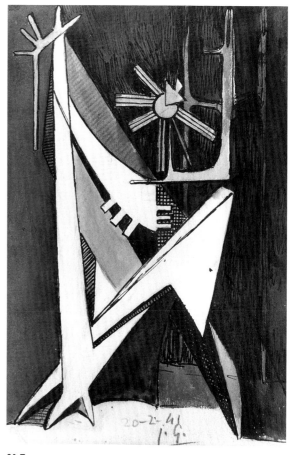

21.6
Personnage dit "Le Requin," 1940
India ink and gray wash over pencil and traces of black crayon on paper, 10¼ x 7¼ in.
Initialed and dated LR: 22–10–40 J.G.
Photo: Gavin Ashworth
Exhibition: *Julio González: The Materials of His Expression*, Saidenberg Gallery, New York, March 14–May 1, 1969. Traveled to Galerie de Montreal; Dunkelman Gallery, Toronto; Gimpel and Hanover Galerie, Zurich
Publication: Josette Gilbert, *Julio González: Dessins*, vol. 9, *Projects pour sculptures: Personnages*. Paris: Carmen Martinez, 1975, p. 117, illus. // *Julio González: The Materials of His Expression*, New York: Saidenberg Gallery, 1969, cat. 24
Provenance: (Sotheby's, New York, May 12, 1994)

21.7
Personnage terrible, 1941
Watercolor, black ink, and gouache on paper, 10½ x 7½ in.
Initialed and dated LC: 20–2–41 J.G.
Publication: Josette Gilbert, *Julio González: Dessins*, vol. 9, *Projects pour sculptures: Personnages*. Paris: Carmen Martinez, 1975, p. 133
Provenance: [Hirschl & Adler Galleries, New York, February 29, 1988]; private collection, New York

22 SIDNEY GORDIN
(b. Russia 1918, worked in U.S. since 1937)

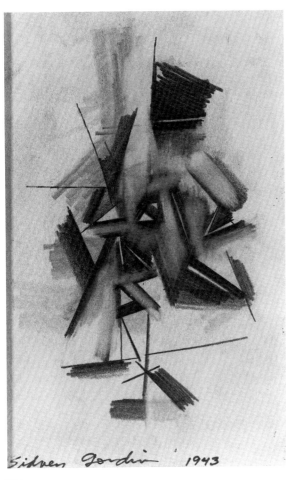

22.1
#281, 1943
Pencil on paper, 5⅝ x 3⅝ in.
Signed and dated in ink along bottom edge: Sidney Gordin 1943
Photo: Gavin Ashworth
Provenance: [Gallery Paule Anglim, San Francisco, December, 1992]

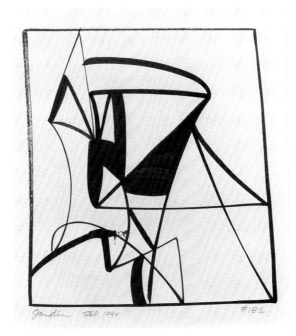

22.2
#182, 1944
Ink on paper, 8½ x 7¾ in.
Signed, dated, and inscribed in pencil LL: Gordin Sep. 1944; LR: #182
Photo: Gavin Ashworth
Provenance: [Gallery Paule Anglim, San Francisco, December, 1992]

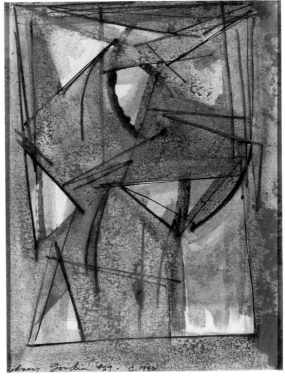

22.3
#29, ca. 1946
Watercolor and ink on paper, 11 x 8½ in.
Signed, dated, inscribed in ink along bottom edge at left: Sidney
Gordin #29 -c. 1946
Photo: Gavin Ashworth
Provenance: [Gallery Paule Anglim, San Francisco, December, 1992]

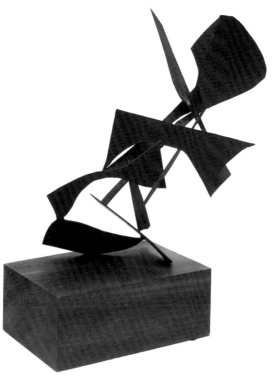

22.4
Construction #2—1956, 1956
Steel painted black, 8 x 7 x 5 in.
Photo: John A. Ferrari
Provenance: [Grace Borgenicht Gallery, New York, February, 1, 1960]

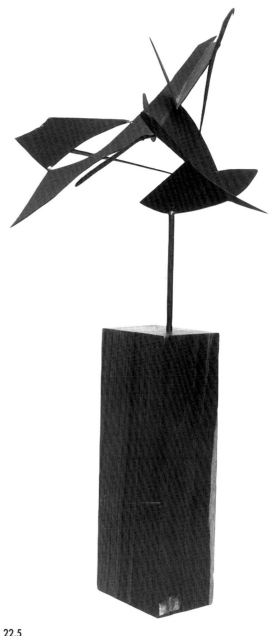

22.5
Construction #3, 1956
Steel painted black, 6 x 7 x 4 in.
Photo: John A. Ferrari
Provenance: [Grace Borgenicht Gallery, New York, February, 1, 1960]

23 DIMITRI HADZI

(American, b. 1921)

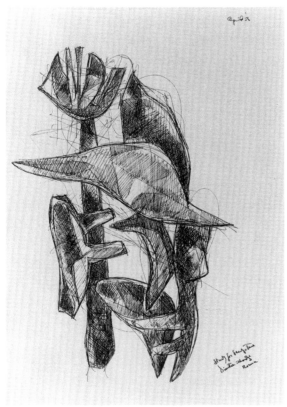

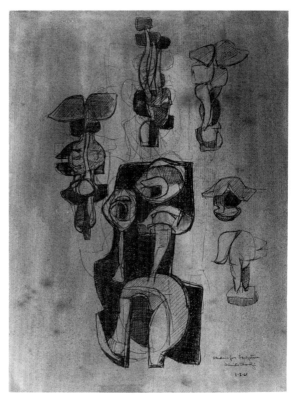

23.1
Study for Sculpture, 1958
Pen and ink on paper, 12 x 9¼ in.
Signed and titled LR: Study for sculpture Dimitri Hadzi Roma; dated
UR: April '58;
Photo: Gavin Ashworth
Provenance: [Stephen Radich Gallery, New York, November 10, 1962]

23.2
Studies for Sculpture, 1961
Ink and watercolor on paper, 11½ x 8¾ in.
Signed and dated LR: Studies for Sculpture Dimitri Hadzi 1–1–61
Provenance: [Stephen Radich Gallery, New York, November 10, 1962]

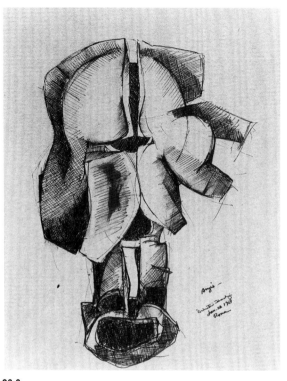

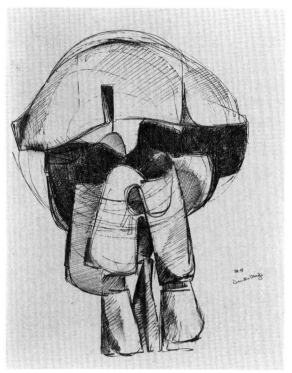

23.3
Sculpture Studies I, 1963
Pen and ink on paper, 10³/₄ x 8¹/₂ in.
Inscribed, signed, and dated LR: Angio-Dimitri Hadzi Jan. 22 1963
Roma
Photo: John A. Ferrari
Provenance: [Stephen Radich Gallery, New York, May 9, 1966]

23.4
Sculpture Studies II, 1963
Pen and ink on paper, 10³/₄ x 8¹/₂ in.
Signed and dated LR: III–63 Dimitri Hadzi
Photo: John A. Ferrari
Provenance: [Stephen Radich Gallery, New York, May 9, 1966]

24 RAOUL HAGUE
(American, b. Turkey, 1905–1993)

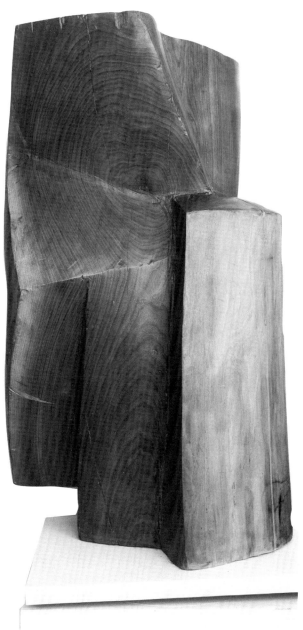

24.1
Echo Notch Walnut, **1958**
Walnut, 46 x 26 x 22 in.
Photo: John A. Ferrari
Exhibition: *Raoul Hague: Sculpture,* The Washington Gallery of
Modern Art, Washington, D.C.: September 21–November 11, 1964
// *Continuity and Change,* Wadsworth Athenaeum, Hartford,
Conn., April 12–May 27, 1962
Publication: *Raoul Hague: Sculpture.* Washington, D.C.: The Wash-
ington Gallery of Modern Art, 1964, cat. 19// *Continuity and
Change.* Hartford, Conn.: Wadsworth Athenaeum, 1962, p. 18, cat.
45 illus. // Daniel Robbins, "Continuity and Change at Hartford,"
Art International 6, no. 8 (October 25, 1962), p. 65, illus.
Provenance: from the artist, December 1962

25 BARBARA HEPWORTH
(British, 1903–1975)

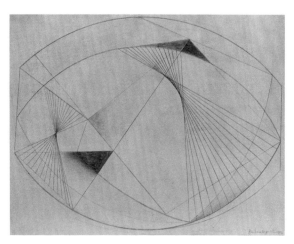

25.1
Drawing for Stone Sculpture, 1942
Gouache, watercolor, and pencil on board, 9 1/8 x 11 3/4 in.
Signed and dated LR: Barbara Hepworth 1942
Photo: Gavin Ashworth
Exhibition: *Retrospective Barbara Hepworth and Paul Nash*, Temple Newsam, Leeds, 1943
Publication: *Retrospective Barbara Hepworth and Paul Nash*. Leeds: Temple Newsam, 1943, no. 118
Provenance: (Sotheby's, London, October 17, 1990, lot 108); ex coll.: private collection; Ernest Musgrave, Leeds

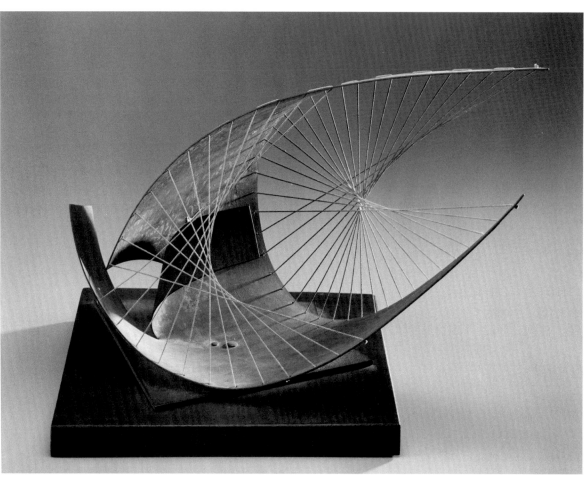

25.2
Stringed Figure (Curlew II), 1957
Brass, string, 10 x 13 in.
Edition of 9
Photo: Gavin Ashworth
Provenance: [Gimple Fils, London, June 2, 1961]

26 RUDOLF HOFLEHNER
(Austrian, b. 1916)

27 GABRIEL KOHN
(American, 1910–1975)

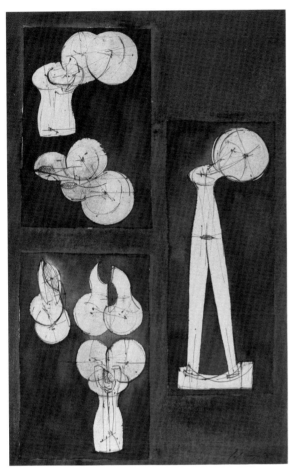

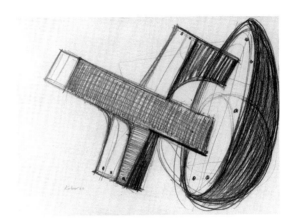

27.1
***Drawing for Sculpture*, 1962**
Pencil on paper, 10¾ x 15 in.
Signed and dated in blue ink LL: Kohn 62
Photo: André Grossmann
Provenance: [Otto Gerson Gallery, New York, November 17, 1962]

26.1
***Venus von Krieau*, 1964**
Ink and watercolor on paper, 17¾ x 12 in.
Signed and dated LR: Hoflehner 64
Photo: Gavin Ashworth
Provenance: [Galleria Odyssia, New York, December 1, 1965]

28 GASTON LACHAISE
(American, b. France, 1882–1935)

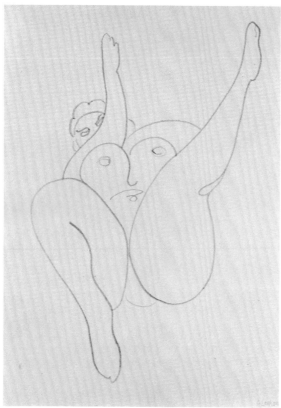

28.1
Nude, ca. 1929–31
Pencil on paper, 16½ x 11½ in.
Signed LR: GLachaise
Photo: Gavin Ashworth
Provenance: [Zabriskie Gallery, New York, March 3, 1992

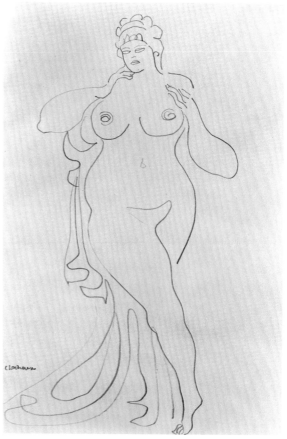

28.2
Woman with Drapery, ca. 1929–1931
Pencil on paper, 17¾ x 12⅛ in.
Signed LL: GLachaise
Exhibition: *Made in New York State: Drawings and Watercolors from The Museum of Modern Art,* State Fair, Syracuse, New York, 1959–60. Traveled to State University Teachers College, Oneonta, N.Y.; State University Teachers College, Brockport, N.Y.; Memorial Art Museum, University of Rochester, N.Y.; Skidmore College, Saratoga Springs, N.Y.; Robinson Memorial Center, Binghamton, N.Y.; Arnot Art Gallery, Elmira, N.Y.; Schenectady Museum Association, N.Y.; State University of New York, Albany; and Wells College, Aurora, N.Y. // *From Sketch to Sculpture,* Vassar College, Poughkeepsie, N.Y., 1953–1954. Traveled to State Teachers College, Lock Haven, Penn.; Skidmore College, Saratoga Springs, N.Y.; J. B. Speed Art Museum, Louisville, Ken.; University of Miami, Coral Gables, Fla.; Wesleyan University, Middletown, Conn.; Williams College, Williamstown, Mass.; Newcomb College, Tulane University, New Orleans; Phillips Exeter Academy, New Hampshire; and Andrew Dickson White Museum of Art, Cornell University, Ithaca, N.Y. // *Drawings from The Collection of The Museum of Modern Art,* Vassar College, Poughkeepsie, N.Y., 1947–48. Traveled to Institute of Modern Art, Boston; Minneapolis Institute of Arts; Grand Rapids Art Gallery, Mich.; and University of Minnesota Art Gallery, Minneapolis.
Publication: *Drawings from The Collection of The Museum of Modern Art.* Poughkeepsie, N.Y.: Vassar College, 1947–48, checklist no. 94.
Provenance: [Hirschl & Adler Galleries, New York, December 13, 1989]; The Museum of Modern Art, New York; ex coll.: Lincoln Kirstein, New York

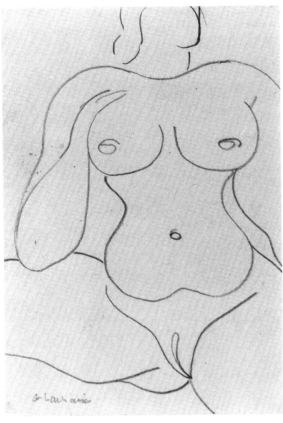

28.3
Female Nude, n.d.
Pencil on paper, 9 3/8 x 6 3/4 in.
Signed LL: G. Lachaise
Photo: Gavin Ashworth
Provenance: (Sotheby's, New York, February 17, 1988, lot 21)

28.4
Female Nude with Raised Arms, n.d.
Pencil on paper, 9 3/8 x 6 3/8 in.
Unsigned
Provenance: (Sotheby's, New York, February 17, 1988, lot 21)

28.7
Untitled, n.d.
Pencil on paper, 9 3/8 x 6 3/8 in.
Signed LR: G Lachaise
Provenance: [E. Weyhe, New York]

28.5
Seated Female Nude (No. 15), n.d.
Pencil on paper, 18 x 11 7/8 in.
Signed LL: GLachaise
Provenance: [Zabriskie Gallery, New York, November 29, 1983]

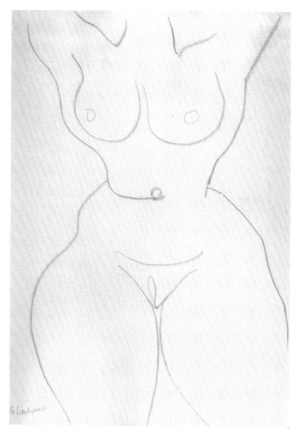

28.6
Standing Woman, n.d.
Pencil on paper, 10 x 6 3/4 in.
Signed LL: G Lachaise
Exhibition: *Gaston Lachaise: Sculpture and Drawings*, Los Angeles County Museum of Art, December 3, 1963–January 19, 1964. Traveled to Whitney Museum of American Art, New York
Provenance: [E. Weyhe, New York, December 15, 1962]

28.8
Untitled, n.d.
Pencil on paper, 9 x 11 7/8 in.
Signed LL: G Lachaise
Provenance: [E. Weyhe, New York]

29 LANNY LASKY
(American, b. 1927)

30 IBRAM LASSAW
(American, b. Egypt 1913)

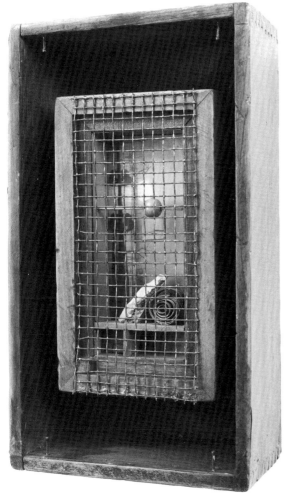

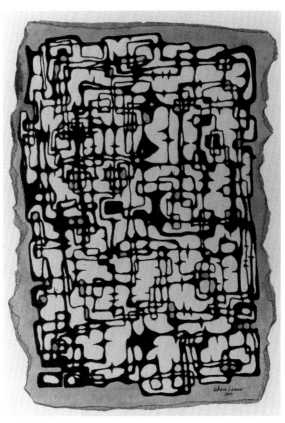

30.1
The Sculptor Explores, 1950
Ink on paper, 14 3/8 x 10 1/8 in.
Signed and dated LR: Ibram Lassaw 1950
Photo: Gavin Ashworth
Exhibition: The Museum of Modern Art , New York // Carnegie Mellon University
Publication: Charlotte Willard, "Drawing Today," *Art in America* 52 (October 1964), p. 55, illus.
Provenance: [Far Gallery, New York, November 6, 1964]

29.1
Parrot Perch, 1984
Wood, wire, wire screening, turquoise, bead, paper collage, 10 1/2 x 6 x 3 3/8 in.
Signed on back: Lanny Lasky
Photo: Ellen Page Wilson
Provenance: from the artist May 1990

31 JACQUES LIPCHITZ
(French, b. Lithuania, 1891–1973)

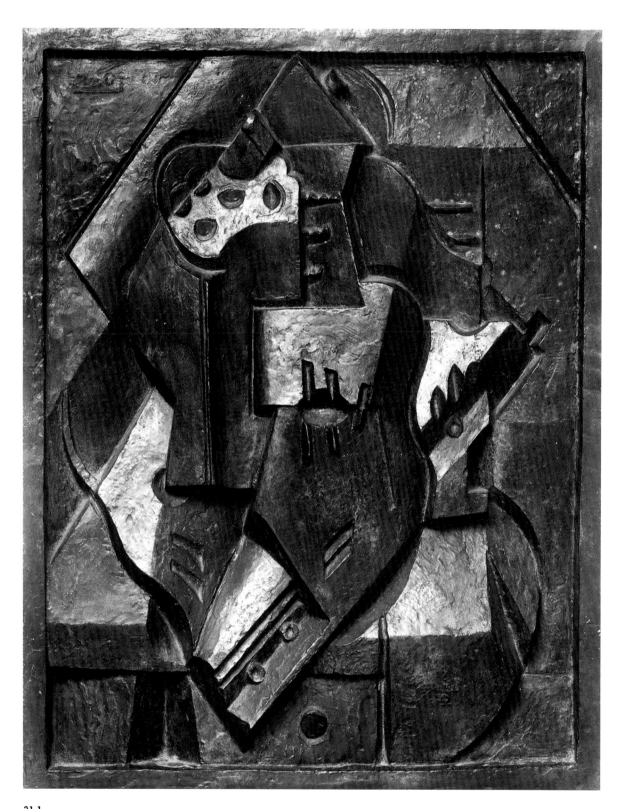

31.1
***Nature morte** (Still-life)*, **1918**
Bronze bas-relief, 27¼ x 21¾ x 3¼ in.
Inscribed UL: Lipchitz; R: Perduecire C. Valsua III, 1918 1/7
Edition: 1/7
Photo: John A. Ferrari
Exhibition: *Lawyers Collect*, The Association of the Bar of the City of New York, January 13–30, 1965 //
Jacques Lipchitz, Musée National d'Art Moderne, Paris, May 20–June 28, 1959
Publication: *Jacques Lipchitz*. Paris: Musée National d'Art Moderne, 1959, cat. 24, illus. n.p.
Provenance: [Fine Arts Associates, New York, November 17,1959]

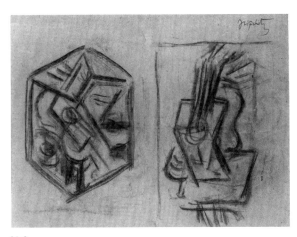

31.2
Etudes pour un relief, 1922
Charcoal on tan paper, 9³/₄ x 13 in.
Signed UR corner: JLipchitz
Photo: Gavin Ashworth
Provenance: (Christie's East, New York, November 2, 1993, lot 151)
[Marlborough-Gerson Gallery, New York]

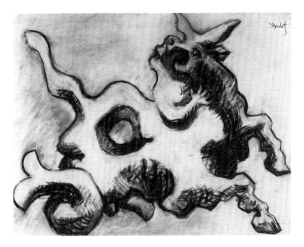

31.3
Study for "Rape of Europa," 1938
Charcoal on paper, 19 x 25 in.
Signed in ink UR: JLipchitz
Photo: John A. Ferrari
Provenance: [Otto Gerson Gallery, New York, October 28, 1961]

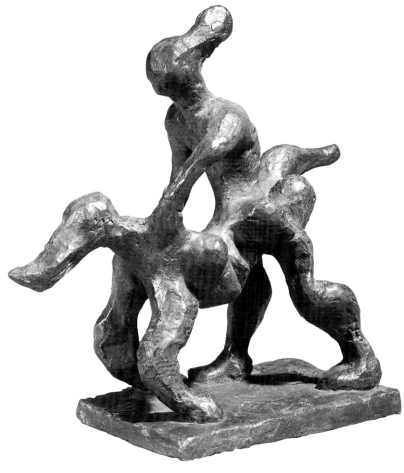

31.4
Study for "The Rescue," ca. 1943–1944
Bronze, 6¹/₂ x 6 in.
Initialed in the wax J.L. and fingerprinted
Provenance: (Parke-Bernet Galleries, New York, April 5, 1967, Sale # 2539, lot 91); Lynonel Feininger; [Curt Valentin Gallery]

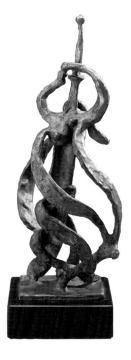

31.5
Danseuse á la voilette, n.d.
Bronze with gold patina, 9¹/₈ in. H.
Initialed and marked with thumbprint on the top of the base: JL
Photo: Gavin Ashworth
Provenance: (Christie's, January 31, 1995, lot 96); ex coll.: Mrs. Blanchette H. Rockefeller; G. D. Thompson; [Curt Valentin Gallery, New York]

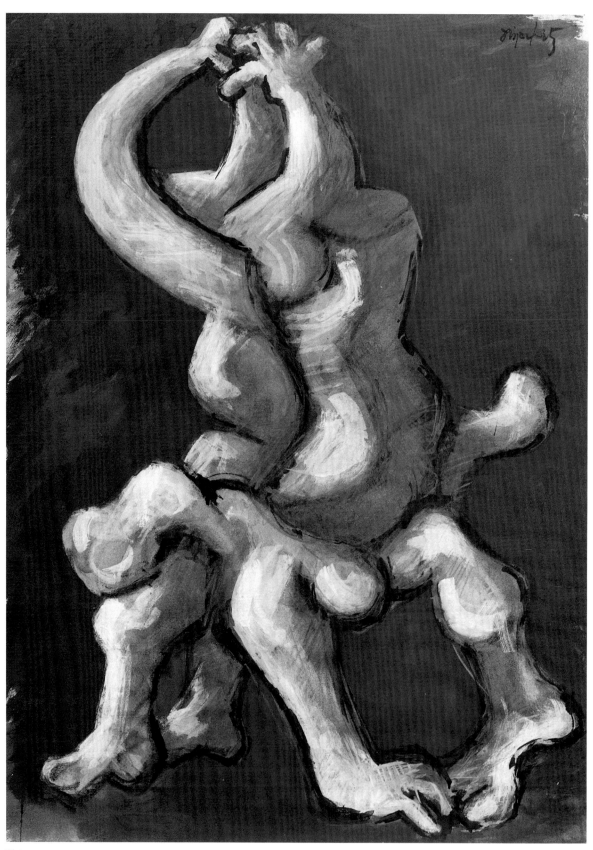

31.6
The Rescue II, n.d.
Gouache, pastel, and India ink on bluish-gray paper, 24³/₄ x 18⁷/₈ in.
Signed UR: JLipchitz
Photo: Gavin Ashworth, Provenance: (Sotheby's, New York, May 12, 1994, lot 425); ex coll.:
Mr. and Mrs. Vincent Prince, Los Angeles; [Buchholz Gallery (Curt Valentin), New York]

32 SEYMOUR LIPTON
(American, 1903–1986)

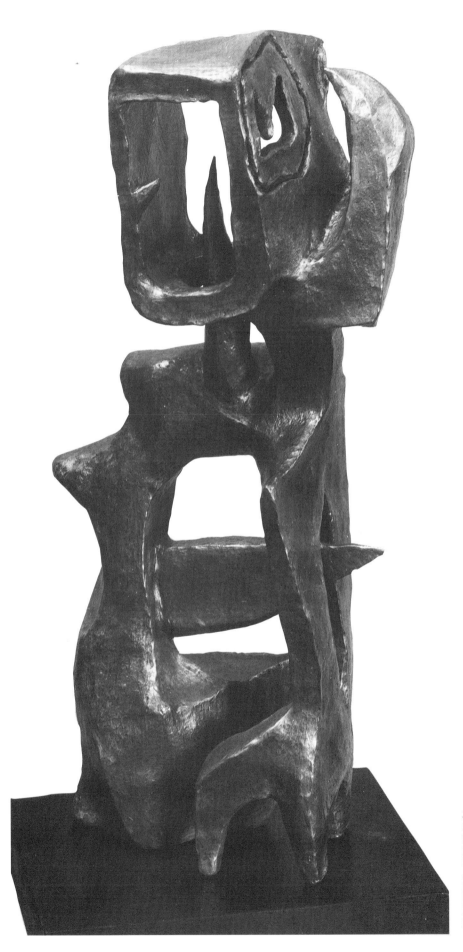

32.0 (not in exhibition)
Cerberus, **1947**
Hammered lead over plaster, 23 in. H.
Photo: Gavin Ashworth
Publication: Andrew Carnduff Ritchie,
Sculpture of the Twentieth Century,
New York: The Museum of Modern Art,
[1952], p. 224, illus.
Provenance: [Betty Parsons Gallery,
New York, August 28, 1963]

32.1
Study for "Cloak," 1951
Crayon on paper, 11 x 8¹/₂ in.
Signed LR: Lipton '51
Photo: Gavin Ashworth
Publication: Elsen, fig. 18
Provenance: from the artist 1963

32.3
Study for "Thunderbird," 1951
Crayon on paper, 8¹/₂ x 11 in.
Signed LR: Lipton '51
Photo: Gavin Ashworth
Exhibition: UW–Milwaukee
Publication: UW–Milwaukee, cat. 26
Provenance: from the artist 1963

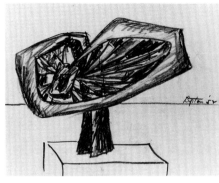

32.5
Study for "Sea Gnome," 1952
Crayon on paper, 8¹/₂ x 11 in.
Signed LR: Lipton '52
Photo: Gavin Ashworth
Exhibition: UW–Milwaukee
Publication: Elsen, fig. 5 // UW–Milwaukee, cat. 24
Provenance: from the artist 1963

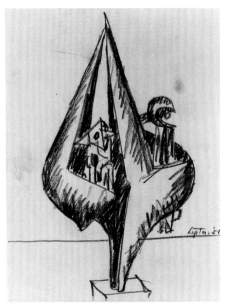

32.2
Study for "Mephisto," 1951
Crayon on paper, 11 x 8¹/₂ in.
Signed LR: Lipton '51
Photo: Gavin Ashworth
Exhibition: UW–Milwaukee
Publication: UW–Milwaukee, cat. 28
Provenance: from the artist 1963

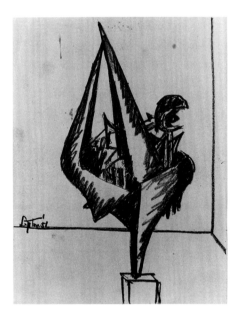

32.4
Study for "Mephisto," 1951
Crayon on paper, 11 x 8¹/₂ in.
Signed LL: Lipton '51
Photo: Gavin Ashworth
Provenance: from the artist 1963

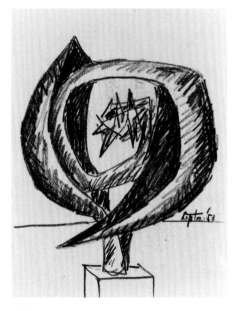

32.6
Study for "Sanctuary," 1953
Crayon on paper, 11 x 8¹/₂ in.
Signed LR: Lipton '53
Photo: Gavin Ashworth
Publication: Elsen, fig. 38
Provenance: from the artist 1963

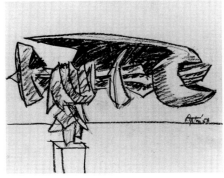

32.7
Study for "Storm Bird," 1953
Crayon on paper, 8¹/₂ x 11 in.
Signed LR: Lipton '53
Photo: Gavin Ashworth
Provenance: from the artist 1963

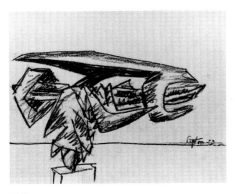

32.8
Study for "Storm Bird," 1953
Crayon on paper, 8¹/₂ x 11 in.
Signed LR: Lipton 53
Photo: Gavin Ashworth
Provenance: from the artist 1963

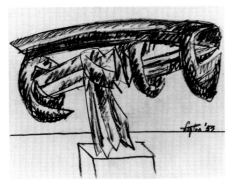

32.9
Study for "Storm Bird," 1953
Crayon on paper, 8¹/₂ x 11 in.
Signed LR: Lipton '53
Photo: Gavin Ashworth
Provenance: from the artist 1963

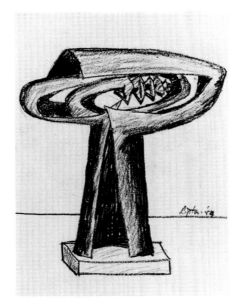

32.10
Study for "Earth Forge #2," 1954
Crayon on paper, 11 x 8¹/₂ in.
Signed LR: Lipton '54
Photo: Gavin Ashworth
Provenance: from the artist 1963

32.11
Study for "Earth Forge #2," 1954
Crayon on paper, 8¹/₂ x 11 in.
Signed LR: Lipton '54
Photo: Gavin Ashworth
Provenance: from the artist 1963

32.12
Study for "Earth Forge," 1954
Crayon on paper, 8¹/₂ x 11 in.
Signed at R: Lipton '54
Photo: Gavin Ashworth
Provenance: from the artist 1963

32.13
Study for "Earth Forge," 1954
Crayon on paper, 8¹/₂ x 11 in.
Signed LR: Lipton '54
Photo: Gavin Ashworth
Exhibition: UW–Milwaukee
Publication: UW–Milwaukee, cat. 20
Provenance: from the artist 1963

32.14
Study for "Dragon Bloom," 1956
Crayon on paper, 8¹/₂ x 11 in.
Signed LR: Lipton '56
Photo: Gavin Ashworth
Exhibition: UW–Milwaukee
Publication: UW–Milwaukee, cat. 23
Provenance: from the artist 1963

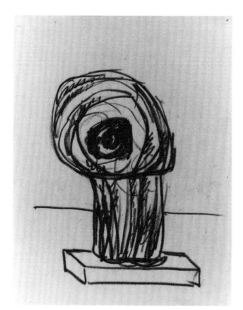

32.15
Study for "Desert Briar," n.d.
Crayon on paper, 11 x 8 in.
Photo: Gavin Ashworth
Provenance: gift of the artist

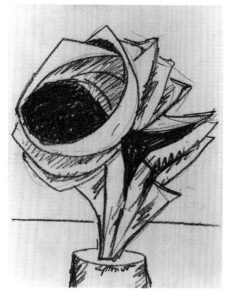

32.17
Study for "Desert Briar," n.d.
Crayon on paper, 11 x 8 in.
Photo: Gavin Ashworth
Provenance: gift of the artist
32.18

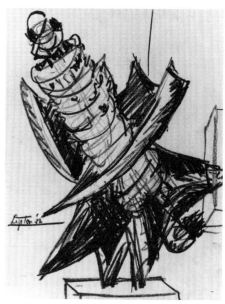

32.19
Study for "Glow Worm," 1952
Crayon on paper, 11 x 8½ in.
Signed LL: Lipton '52
Photo: Gavin Ashworth
Exhibition: UW–Milwaukee
Publication: UW–Milwaukee, cat. 9
Provenance: from the artist 1963

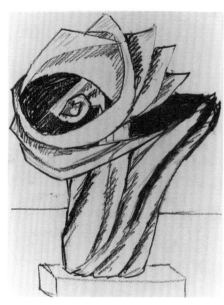

32.16
Study for "Desert Briar," 1955
Crayon on paper, 11 x 8 in.
Signed bottom center on stand: Lipton '55
Publication: Elsen, cat. 20 (printed negative)
Provenance: gift of the artist

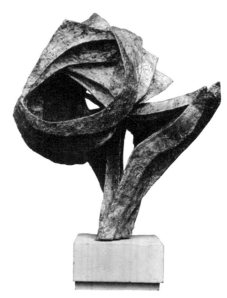

Desert Briar, 1955
Sheet steel brazed with nickel-silver, 29 in. H.
Photo: Oliver Baker Assoc.
Exhibition: *Lawyers Collect,* The Association of the Bar of the City of New York, January 13–30, 1965 // Phillips // *Nature in Abstraction,* Whitney Museum of American Art, New York, January 14–March 16, 1958. Traveled to The Phillips Gallery, Washington, D.C.; Fort Worth Art Center; Los Angeles County Museum; San Francisco Museum of Art; Walker Art Center, Minneapolis; and City Art Museum of St. Louis
Publication: John I. H. Baur, *Nature in Abstraction.* New York: The Macmillen Company for Whitney Museum of American Art, 1958, cover and p. 49 // Elsen, cat. 132 // Phillips, Drawings, cat. 5
Provenance: [Betty Parsons Gallery, New York, March 16, 1959]
32.19

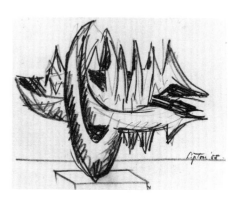

32.20
Study for "Sea King," 1955
Crayon on paper, 8½ x 11 in.
Signed LR: Lipton '55
Photo: Gavin Ashworth
Exhibition: UW–Milwaukee // Phillips
Publication: UW–Milwaukee, cat. 14 // Phillips, Drawings, cat. 9
Provenance: from the artist 1963

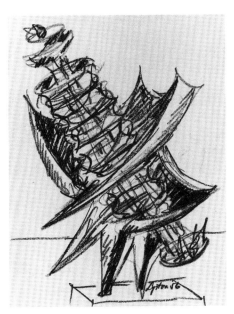

32.21
Study for "Glow Worm" (Version 1), **1956**
Crayon on paper, 11 x 8¹/₂ in.
Signed LR: Lipton '56
Photo: Gavin Ashworth
Exhibition: UW–Milwaukee // Phillips
Publication: UW–Milwaukee, cat. 10 // Phillips, Draw-ings, cat.10
Provenance: from the artist 1963

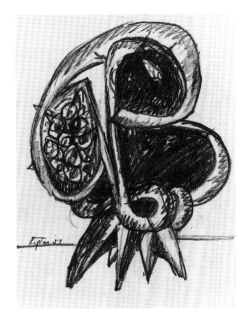

32.23
Study for "Fountainhead," **1957**
Crayon on paper, 11 x 8¹/₂ in.
Signed LL: Lipton '57
Photo: Gavin Ashworth
Exhibition: UW–Milwaukee // Phillips
Publication: UW–Milwaukee, cat. 21 // Phillips, Drawings, cat. 5 // Elsen, fig. 6
Provenance: from the artist 1963

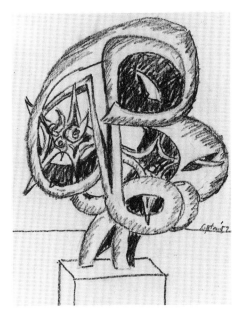

32.25
Study for "Fountainhead," **1957**
Crayon on paper, 11 x 8¹/₂ in.
Signed LR: Lipton '57
Photo: Gavin Ashworth
Provenance: from the artist 1963

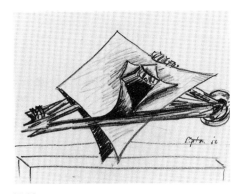

32.22
Study for "Viking," **1956**
Crayon on paper, 8¹/₂ x 11 in.
Signed LR: Lipton '56
Photo: Gavin Ashworth
Exhibition: Phillips
Publication: Elsen, fig.30 // Phillips, Drawings, cat. 4
Provenance: from the artist 1963

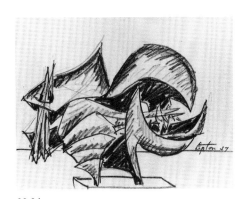

32.24
Study for "Avenger," **1957**
Crayon on paper, 8¹/₂ x 11 in.
Signed LR: Lipton 57
Photo: Gavin Ashworth
Exhibition: UW–Milwaukee // Phillips
Publication: UW–Milwaukee, cat. 12 // Phillips, Draw-ings, cat. 3
Provenance: from the artist 1963

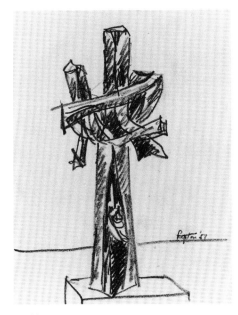

32.26
Study for "Pioneer," **1957**
Crayon on paper, 11 x 8¹/₂ in.
Signed LR: Lipton 57
Photo: Gavin Ashworth
Exhibition: UW–Milwaukee
Publication: Elsen, fig. 28 // UW–Milwaukee. cat. 27
Provenance: from the artist 1963

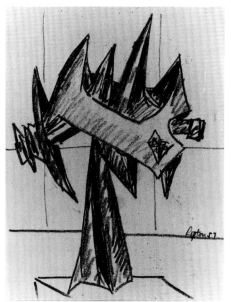

32.27
Study for "Hero," 1957
Crayon on paper, 11 x 8¹/₂ in.
Signed LR: Lipton 57
Photo: Gavin Ashworth
Exhibition: UW–Milwaukee
Publication: Elsen, title page // UW–Milwaukee, cat. 29
Provenance: from the artist 1963

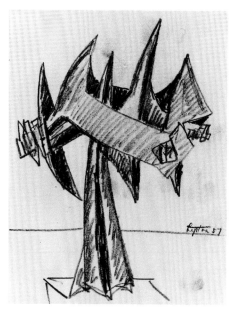

32.29
Study for "Hero," 1957
Crayon on paper, 11 x 8¹/₂ in.
Signed LR: Lipton 57
Photo: Gavin Ashworth
Provenance: from the artist 1963

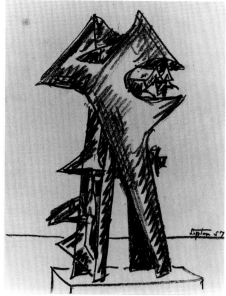

32.31
Study for "Prophet," 1957
Crayon on paper, 11 x 8¹/₂ in.
Signed LR: Lipton 57
Photo: Gavin Ashworth
Publication: Elsen, cat. 23
Provenance: from the artist 1963

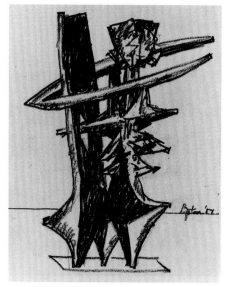

32.28
Study for "Sorcerer," 1957
Crayon on paper, 11 x 8¹/₂ in.
Signed LR: Lipton '57
Photo: Gavin Ashworth
Provenance: from the artist 1963

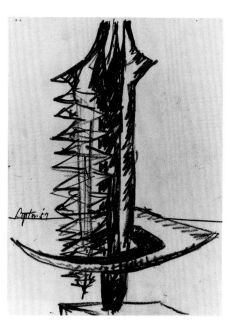

32.30
Study for "Sorcerer," 1957
Crayon on paper, 11 x 8¹/₂ in.
Signed LL: Lipton '57
Photo: Gavin Ashworth
Provenance: from the artist

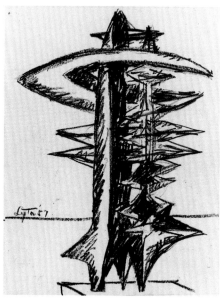

32.32
Study for "Sorcerer," 1957
Crayon on paper, 11 x 8¹/₂ in.
Signed LL: Lipton '57
Photo: Gavin Ashworth
Publication: Elsen, fig. 25
Provenance: from the artist 1963

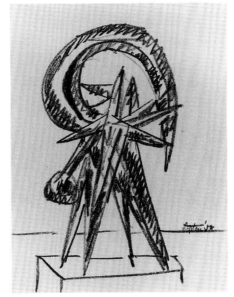

32.33
Study for "Diadem," 1957
Crayon on paper, 11 x 8¹/₂ in.
Signed LR: Lipton '57
Photo: Gavin Ashworth
Exhibition: Phillips
Publication: Philips, Drawings cat. 6
Provenance: from the artist 1963

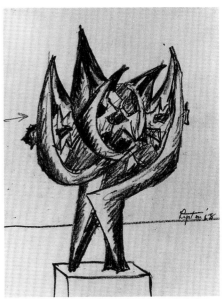

32.35
Study for "Diadem," 1958
Crayon on paper, 11 x 8¹/₂ in.
Signed LR: Lipton '58
Photo: Gavin Ashworth
Provenance: from the artist 1963

32.37
*Study for "Redwood,"*1958
Crayon on paper, 11 x 8¹/₂ in.
Signed LR: Lipton '58
Photo: Gavin Ashworth
Provenance: from the artist 1963

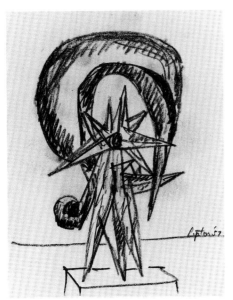

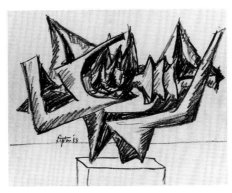

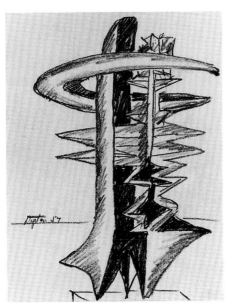

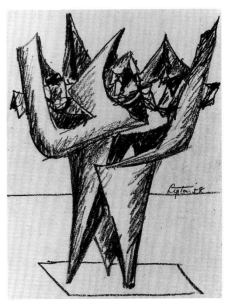

32.36
Study for "Redwood," 1958
Crayon on paper, 8¹/₂ x 11 in.
Signed LL: Lipton '58
Photo: Gavin Ashworth
Provenance: from the artist 1963

32.34
Study for "Sorcerer," 1957
Crayon on paper, 11 x 8¹/₂ in.
Signed LL: Lipton 57
Photo: Gavin Ashworth
Exhibition: UW–Milwaukee // Phillips
Publication: UW–Milwaukee cat. 15 // Phillips, Drawings, cat. 1
Provenance: from the artist 1963

32.38
Study for "Redwood," 1958
Crayon on paper, 11 x 8¹/₂ in.
Signed LR: Lipton '58
Photo: Gavin Ashworth
Exhibition: UW–Milwaukee
Publication: UW–Milwaukee, cat.31
Provenance: from the artist 1963

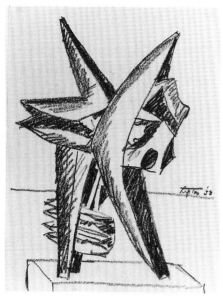

32.39
Study for "Knight," 1958
Crayon on paper, 11 x 8¹/₂ in.
Signed LR: Lipton '58
Photo: Gavin Ashworth
Exhibition: UW–Milwaukee // Phillips
Publication: UW–Milwaukee, cat. 16 // Phillips, Drawings, cat. 8
Provenance: from the artist 1963

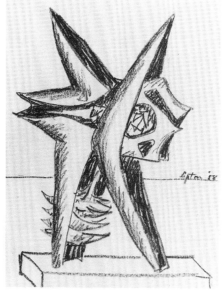

32.41
Study for "Knight," 1958
Crayon on paper, 11 x 8¹/₂ in.
Signed LR: Lipton '58
Photo: Gavin Ashworth
Provenance: from the artist 1963

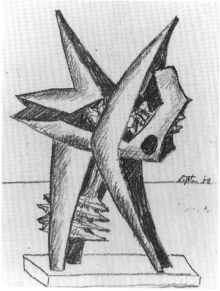

32.43
Study for "Knight," 1958
Crayon on paper, 11 x 8¹/₂ in.
Signed LR: Lipton '58
Photo: Gavin Ashworth
Provenance: from the artist 1963

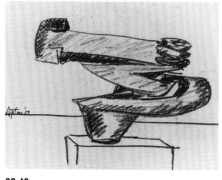

32.40
Study for "Earth Loom," 1959
Crayon on paper, 8¹/₂ x 11 in.
Signed LL: Lipton '59
Photo: Gavin Ashworth
Provenance: from the artist 1963

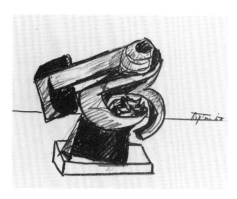

32.42
Study for "Earth Loom," 1958
Crayon on paper, 8¹/₂ x 11 in.
Signed LR: Lipton '58
Photo: Gavin Ashworth
Exhibition: UW–Milwaukee
Publication: Elsen fig. 19 // UW–Milwaukee, cat. 30
Provenance: from the artist 1963

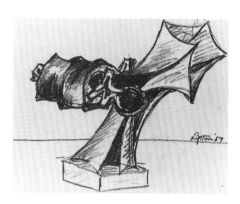

32.44
Study for "Mandrake," 1959
Crayon on paper, 8¹/₂ x 11 in.
Signed LR: Lipton '59
Photo: Gavin Ashworth
Exhibition: UW–Milwaukee
Publication: UW–Milwaukee, cat. 13
Provenance: from the artist 1963

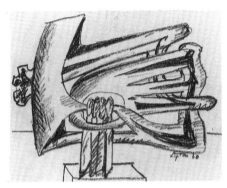

32.45
Study for "Gauntlet," 1960
Crayon on paper, 8½ x 11 in.
Signed LR: Lipton '60
Photo: Gavin Ashworth
Provenance: from the artist 1963

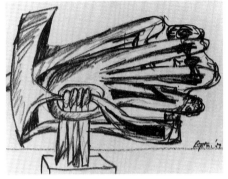

32.47
Study for "Gauntlet," 1959
Crayon on paper, 8½ x 11 in.
Signed LR: Lipton '59
Photo: Gavin Ashworth
Exhibition: UW–Milwaukee // Phillips
Publication: Elsen, fig. 29 // UW–Milwaukee cat. 18
// Phillips, Drawings, cat. 7
Provenance: from the artist 1963

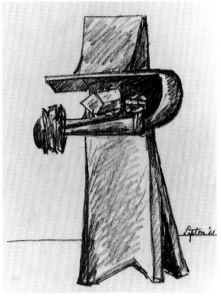

32.50
Study for "Defender," 1961
Crayon on paper, 11 x 8½ in.
Signed LR: Lipton '61
Photo: Gavin Ashworth
Exhibition: UW–Milwaukee
Publication: Elsen, fig. 7 // UW–Milwaukee, cat. 25
Provenance: from the artist 1963

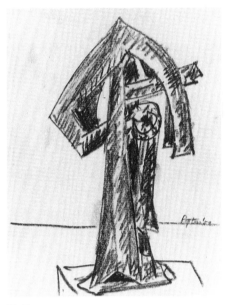

32.46
Study for "Sentinel," 1959
Crayon on paper, 11 x 8½ in.
Signed LR: Lipton '59
Photo: Gavin Ashworth
Exhibition: Phillips
Publication: Elsen fig. 13 // Phillips, Drawings, cat. 2
Provenance: from the artist 1963

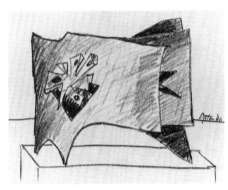

32.48
Study for "Manuscript," 1960
Crayon on paper, 8½ x 11 in.
Signed LR: Lipton '60
Photo: Gavin Ashworth
Provenance: from the artist 1963

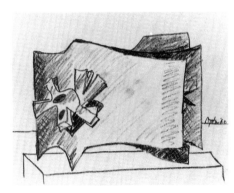

32.49
Study for "Manuscript," 1960
Crayon on paper, 8½ x 11 in.
Signed LR: Lipton '60
Photo: Gavin Ashworth
Exhibition: UW–Milwaukee
Publication: UW–Milwaukee, cat. 17
Provenance: from the artist 1963

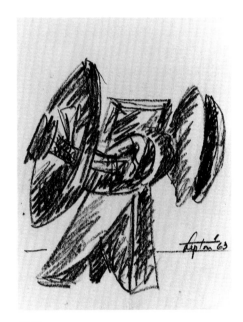

32.51
Study for "Archangel," 1963
Crayon on paper, 11 x 8½ in.
Signed LR: Lipton '63
Photo: Gavin Ashworth
Exhibition: UW–Milwaukee
Publication: UW–Milwaukee, cat. 11
Provenance: from the artist 1963

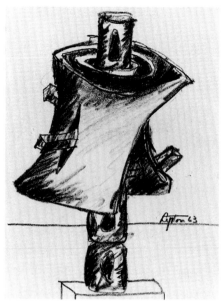

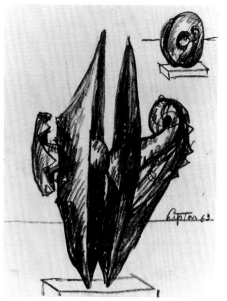

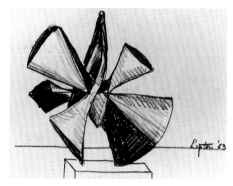

32.56
Study for "Sea Loom," 1963
Crayon on paper, 8¹/₂ x 11 in.
Signed LR: Lipton '63
Photo: Gavin Ashworth
Exhibition: UW–Milwaukee
Publication: UW–Milwaukee, cat. 22
Provenance: from the artist 1963

32.52
Study for "Earth Bell," 1963
Crayon on paper, 11 x 8¹/₂ in.
Signed LR: Lipton 63
Photo: Gavin Ashworth
Exhibition: UW–Milwaukee
Publication: Elsen fig. 32 // UW–Milwaukee, cat. 8
Provenance: from the artist 1963

32.54
Study for "Ring #1," 1963
Crayon on paper, 11 x 8¹/₂ in.
Signed LR quadrant: Lipton 63
Photo: Gavin Ashworth
Provenance: from the artist 1963

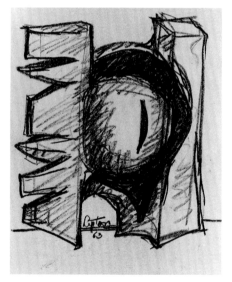

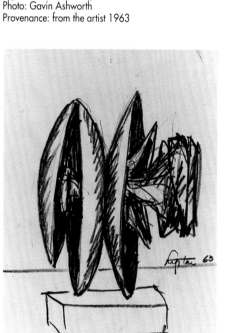

32.55
Study for "Ring #2," 1963
Crayon on paper, 11 x 8¹/₂ in.
Signed LR quadrant: Lipton 63
Photo: Gavin Ashworth
Exhibition: UW–Milwaukee
Publication: Elsen, fig. 31 // UW–Milwaukee, cat. 19
Provenance: from the artist 1963

32.53
Study for "Gateway," 1963
Crayon on paper, 11 x 8¹/₂ in.
Signed LC: Lipton 63
Photo: Gavin Ashworth
Exhibition: UW–Milwaukee
Publication: UW–Milwaukee, cat. 7
Provenance: from the artist 1963

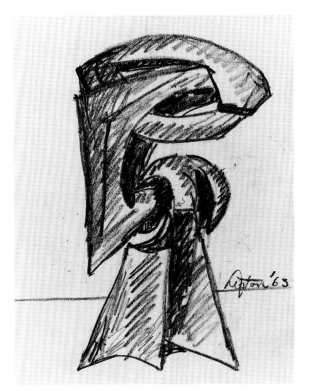

32.57
Study for "Explorer," **1963**
Crayon on paper, 11 x 8½ in.
Signed LR: Lipton '63
Photo: Gavin Ashworth
Provenance: from the artist 1963

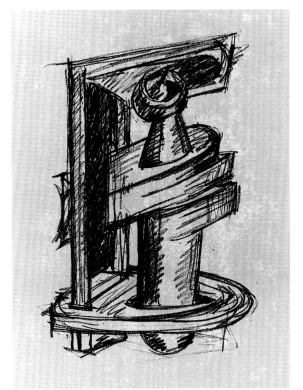

32.58
Untitled, 1969
Lithograph, 25½ x 19⅞ in.
Signed LR: Lipton '69
Artist's proof
Photo: Gavin Ashworth
Provenance: gift of the artist

33 ARISTIDE MAILLOL
(French, 1861–1944)

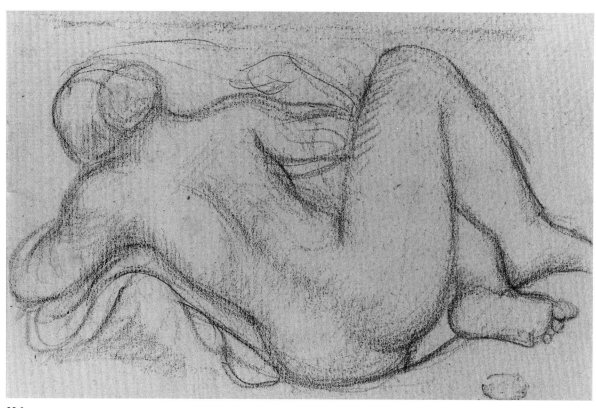

33.1
Etude pour "Cézanne," **1918–1919**
Pencil on paper, 5³/₄ x 8³/₄ in.
Signed LR with stamped encircled M
Photo: Gavin Ashworth
Provenance: [Perls Galleries, New York, October 12, 1962]; ex coll.:
Mme. Dina Vierny, Paris

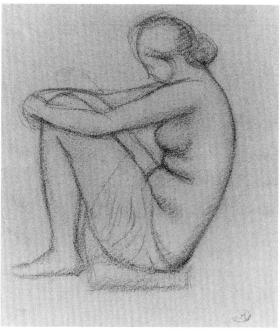

33.2
Etude pour "Debussy," **1929**
Sanguine on paper, 13¹/₄ x 9¹/₄ in.
Signed LR with a stamped encircled M
Photo: Gavin Ashworth
Provenance: [Perls Galleries, New York, October 12, 1962]; ex
coll.: Mme. Dina Vierny, Paris

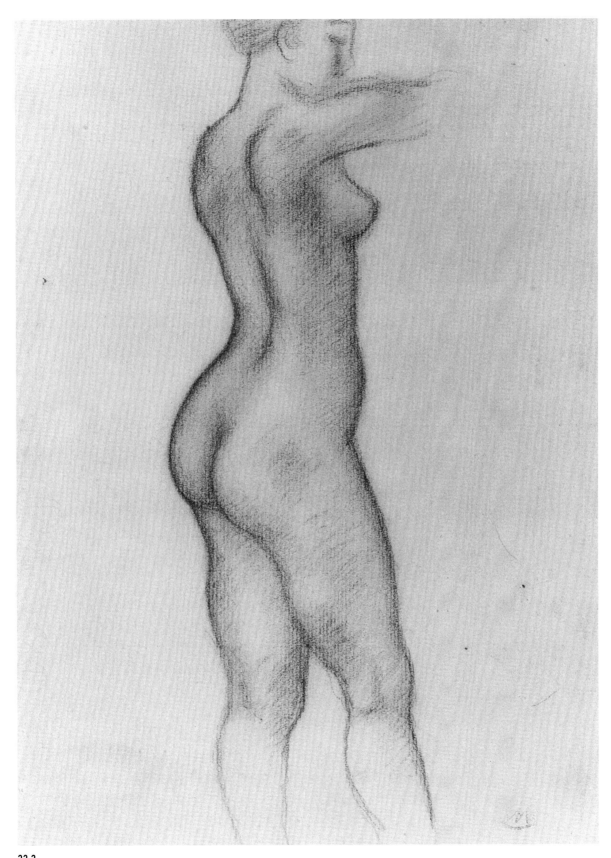

33.3
Modèle de profil, 1930
Sanguine on paper, 12¹/₂ x 9⁵/₈ in.
Signed LR with a stamped encircled M
Photo: Gavin Ashworth
Provenance: [Perls Galleries, New York, October 12, 1962]; ex coll.: Mme. Dina Vierny, Paris

34 CONRAD MARCA-RELLI
(American, b. 1913)

35 UMBERTO MASTROIANNI
(Italian, b. 1910)

34.1
Untitled, 1959
Canvas collage, 20 x 22 in.
Signed in paint LL: Marca-Relli
Exhibition: *Abstract Expressionism: Other Dimensions,* Zimmerli Art
Museum, Rutgers University, New Brunswick, New Jersey, March
25–June 13, 1990
Provenance: [Samuel M. Kootz Gallery, New York, April 29, 1961]

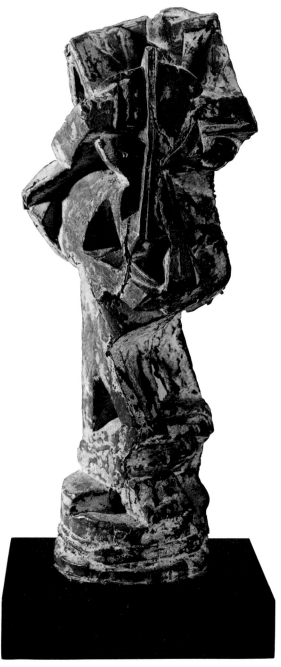

35.1
***Testa*, 1958**
Bronze, 21$\frac{1}{2}$ in. H.
Signed and dated on side of sculpture: 1958 Mastroianni
Photo: Gavin Ashworth
Exhibition: *Abstract Expressionist and Other Contemporary Paintings,
Collages and Sculptures from the Lester H. Dana Collection and Other
Sources,* Parke-Bernet Galleries, New York, February 23–27, 1963 //
Biennale, Venice, 1958
Provenance: [Parke-Bernet Galleries, New York, February 27, 1963,
lot 20]

36 BERNARD MEADOWS
(British, b. 1915)

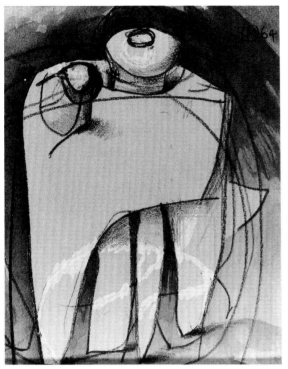

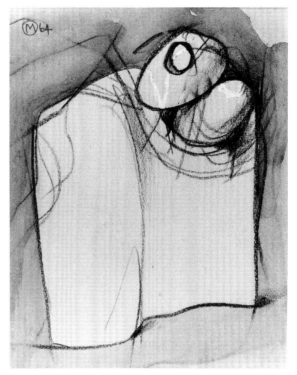

36.1a
Drawing for Sculpture, 1964
Pencil and wash on paper, 3¹/₂ x 3 in.
Signed and dated UR: encircled M 64
Photo: Gavin Ashworth

36.1b
Drawing for Sculpture, 1964
Pencil and wash on paper, 3¹/₂ x 3 in.
Signed and dated UL: encircled M 64
Photo: Gavin Ashworth
Provenance: [Gimpel Fils Ltd, London, May 11, 1972]

37 JOAN MIRÓ
(Spanish, 1893–1983)

37.1
Monument, 1956
Ceramic, 28¼ x 12¾ x 12¾ in.
L'atelier d'Artigas, Barcelona
Photo: Gavin Ashworth
Exhibition: *Joan Miró,* The Museum of Modern Art, New York, October 17, 1993–January 11, 1994 // *The Sculpture of Miró,* The Pace Gallery, New York, April 27–June 9, 1984 // *Sculptures de Miró, céramics de Miró et Llorens Artigas,* Fondation Maeght, Saint-Paul-de Vence, France, April 14–June 30, 1973 //*Joan Miró.* Haus der Kunst, Munchen, March 15–May 11, 1969
Publication: Carolyn Lanchner, *Joan Miró.* New York: The Museum of Modern Art, New York, 1993, p. 286, illus. // *The Sculpture of Miró.* Text by Peter Schjeldahl. New York: The Pace Gallery, 1984, p. 13, illus. in color // Enrique Garcia-Harraiz, "Cronica de Nueva York," *Goya,* no. 183 (November-December 1984), p. 184, illus. // Alain Jouffroy and Joan Teixidor, eds., *Miró Sculptures.* New York: Leon Amiel, 1974. illus. frontispiece // José Pierre and José Corredor-Matheos, *Miró & Artigas, Ceramiques.* Paris: Maeght, 1974, p. 130, pl. 270, illus. in color //*Joan Miró.* Paris: Editions des Musées nationaux, 1974, p. 165, cat. 305, illus. // *Sculptures de Miró, céramics de Miró et Llorens Artigas,* Saint-Paul-de-Vence, France: Fondation Maeght, 1973, cat. 199, illus. // *Joan Miró.* Munchen: Ausstellungsleitung Haus de Kunst, 1969. cat. 212, illus. n.p.
Provenance: [The Pace Gallery, New York, May 1984]; [Galerie Maeght, Paris]

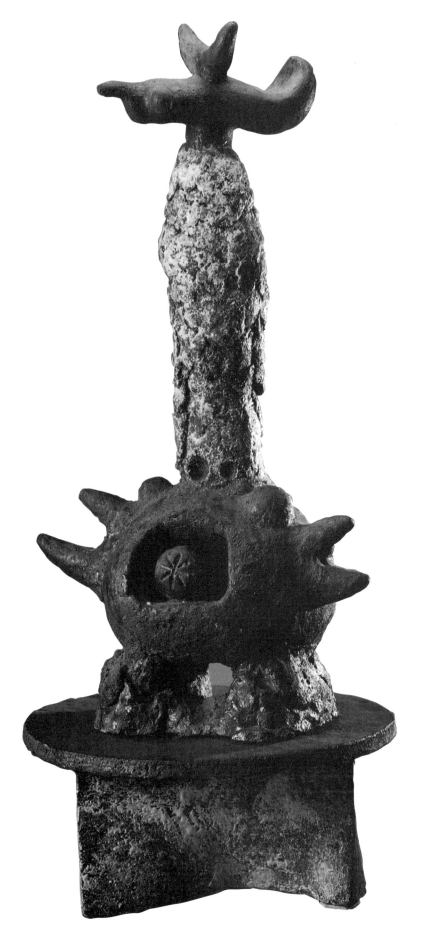

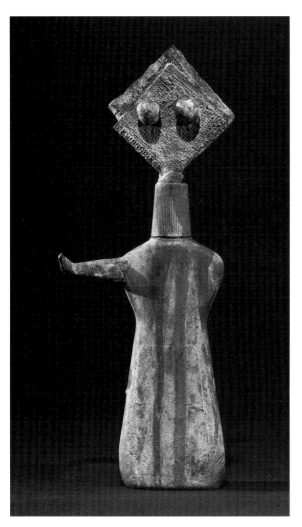

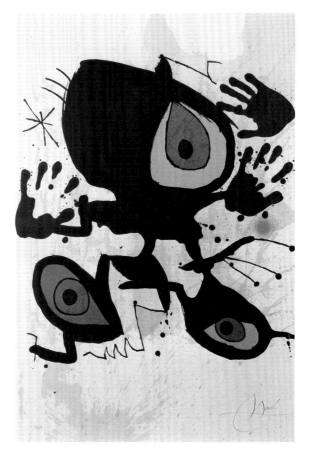

37.3
Untitled, n.d.
Lithograph, 35¹/₄ x 24 in.
Signed LR: Miró
Edition: 93/150
Photo: Gavin Ashworth
Provenance: The Museum of Modern Art, New York

37.2
Personnage, **1973–1981**
Bronze, 13³/₄ x 5¹/₂ x 2¹/₂ in.
Fonderia Parellada, Barcelona
Edition: 2/2
Photo: Al Mozell
Exhibition: *The Sculpture of Miró,* The Pace Gallery, New York, April 27–June 9, 1984 // *Joan Miró,* Galerie Adrien Maeght, Paris, 1983
Publication: *Obra de Joan Miró: Dibuixos, pintura, escultura, cerámica tèxtils.* Barcelona: Fundació Joan Miró, 1988, p. 171, pl. 303 // *Joan Miró.* Paris: Galerie Adrien Maeght, 1983, illus. in color pl.
Provenance: [The Pace Gallery, New York, May 1984]; [Galerie Adrien Maeght, Paris]

38 HENRY MOORE
(British, 1898–1986)

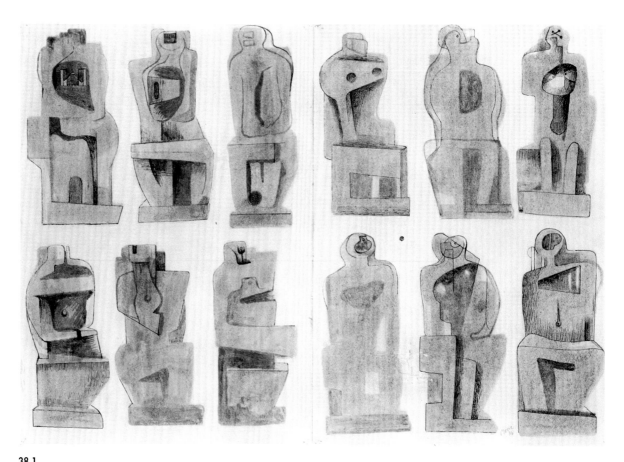

38.1
Ideas for Stone Seated Figures, 1934
Gray wash, charcoal, pen, and black ink on 2 sheets of paper on board, 14¾ x 21¾ in.
Signed and dated LR: Moore 34
Publication: Kenneth Clark, *Henry Moore Drawings.* London: Thames and Hudson, 1974, p. 94, cat. 80, illus. // Robert Melville, *Henry Moore Sculpture and Drawings 1921–1969.* New York: Harry N. Abrams, 1970, p. 79, cat. 120, illus. // Herbert Read, *Henry Moore Sculpture and Drawings.* London: Lund Humphries, 1949, p. 124, cat. 124B, illus.
Provenance: (Christie's, New York, November, 1979); ex coll. Mrs. Peggy Anderson; Stephen Spender.

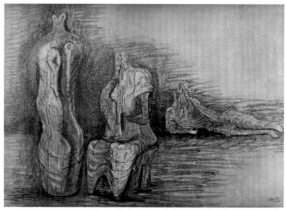

38.2
Study for Three Figures, 1943
Pencil, charcoal, and watercolor on paper, 15 x 22 in.
Signed LR: Moore 43
Provenance: [Galleria Odyssia, New York, November 23, 1966]; [Galatea, Turin]; [Cramer Gallery, Geneva]; [Klipstein, Berne]

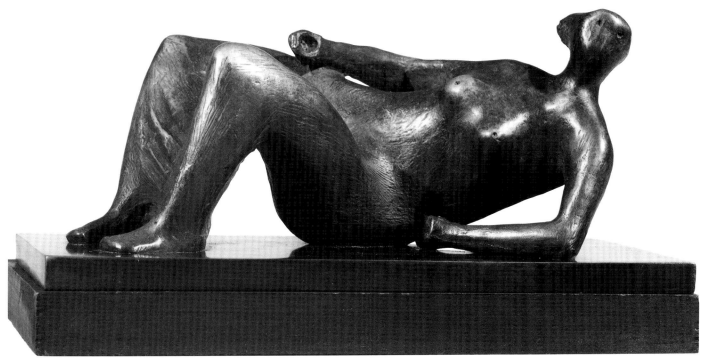

38.3
Reclining Woman: Hair, 1981–82
Bronze, 4³/₄ x 9³/₄ x 4¹/₄ in. D. (overall, including base: 5 x 5³/₈ x
10⁵/₁₆ in.)
Signed on base: Moore 7/9
Edition: 7/9
Exhibition: *Masters of Modern and Contemporary Sculpture*, Marlbor-
ough Gallery, New York, November 8–December 4, 1984
Provenance: [Marlborough Gallery, New York, December 1984]

39 ELIE NADELMAN
(American, b. Poland, 1885–1964)

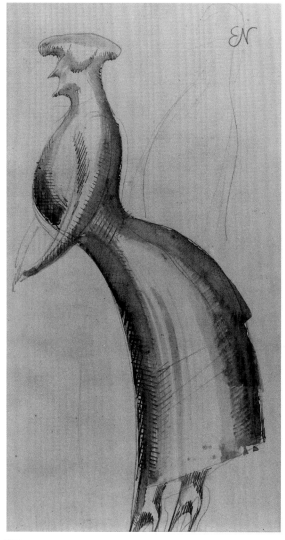

39.1
***Study for "Chanteuse,"* ca. 1918**
Ink, pencil, and blue-gray wash on cream-colored paper, 10³/₈ x
5⁵/₈ in.
Initialed UR: EN
Provenance: [ACA Galleries, New York, February 27, 1993]; ex coll.:
Mr. and Mrs. Herbert A. Goldstone; [M. Knoedler]

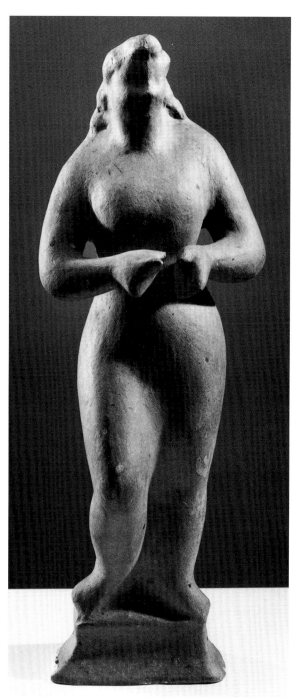

39.2
***Standing Woman,* 1930–35**
Papier-mâché, 13 in. H.
Photo: Allan Finkelman
Exhibition: *Sculpture by Elie Nadelman*, Sidney Janis Gallery, New
York, September 28–October 31, 1987
Publication: *Sculpture by Elie Nadelman*. New York: Sidney Janis
Gallery, 1987, checklist no. 29
Provenance: [Sidney Janis Gallery, New York, September, 1987]

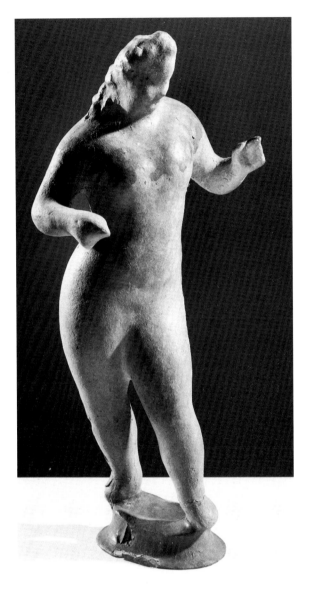

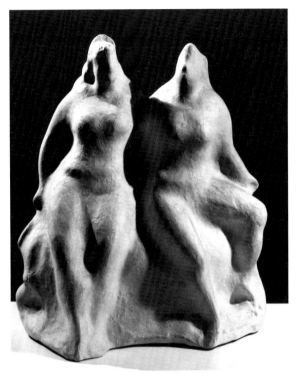

39.4
***Two Seated Women*, 1930–35**
Papier-mâché, 11 in. H.
Photo: Allan Finkelman
Exhibition: *Sculpture by Elie Nadelman*, Sidney Janis Gallery, New York, September 28–October 31, 1987
Publication: *Sculpture by Elie Nadelman*. New York: Sidney Janis Gallery, 1987, checklist no. 35
Provenance: [Sidney Janis Gallery, New York, September, 1987]

39.3
***Standing Woman*, 1930–35**
Papier-mâché, 11½ in. H.
Photo: Allan Finkelman
Exhibition: *Sculpture by Elie Nadelman*, Sidney Janis Gallery, New York, September 28–October 31, 1987
Publication: *Sculpture by Elie Nadelman*. New York: Sidney Janis Gallery, 1987, checklist no. 34
Provenance: [Sidney Janis Gallery, New York, September, 1987]

40 REUBEN NAKIAN
(American, 1897–1986)

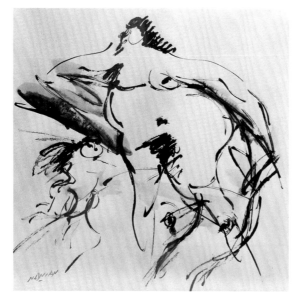

40.1
Europa and Bull, 1959–1960
Ink on paper, 13⁷/₈ x 16¹/₂ in.
Exhibition: VI Bienel, Sao Paulo, Brazil, 1961
Signed in ink LL: NAKIAN
Provenance: [Egan Gallery, New York, May 17, 1964]

40.3
Leda and Swan, 1964
Ink on paper, 14 x 16¹/₂ in.
Signed LR quadrant: NAKIAN
Photo: John A. Ferrari
Provenance: [Egan Gallery, New York, December 10, 1964]

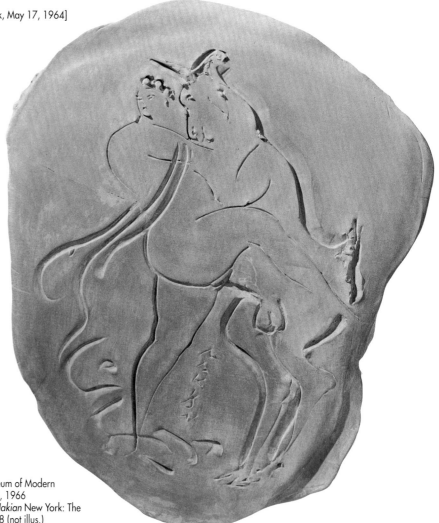

40.2
Nymph and Goat, 1964–65
Terracotta, 18 x 15 in.
Inscribed on clay LC: NAKIAN
Photo: Thor Bostrom
Exhibition: *Reuben Nakian*, The Museum of Modern
Art, New York, June 20–September 5, 1966
Publication: Frank O'Hara, *Reuben Nakian* New York: The
Museum of Modern Art, 1966, cat. 98 (not illus.)
Provenance: [Egan Gallery, New York, October, 1964]

41 LOUISE NEVELSON
(American, b. Russia, 1899–1988)

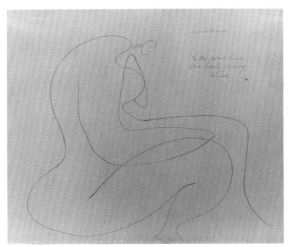

41.1
Untitled, ca. 1930
Pencil on paper, 9 x 11 in.
Signed and inscribed UR: nevelson/ To the Alvin Lanes/for a lovely
evening/Louise
Photo: Gavin Ashworth
Provenance: gift of artist

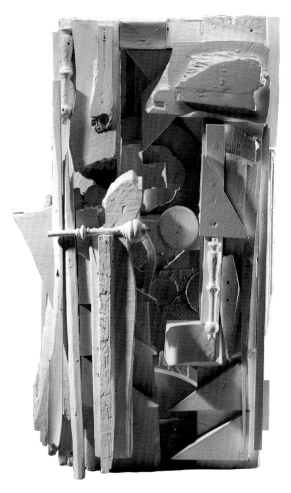

41.2
***Dawn's Wedding Chest*, 1959**
Wood, white paint, 27 x 15 x 6 in.
Photo: Gavin Ashworth
Exhibition: *Louise Nevelson: Atmospheres and Environments*, Whitney
Museum of American Art, New York, May 29–September 7, 1980 //
Louise Nevelson, Whitney Museum of American Art, New York, March
8–April 30, 1967 // *Sixteen Americans* (as part of *Dawn's Wedding
Feast*), The Museum of Modern Art, New York, December 16,
1959–February 14, 1960
Publication: Jean Lipman, *Nevelson's World*. New York: Hudson Hills
Press, 1983, p. 123 // Barbaralee Diamonstein, *Artistul plastic la lucru
in America*. Romania: 1979, p. 15, illus. // Wayne Andersen, *Ameri-
can Sculpture in Process: 1930–1970*. Boston: New York Graphic Soci-
ety, 1975 // Oliver Andrews, *Living Materials: A Sculptor's Handbook*.
New York: Holt, Rinehart and Winston, 1974 // Arnold Glimcher,
Louise Nevelson. New York: Praeger, 1972, p. 34, illus. (printed upside
down) // John Gordon, *Louise Nevelson*. New York: Whitney Museum
of American Art, 1967, p. 58, cat. 46, not illus. // Dorothy C. Miller,
ed. *Sixteen Americans* (as part of *Dawn's Wedding Feast*). New York:
The Museum of Modern Art, 1959, pp. 52–57, not illus.
Provenance: [Martha Jackson Gallery, New York, November 15, 1969]

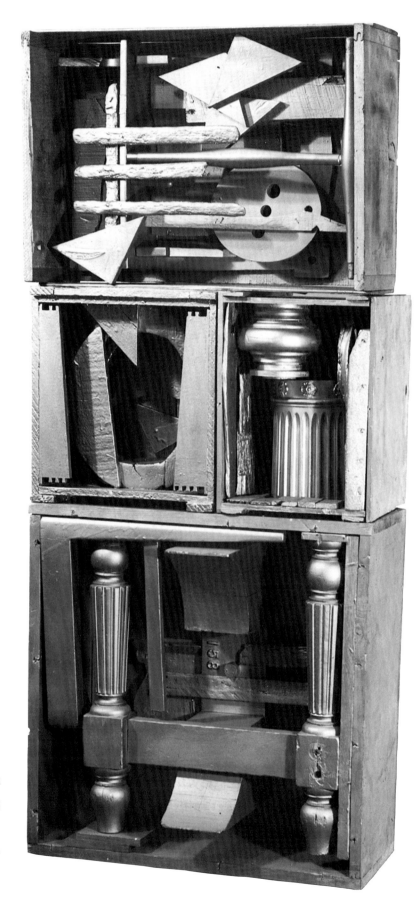

41.3
Little Triptych Wall, 1960
Wood, paint, box: top: 16⅝ x 23⅝ x 8
in.; middle left: 14¼ x 13⅛ x 7⅝ in.;
middle right: 14¼ x 10½ x 12¼ in.; bot-
tom: 24⅛ x 24 x 12¾ in.; overall: 57⅝ x
26⅜ x 13½ in.
Each section signed and dated: NEVELSON
1960 (top box: right side; middle-left: top;
middle-right: top; bottom: bottom)
Photo: John D. Schift
Provenance: [Martha Jackson Gallery, New
York, January 15, 1969]

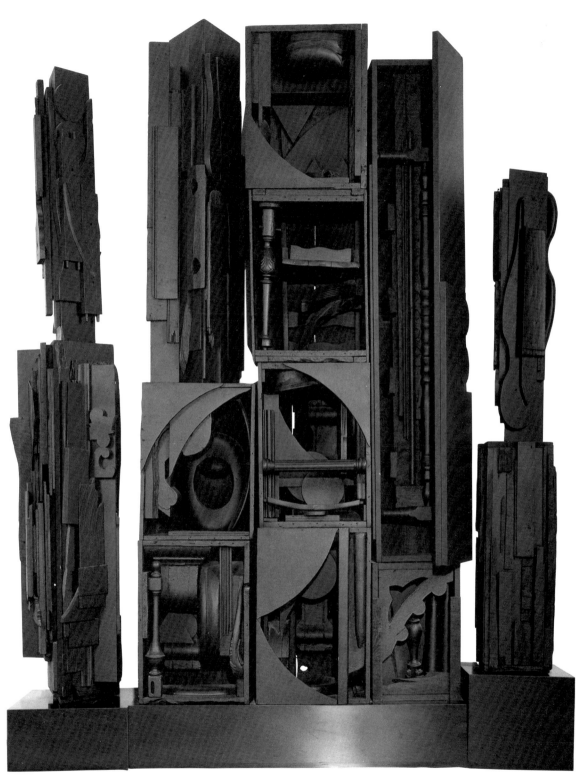

41.4
Cathedral Garden #4, **1963**
Wood, paint, wall: 90 x 44 x 17 in.; columns: 84 x 17,
66¹/₄ x 10¹/₄ in.
Each section signed and dated: Nevelson 1963
Photo: Gavin Ashworth
Publication: Arnold Glimcher, *Louise Nevelson.* New York: Praeger,
1972, p. 176, illus.
Provenance: commissioned by Alvin S. Lane, 1963

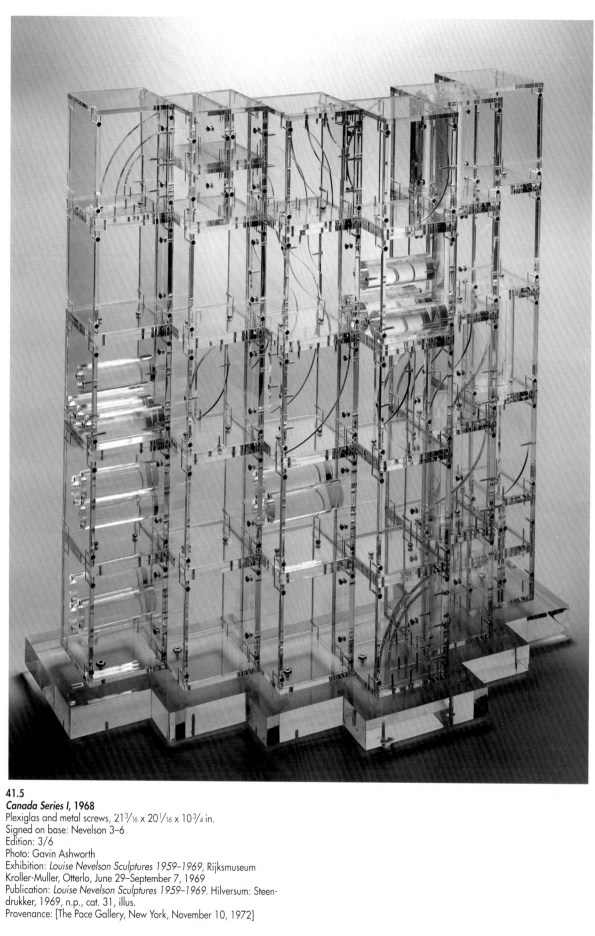

41.5
Canada Series I, 1968
Plexiglas and metal screws, 21³/₁₆ x 20¹/₁₆ x 10³/₄ in.
Signed on base: Nevelson 3–6
Edition: 3/6
Photo: Gavin Ashworth
Exhibition: *Louise Nevelson Sculptures 1959–1969*, Rijksmuseum
Kroller-Muller, Otterlo, June 29–September 7, 1969
Publication: *Louise Nevelson Sculptures 1959–1969*. Hilversum: Steen-
drukker, 1969, n.p., cat. 31, illus.
Provenance: [The Pace Gallery, New York, November 10, 1972]

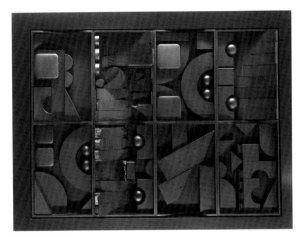

41.6
Black Light I, 1970
Painted black wood and formica frame, 36½ x 47 x 5½ in.
Photo: Ferdinand Boesch
Provenance: [The Pace Gallery, New York, February 11, 1971]

41.7
Night Scene, 1971
Lithograph, 22 x 15 in.
Signed, dated, titled LC: "Night Scene"; LR: Louise Nevelson/To the
Alvin Lane Family with Love. L ; LL: August 27–71
Edition: 12/20
Photo: Gavin Ashworth
Provenance: gift of artist 1971

42 ISAMU NOGUCHI
(American, 1904–1988)

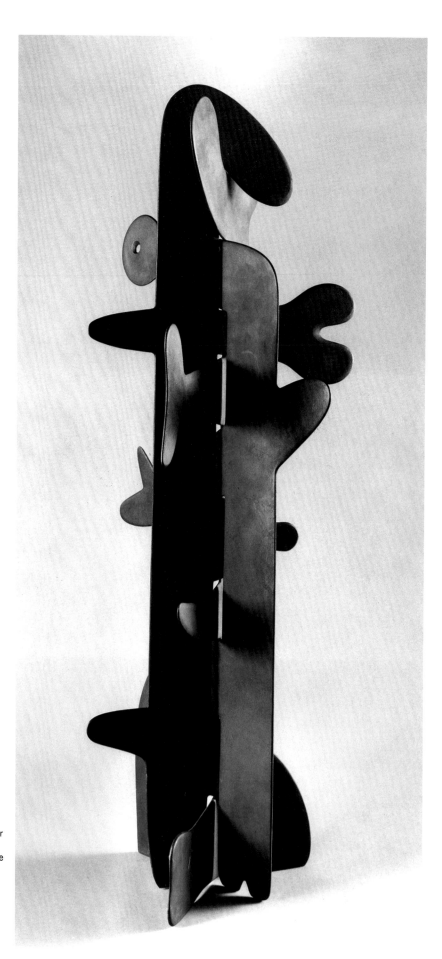

42.1
Trinity (Triple), **made in 1987 from a slate prototype executed in 1945**
Bronze, 55 x 22 x 20 in.
Edition: 4/8
Photo: Ivan Dalla Tana
Exhibition: The Pace Gallery, New York, May 13–June 11, 1988 // Zabriskie Gallery, New York, September 22–October 33, 1987
Publication: *Isamu Noguchi*, New York: The Pace Gallery, 1988, pl. 4 // Isamu Noguchi, *The Isamu Noguchi Garden Museum*. New York: Harry N. Abrams, 1987, p. 247, pl. 29
Provenance: [The Pace Gallery, New York, April 4, 1988]

43 TOSHIO ODATE
(American, b. Japan 1930)

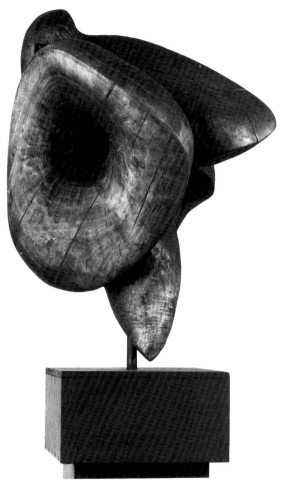

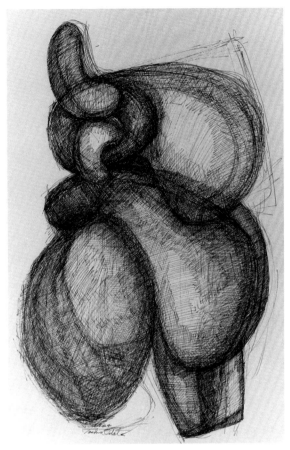

43.1
Azuma Gata, **1962**
Walnut, 28 in. H.
Exhibition: *Toshio Odate*, Stephen Radich Gallery, New York,
February 26–March 26, 1963
Provenance: [Stephen Radich Gallery, New York, July 17, 1964]

43.2
Space Drawing-Sculpture Forms, **1964**
Pen and ink on yellow paper, 17 x 11¼ in.
Signed and dated LC: 1964/Toshio Odate
Photo: Gavin Ashworth
Provenance: [Stephen Radich Gallery, New York, October 13, 1964]

44 CLAES OLDENBURG
(American, b. Sweden 1929)

44.1
Giant Soft Sculpture Visualized in Green Gallery, Cone,
Sandwich, Hat, **1962**
Crayon, watercolor on paper, 10 x 13 in.
Initialed and dated LR: CO 1962; Titled along bottom: Cone,
Sandwich, Hat
Exhibition: *New Dimensions in Drawing*
Publication: Gene Baro, *Claes Oldenburg Drawings and Prints.* London:
Chelsea House, 1969, p. 247, cat. 129
Provenance: [Sidney Janis Gallery, New York, 1972]

44.2
Proposed Colossal Monument for Lower East Side: Ironing Board,
1965
Crayon, pencil, and watercolor on paper, 21³/₄ x 29¹/₂ in.
Initialed and dated in crayon LR: C.O. 1965; Inscribed LL: N.Y.
Photo: Gavin Ashworth
Exhibition: *New Dimensions in Drawing* // *Claes Oldenburg,* The
Museum of Modern Art, New York, September 25–November 23,
1969 // *Claes Oldenburg Skulpturer Och Teckningar,* Moderna
Museet, Stockholm, September 17–October 30, 1966
Publication: Ellen H. Johnson, *Claes Oldenburg.* Baltimore: Penguin
Books, 1971, p. 36, cat. 23, illus. // Gene Baro, *Claes Oldenburg*
Drawings and Prints. London: Chelsea House, 1969, pp. 160–61,
255, cat. 216, illus. // Claes Oldenburg, *Proposal for Monuments and*
Buildings. Chicago: Big Table, 1969, pp. 52–53, pl. 7 // Barbara
Rose, *Claes Oldenburg.* New York: The Museum of Modern Art, 1969,
cat. 181 // *Claes Oldenburg Skulpturer Och Teckningar.* Stockholm:
Moderna Museet, 1966, illus. n.p.
Provenance: (Sotheby Parke Bernet, New York, May 4, 1974); ex coll.
Barbara Goodman Trust and Stephen Goodman Trust; Mr. and Mrs.
Marvin Goodman, Toronto; [Sidney Janis Gallery, New York]

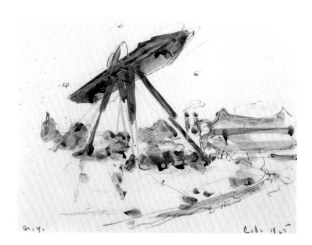

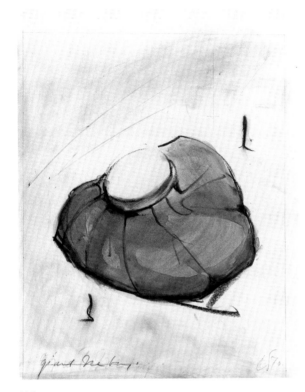

44.3
Visualization of the Giant Ice Bag, 1970
Crayon, pencil, and watercolor on paper, 19 x 12⅞ in.
Initialed and dated LR: CO 70; titled: LL: Giant Ice Bag
Photo: Gavin Ashworth
Exhibition: *New Dimensions in Drawing* // *Claes Oldenburg*, The Tate
Gallery, London, June 24–August 16, 1970 // *New Work by Claes
Oldenburg*, Sidney Janis Gallery, November 4–28, 1970 //
Publication: *New Work by Claes Oldenburg*. New York: Sidney Janis
Gallery, 1970, cat. 23 // *Claes Oldenburg*. London: The Arts Council
of Great Britain, 1970, cat. 112, illus.
Provenance: [Sidney Janis Gallery, New York, December 28, 1970]

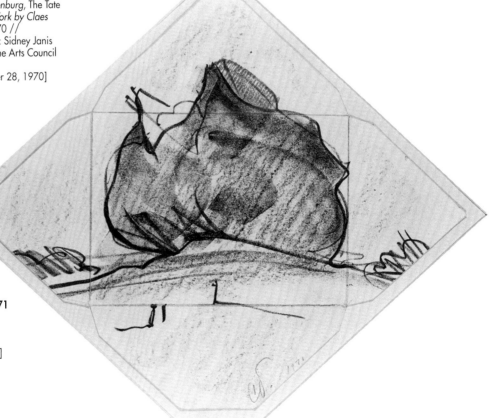

44.4
Colossal Baked Potato in a Landscape Version #1, 1971
Graphite trial proof, 9⅞ x 12 in.
Initialed and dated LC: CO. 1971
Photo: Gavin Ashworth
Provenance: [M. Knoedler, New York, March 27, 1973]

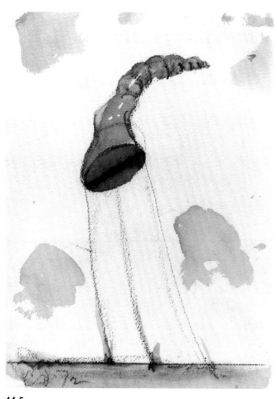

44.5
Floating Screw, 1972
Watercolor and black crayon on paper, 12¼ x 9 in.
Initialed and dated LL: CO 72
Photo: André Grossmann
Provenance: (Christie's, New York, November 10, 1988, lot 154); The
Points, Co., Houston (1984); [James Goodman Gallery, New York];
Daniel Varenne, Geneva; [James Mayor Gallery, London, 1977]; [Leo
Castelli, New York]

44.6
Soft Screw, 1975
Rubber with revolving wooden base painted black, 47¼ in. H., black
inclined base ca. 15 in. D.
Stamped with artist's signature and inscribed "Soft Screw Copyright
1975 Claes Oldenburg Produced by Gemini G.E.L."
Edition: 12/24
Photo: Gavin Ashworth
Provenance: (Sotheby's, New York, May 7, 1992, lot 307); Gemini
G.E.L., Los Angeles

44.7
Double Screwarch Bridge, State II, 1981
Etching and aquatint from 5 copper plates, Arches paper, 23⅛ x 50⅝ in.
Signed LR: Claes Oldenburg
Edition: 1/35 plus 12 artist's proofs and 1 printer's proof
Photo: Gavin Ashworth
Publication: Judith Goldman, *American Prints: Process and Proofs.*
New York: Harper & Row for Whitney Museum of American Art, 1981, pp. 124–29
Provenance: [Pace Prints, New York, February 7, 1995]

44.8
Double Screwarch Bridge, State III, 1981
Etching with aquatint, monotype printed in colors 23¼ x 50¾ in.
Signed LR: Claes Oldenburg; LL: AP VII/XIII
Edition: artist's proof 7/13, an edition of 25 plus 13 artist's proofs and 1 printer's proof
Photo: Gavin Ashworth
Publication: Judith Goldman, *American Prints: Process and Proofs.*
New York: Harper & Row for Whitney Museum of American Art, 1981, pp. 124–29
Provenance: [Charles M. Young, Glastonbury, Conn., February 9, 1995]; [Marian Goodman Gallery, New York]

44.9
Notebook Page: Eraser Studies, 1970
Felt pen and crayon on paper, 8½ x 11 in.
Initialed and dated LR: CO. 4/70; inscribed in yellow LL: Eraser
Photo: Ellen Page Wilson
Exhibition: *Claes Oldenburg, Teckningar, Ackvareller Och Grafik*,
Moderna Museet, Stockholm, October 29–December 4, 1977 // *Claes
Oldenburg dessins, aquarelles et estampes*, Musée National d'Art
Moderne, Paris, August 24–October 16, 1977
Publication: *Claes Oldenburg, Teckningar, Ackvareller Och Grafik*.
Stockholm: Moderna Museet, 1977, p. 57, cat. 162 // *Claes Olden-
burg dessins, aquarelles et estampes*. Paris: Centre Georges Pompidou,
1977, p. 37, cat. 210, illus.
Provenance: [The Pace Gallery, New York, March 25, 1992]

44.10
Seated Typewriter Eraser, 1970
Pencil and colored pencil on paper, 9¾ x 7⅞ in.
Initialed and dated LL: CO. Poster Print 3/70; inscribed LR: Seated
Typewriter Eraser
Photo: Ellen Page Wilson
Provenance: [The Pace Gallery, New York, March 25, 1992]

44.11
Typewriter Eraser, 1977
Pigment, concrete, aluminum rods, stainless steel,
32 x 35 x 23 in.
Stamped "Typewriter Eraser 12/18 Copyright
1977 Claes Oldenburg" on base and stamped
with signature and numbered 12/18
Edition: 12/18
Provenance: (Sotheby's, New York, February 27,
1990, lot 208); Shaindy Fenton, Fort Worth; [Leo
Castelli, New York]

44.12
Clothespin Kiss, **1981**
Color lithograph, 30 x 21½ in
Signed LR: Oldenburg; inscribed LL: 157/200
Edition: 157/200
Photo: Gavin Ashworth
Provenance: [M. Knoedler, New York, ca. 1985]

45 ALFONSO OSSORIO
(American, b. Philippines, 1916–1990)

45.1
Palimpsest, 1951
Lithograph, 8 3/4 x 6 5/16 in.
Signed and dated LR: A. Ossorio, '51; titled LL: Palimpsest
Edition: 25
Photo: Gavin Ashworth
Provenance: [Charles M. Young, Glastonbury, Conn., February 4, 1995]; the artist's estate

46 ANTOINE PEVSNER
(Russian, 1884–1962)

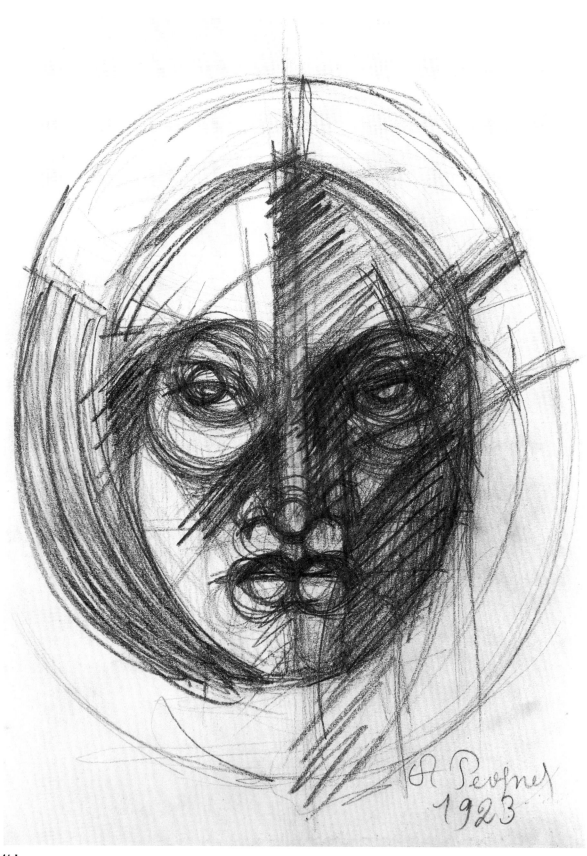

46.1
Tête de femme, 1923
Pencil on paper, 12 x 8⅞ in.
Signed and dated LR: A Pevsner 1923
Provenance: (Sotheby's, London, April 6, 1989, lot 558); ex coll.: René
Massat, Paris; from the artist

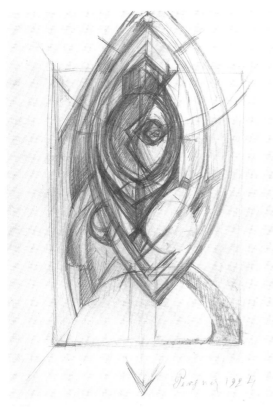

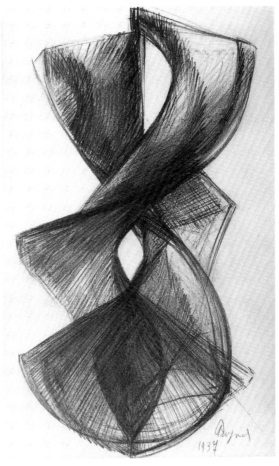

46.2
Tête de femme, **1924**
Pencil on paper, 11 3/8 x 8 3/8 in
Signed and dated LR: Pevsner 1924
Provenance: (Sotheby's London, October 16, 1991, lot 65); ex coll.:
René Massat, Paris; from the artist

46.3
Projet de sculpture, **1937**
Pencil on paper, 15 1/2 x 9 3/4 in.
Signed and dated LR: Pevsner 1937
Photo: Gavin Ashworth
Provenance: (Sotheby's, London, June 26, 1991, lot 235); ex coll.:
René Massat, Paris; from the artist

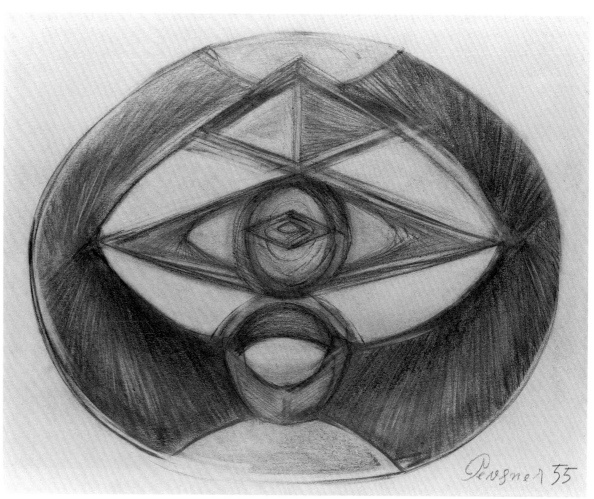

46.4
*Projet de sculpture—Monument pour le prisonnier politique
inconnu, 1955*
Pencil on paper, 14¼ x 17¾ in.
Signed and dated LR: Pevsner 55
Provenance: (Sotheby's, London, October 14, 1992, lot 59); ex coll.:
René Massat, Paris; from the artist

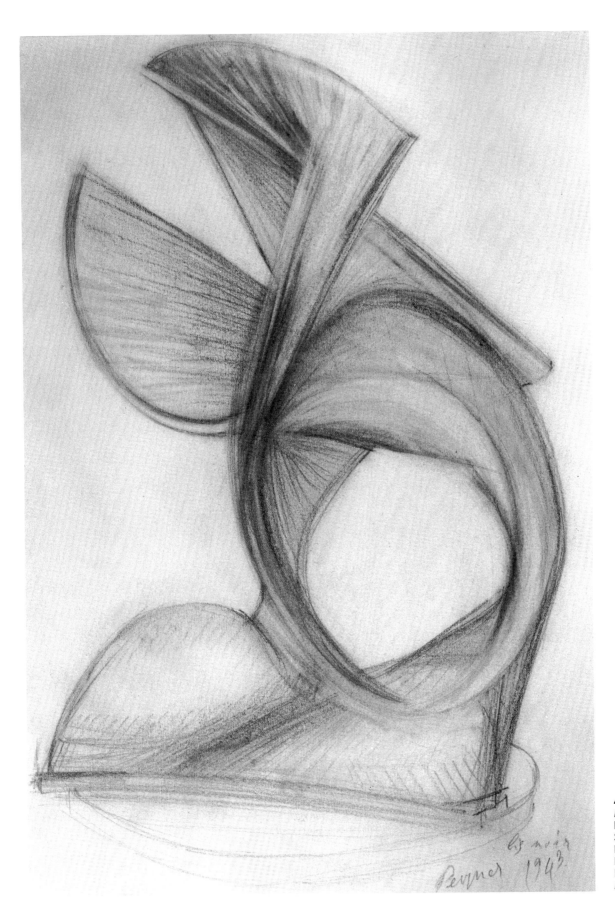

46.5
Lis noir, 1963
Pencil on paper, 14 x 9½ in.
Signed, inscribed, and dated
LR: lis noir/ Pevsner 1963
Photo: André Grossmann
Provenance: Ex coll.: René
Massat, Paris; from the artist

47 PABLO PICASSO
(Spanish, 1881–1973)

47.1
***Etude pour une tole découpée "Femme
debout,"* 1961**
Pencil on cut paper, 16³/₄ x 6¹/₂ x 2¹/₄ in.
Photo: Al Mozell
Publication: Werner Spies, *Picasso Das
plastiche Werk*. Stuttgart: Verlag Gerd
Hatje, c1983, cat. 580.1a, illus. n.p.
Provenance: [The Pace Gallery, New York,
October 25, 1982; ex coll.: Bernard Ruiz-
Picasso]

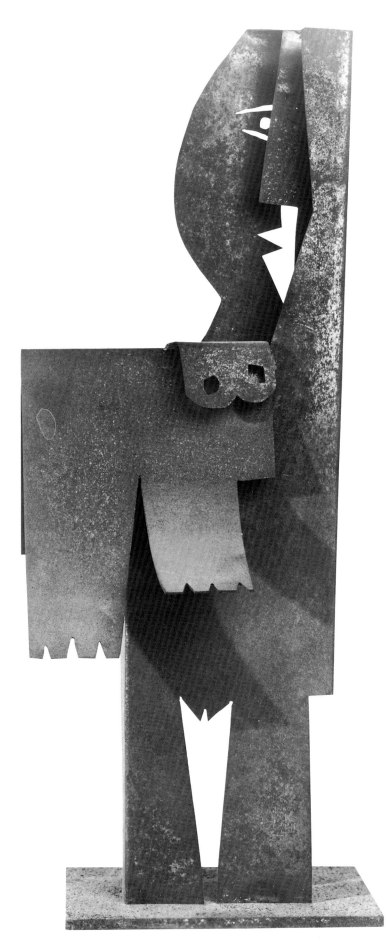

47.2
Femme debout, 1961
Cut out sheet metal, folded and painted, 17 x 6¹/₂ in.
Exhibition: *The Sculpture of Picasso*, The Pace Gallery,
New York, September 16–October 23, 1982 //
Picasso: Opere dal 1895–1971 dalla Marina Picasso,
Centro di Cultura di Palazzo Grassi, Venice, May
3–July 26, 1981 // *Pablo Picasso 100th Birthday Exhibition: Works from the Collection of Marina Picasso*,
Haus der Kunst Munchen, February 14–April 20, 1981.
Traveled to Josef-Haubrich-Kunsthalle and Museum Ludwig, Koln; Stadtiche Galerie in Stadelisches Kunstinstitut, Frankfurt am Main
Publication: Werner Spies, *Picasso Das plastiche Werk.*
Stuttgart: Verlag Gerd Hatje, c1983, cat. 580.2b, illus.,
n.p. // Kay Larson, "The Master's Choice," *New York*,
(October 18, 1982), p. 78 // *The Sculpture of Picasso.*
New York: The Pace Gallery, 1982, p. 51, no. 47 //
Picasso: Opere dal 1895–1971 dalla Marina Picasso.
Venice: Centro di Cultura di Palazzo Grassi, 1981, p.
394, illus. // *Pablo Picasso 100th Birthday Exhibition:
Works from the Collection of Marina Picasso.* Munchen:
Haus der Kunst, 1981, p. 403, illus. // Werner Spies,
Les Sculpture de Picasso. Lausanne: La Guilde du Livre
et Clairefontaine, 1971, p. 284, no. 580
Provenance: [The Pace Gallery, New York, October 25,
1982]; estate of the artist (collection of Marina Picasso)

47.3
Tête, 1961
Pencil on paper, 10⁵/₈ x 8¹/₄ in.
Provenance: [The Pace Gallery, New York, October 25,
1982; ex coll.: Bernard Ruiz-Picasso]

48 IVAN (IWAN) PUNI (JEAN POUGNY)
(French, b. Russia, 1894–1956)

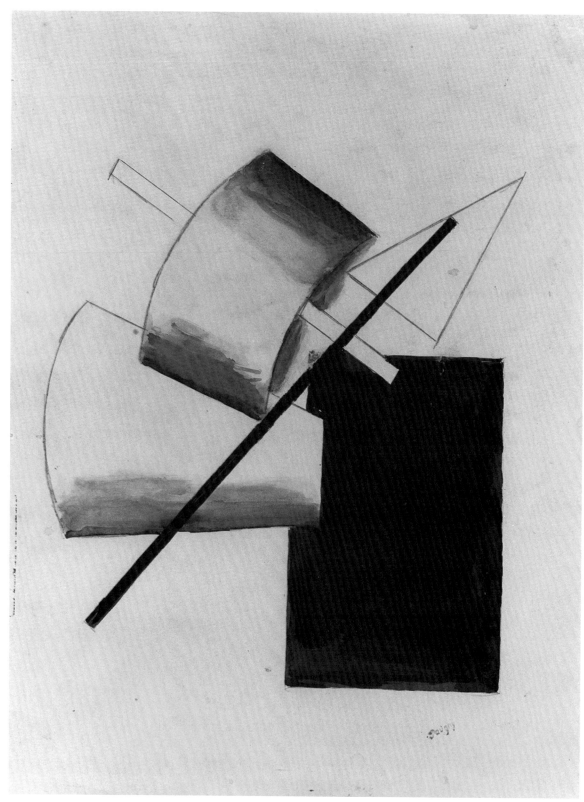

48.1
Composition, ca. 1915
Brush, ink, and wash on paper, 19³/₄ x 15³/₄ in.
Stamped with signature LR: Pougny
Provenance: (Sotheby's, London, April 6, 1989, lot 518); ex coll.:
Madame Pougny, Paris

49 THEODORE ROSZAK
(American, b. Poland, 1907–1981)

49.1
Cubist Head No. 1, 1932
Watercolor on paper, 8½ x 10½ in.
Exhibition: *Constructivist*
Publication: *Constructivist* , cat. 54, p. 10.
Provenance: [Walter F. Mailbaum Fine Art, New York, March 11, 1993]

49.3
Study for "Airport," 1933
Watercolor and ink on paper, 4½ x 6½ in.
Initialed and dated LR: TR '33
Provenance: [Hirschl & Adler Galleries, New York, January 21, 1989];
estate of artist

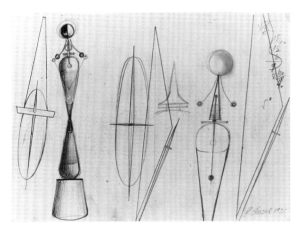

49.2a (recto)
Study, 1935
Colored pencil, pencil, and pen on paper, 8 x 11 in.
Double-sided drawing
Signed with yellow pencil LR: T. Roszak 1935
Photo: Gavin Ashworth

49.2b (verso)
Study, 1935
Colored pencil, pencil, and pen on paper, 8 x 11 in.
Double-sided drawing
Photo: Gavin Ashworth
Provenance: [Zabriskie Gallery, New York, January 31, 1987]

49.4
Studies for Sculpture, 1938
Pencil on graph paper, 13⅝ x 8 in.
Signed and dated LL: T. Roszak 1938
Photo: Gavin Ashworth
Provenance: [Zabriskie Gallery, New York, January 31, 1987]

49.5
Study for "Suspended Construction" [front ³/₄ **top elevation**],
1936–38
Ink on paper, 11¹/₂ x 6¹/₄ in.
Exhibition: *Constructivist*
Publication: *Constructivist*, cat. 62, p. 45.
Provenance: [Hirschl & Adler Galleries, New York, February 29,
1988]; estate of the artist

49.6
Study for "Suspended Construction" [front elevation], 1936–38
Ink on paper, 13¹/₂ x 8¹/₂ in.
Exhibition: *Constructivist*
Publication: *Constructivist*, cat. 63, p. 45.
Provenance: [Hirschl & Adler Galleries, New York, February 29,
1988]; estate of the artist

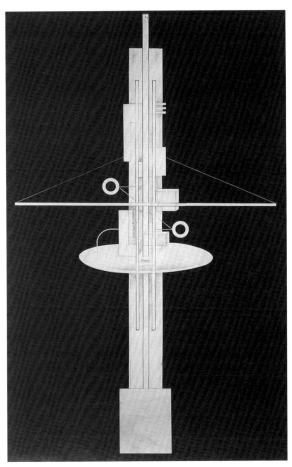

49.7
***Study for "Suspended Construction"* [side elevation], 1936–38**
Ink on paper, 13½ x 8½ in.
Exhibition: *Constructivist*
Publication: *Constructivist*, cat. 64, p. 46.
Provenance: [Hirschl & Adler Galleries, New York, February 29, 1988]; estate of the artist

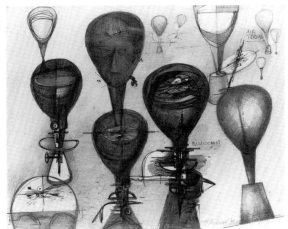

49.8
***The Balloonist* (Study for *Lighter than Air*), 1941**
Pen and ink on paper, 8½ x 11 in.
Signed and dated LR: T. Roszak '41; inscribed BALLOONIST in LR quadrant
Photo: Gavin Ashworth
Provenance: [Hirschl & Adler Galleries, New York, June 21, 1988]; estate of the artist

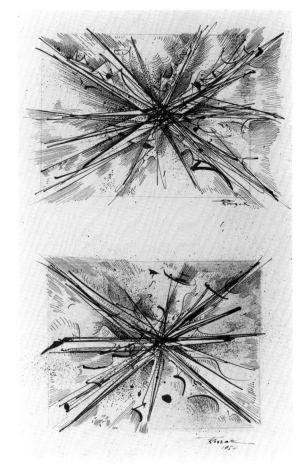

49.9
***Studies for "Nova,"* 1954**
Ink and wash on paper, 12⅝ x 8¼ in.
Signed LR: T. Roszak 1954
Photo: Gavin Ashworth
Provenance: from the artist 1962

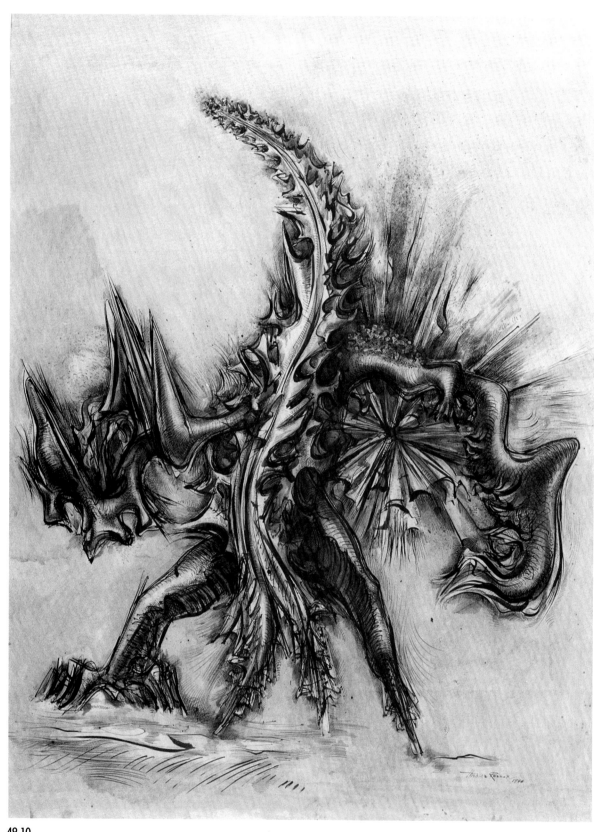

49.10
Study for "Spectre of Kitty Hawk," 1946
Ink and brown wash on paper, 57⅛ x 42½ in.
Signed and dated LR: Theodore Roszak 1946
Photo: Gavin Ashworth
Provenance: from the artist February 27, 1962

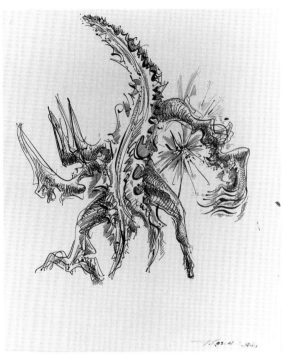

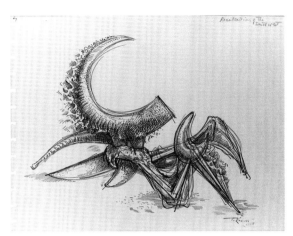

49.13
***Recollection of the Southwest,* 1948**
Ink on paper, 8 13/16 x 11 3/4 in.
Signed and dated LR: T. Roszak 1948; inscribed UL: Recollection of the
Southwest
Photo: Gavin Ashworth
Provenance: from the artist 1962

49.11
***Study for "Spectre of Kitty Hawk,"* 1946**
Ink on paper, approx. 14 x 10 7/8 in.
Signed and dated LR: T. Roszak 1946
Photo: Gavin Ashworth
Provenance: from the artist 1962

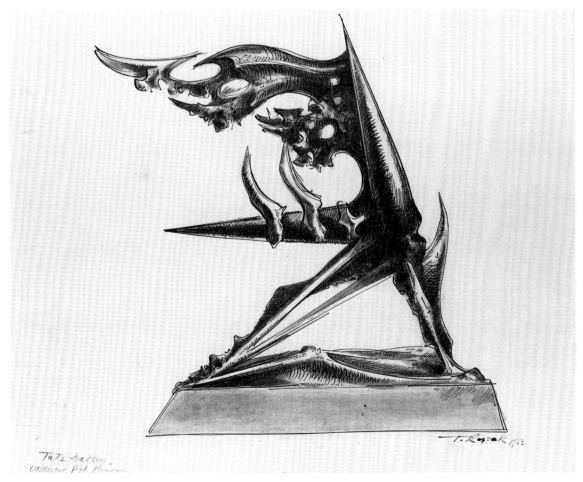

49.12
***Study for "Monument for an
Unknown Political Prisoner,"*
1951**
Ink and ink wash on paper, 10 7/8
x 13 7/8 in.
Signed and dated LR: T. Roszak
1952, inscribed LL: Tate
Gallery/Unknown Pol. Prisoner
Photo: Gavin Ashworth
Provenance: from the artist 1962

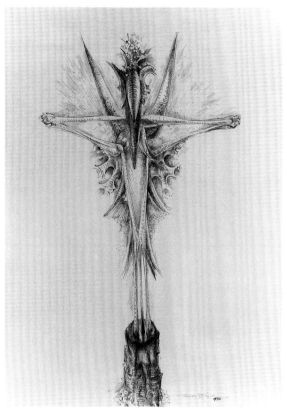

49.14
***Study for "Sea Sentinel,"* 1950**
Ink on paper, 26 x 19 in. (uneven edges)
Signed, dated and inscribed LR: Theodore Roszak/1950 N.Y.C
Photo: Gavin Ashworth
Provenance: from the artist 1962

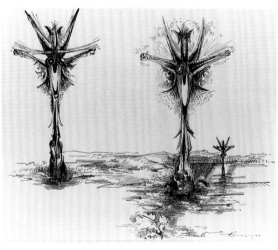

49.15
***Studies for "Sea Sentinel,"* 1950**
Ink on paper, 10⅝ x 13¼ in.
Signed and dated LR: TRoszak 1950
Photo: Gavin Ashworth
Provenance: from the artist 1962

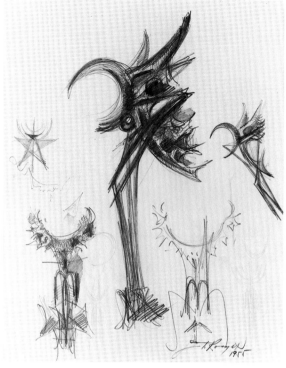

49.16
***Studies for "Sea Sentinel,"* 1955**
Pencil and ink on paper, 13⅞ x 10⅞ in.
Signed and dated LR: T. Roszak 1955
Photo: Gavin Ashworth
Provenance: from the artist 1962

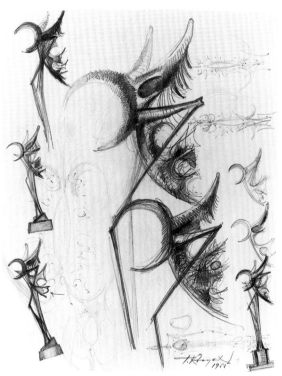

49.17
***Studies for "Sea Sentinel,"* 1955**
Pencil and ink on paper, 13⅞ x 10⅞ in.
Signed and dated LR: T. Roszak 1955
Photo: Gavin Ashworth
Provenance: from the artist 1962

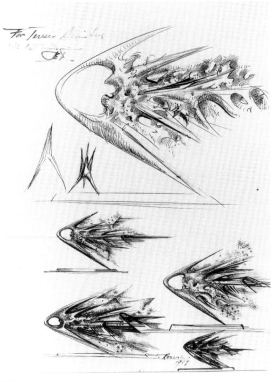

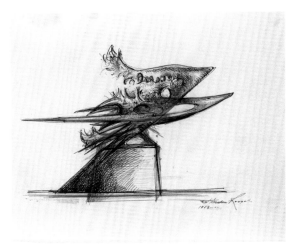

49.18
Studies for "Comet," 1957
Ink on paper, 13⅞ x 11 in.
Signed, dated and inscribed: LR: T.Roszak 1957; UL: For Terese &
Alvin Lane/with best wishes/ (indecipherable signature)
Photo: Gavin Ashworth
Provenance: from the artist 1962

49.20
Study for "Night Flight," 1958
Ballpoint pen on paper, 8¾ x 11
Signed and dated LR: Theodore Roszak 1958
Provenance: from the artist 1962

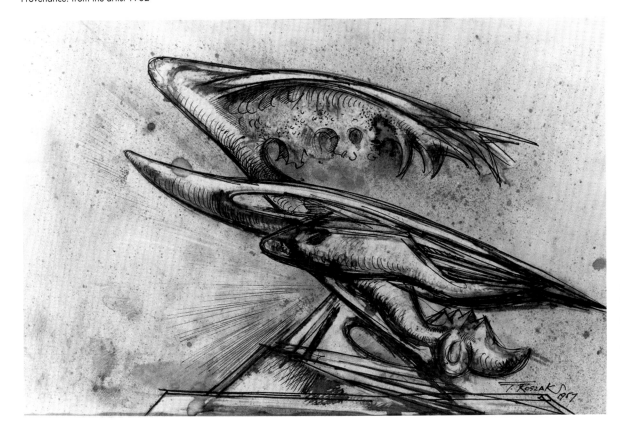

49.19
Study for "Night Flight,"
1957
Sepia and ink on paper,
11¼ x 17¼ in.
Signed and dated LR: T.
Roszak 1957
Photo: Gavin Ashworth
Provenance: from the artist
1962

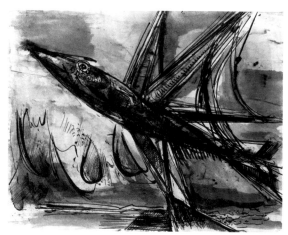

49.21
Study for "Flying Fish," ca. 1959
Ink and wash on paper, 8 3/8 x 11 in.
Photo: Gavin Ashworth
Provenance: from the artist 1962

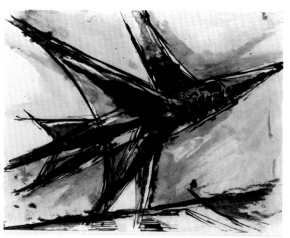

49.23
Study for "Flying Fish," ca. 1959
Ink and wash on paper, 8 1/2 x 11 in.
Photo: Gavin Ashworth
Provenance: from the artist 1962

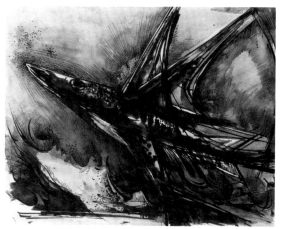

49.22
Study for "Flying Fish," ca. 1959
Ink and wash on paper, 8 3/8 x 11 in.
Photo: Gavin Ashworth
Provenance: from the artist 1962

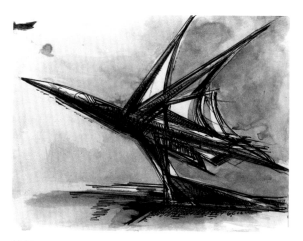

49.24
Study for "Flying Fish," ca. 1959
Ink and wash on paper, 8 3/8 x 11 in.
Photo: Gavin Ashworth
Provenance: gift of the artist May 31, 1962

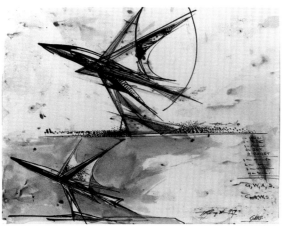

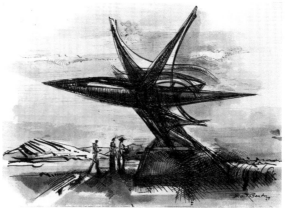

49.25
Studies for "Flying Fish," 1959
Ink and wash on paper, 8³/₈ x 11 in.
Signed and dated LR: T. Roszak 1959
Photo: Gavin Ashworth
Provenance: from the artist 1962

49.27
Study for "Flying Fish," 1959
Ink and wash on paper, 10 x 14¹/₈ in.
Signed LR: Theo Roszak '59
Photo: Gavin Ashworth
Provenance: from the artist 1962

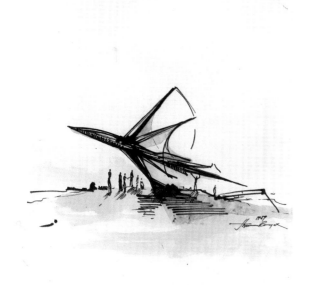

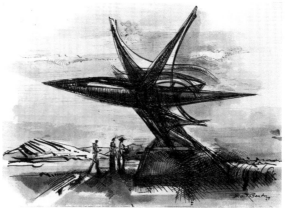

49.28
Study for "Flying Fish," 1959
Ink and wash on paper, 8³/₄ x 11⁷/₈ in.
Photo: Gavin Ashworth
Provenance: from the artist 1962

49.26
Study for "Flying Fish," 1959
Ink on paper, 8³/₄ x 11 in
Signed and dated LR: Theodore Roszak 1959
Provenance: from the artist 1962

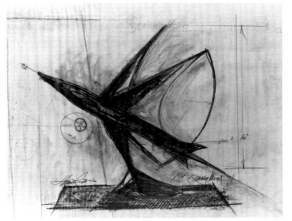

49.29
Mechanical Drawing for "Flying Fish," ca. 1959
Black and red crayon on paper, 25⅞ x 34 in.
Signed LL: Theodore Roszak; inscribed LR: Working Drawing
Photo: Gavin Ashworth
Provenance: from the artist 1962

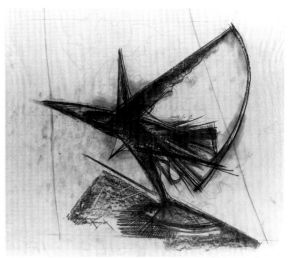

49.31
Study for "Flying Fish," ca. 1959
Black and red crayon on paper, 32⅛ x 36 in.
Signed LL: Theodore Roszak
Photo: Gavin Ashworth
Provenance: from the artist 1962

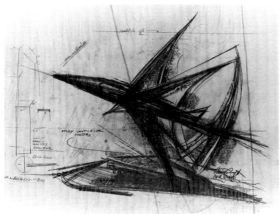

49.30
Mechanical Drawing for "Flying Fish," ca. 1959
Black and red crayon on paper, 26½ x 36 in.
Signed LR: Theodore Roszak; inscribed LR: Working Drawing
Photo: Gavin Ashworth
Provenance: from the artist 1962

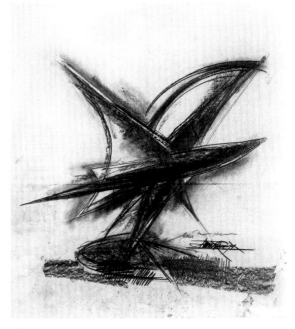

49.32
Study for "Flying Fish," ca. 1959
Black and red crayon on brown paper, 35 x 32¾ in.
Signed in LR quadrant: Theodore Roszak; inscribed in red
(indecipherable) in LR quadrant
Photo: John A. Ferrari
Provenance: from the artist 1962

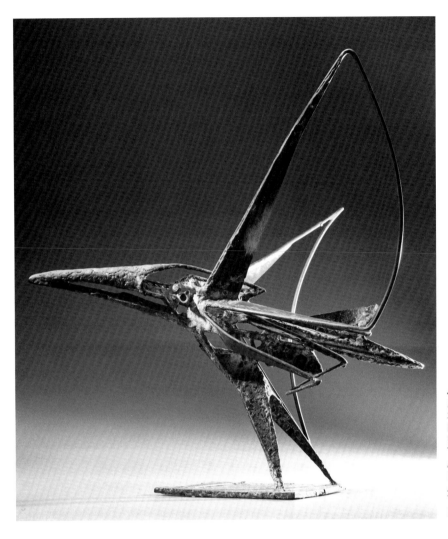

49.33
Flying Fish, **1959**
Steel brazed with brass and silver-nickel, 23 x 24 in.
Photo: Gavin Ashworth
Exhibition: *Artists Select*, Finch College Museum of Art, New
York, November-December, 1964 // *Roszak 1956–62*, Pierre
Matisse Gallery, New York, April 17–May 12, 1962
Publication: *Artists Select*. New York: Finch College Museum of
Art, New York, 1964, cat. 20, illus. // *Roszak 1956–62*. New
York: Pierre Matisse Gallery, 1962, cat. 14, illus.
Provenance: from the artist, April 24, 1962

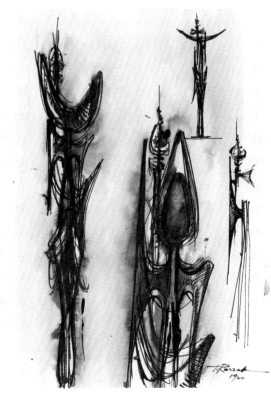

49.34
Studies for "Surveyor," **1960**
Ink and ink wash on paper, 10⅞ x 8½ in.
Signed and dated LR: T. Roszak 1960
Photo: Gavin Ashworth
Provenance: from the artist 1962

50 JULIUS SCHMIDT
(American, b. 1923)

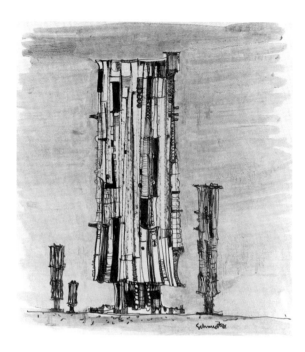

50.1
Drawing for Sculpture, **1961**
Ink and wash drawing on paper, 21¼ x 19¾ in.
Signed and dated LR: Schmidt 61
Photo: Gavin Ashworth
Provenance: [Otto Gerson Gallery, New York, December 19, 1962]

50.2
Untitled, 1962
Alloy cast iron, 18½ x 10 x 11½ in.
Photo: Rudolph Burckhardt
Exhibition: *Ten American Sculptors*, U.S. Section Sao Paulo Bienal VII, Brazil, September-December, 1963. Traveled to Walker Art Center, Minneapolis; San Francisco Museum of Art; City Museum of St. Louis; The Dayton Art Institute // Otto Gerson Gallery, New York, December, 1962
Publication: Exhibition catalogue. New York: Otto Gerson Gallery, 1962, cat. 9
Provenance: [Otto Gerson Gallery, New York, December 19, 1962

51 DAVID SMITH
(American, 1906–1965)

51.3
Untitled (reclining figure), 1939–40
Tempera on paper, 12⅛ x 18¼ in.
Initialed in Greek LR quadrant: ΔΣ
Exhibition: *David Smith: Sculpture and Drawings*, Dusseldorf, Kunstsammlung Nordrhein-Westfalen, March 14–April 27, 1986. Traveled to Stadtische Galerie im Stadelsches Kunstinstitut, Frankfurt; Whitechapel Art Gallery, London // Hirshhorn // *Smith Drawings*
Publication: John Merkert, Nick Serota, and Hannelore Kersting, *David Smith: Sculpture and Drawings*. Dusseldorf: Kunstsammlung Nordrhein-Westfalen, 1986, p. 116, illus. // Hirshhorn, p. 62, pl. 24 // *Smith Drawings*, p. 47, pl. 12
Provenance: [Anthony d'Offay Gallery, London, February 24, 1987]

51.1
Untitled, March 1935
Oil on canvas, 17 x 17 in.
Signed and dated UR edge: David Smith 3/35
Estate 75.30.34
Exhibition: *David Smith: Paintings from the Thirties*, Washburn Gallery, New York, March 3–28, 1987
Publication: *David Smith: Paintings from the Thirties*. New York: Washburn Gallery, 1987, color illus. n.p. // Krauss, cat. 715, illus.
Provenance: [Washburn Gallery, N.Y., March 12, 1987]; estate of the artist

51.2
Study for Sculpture, 1937
Pastel on paper, 22 x 17 in.
Initialed in Greek and dated LR: ΔΣ 37
Estate 73.37.009
Exhibition: *Smith Drawings*
Publication: *Picasso and the Age of Iron*. New York: Solomon R. Guggenheim Museum of Art, 1993, p. 271, illus. // *Smith Drawings*, p. 64, no. 7, illus. // Karen Wilken, *David Smith*. New York: Abbeville Press, 1984, p. 25, cat. 17, illus. // Krauss, cat. 719, illus.
Provenance: [Anthony d'Offay Gallery, London, December 22, 1989]; ex coll.: Candida and Rebecca Smith

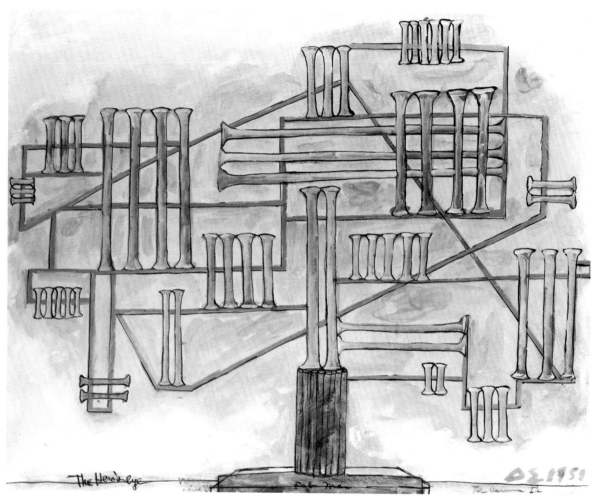

51.5
The Hero's Eye, 1951
Ink and watercolor on paper, 18¼ x 22¾ in.
Initialed in Greek and dated LR: ΔΣ 1951; inscribed LL: The Hero's Eye
Photo: Geoffrey Clements
Estate 73.51.15
Exhibition: *Smith Drawings*
Publication: *Smith Drawings*, p. 72, no. 49, illus.
Provenance: [Anthony d'Offay Gallery, London, November 21, 1986]

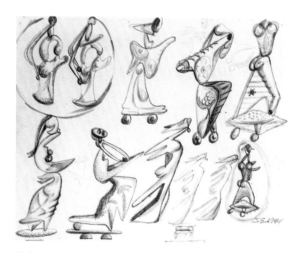

51.4
Untitled (Study for "Aftermath Figure"), 1944
Pen and ink, blue and gray-purple wash on paper, 19½ x 25 in.
Initialed in Greek and dated LR: ΔΣ 1944
Photo: Geoffrey Clements
Estate 73.44.1
Exhibition: Hirshhorn // *Smith Drawings*
Publication: Hirshhorn, p.78, pl. 47 // *Smith Drawings*, p. 29, cat. 17, illus.
Provenance: [Anthony d'Offay Gallery, London, February 21, 1986]

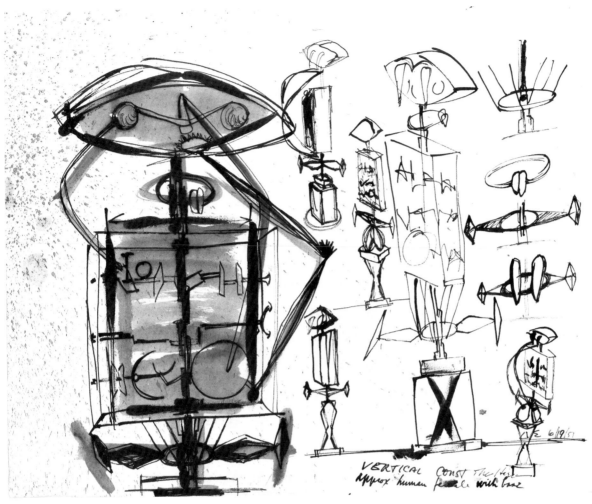

51.6
Study for "The Hero," 1951
Watercolor and ink on paper, 18⅛ x 22¾ in.
Initialed in Greek and dated LR: ΔΣ 6/19/51
Estate 73.51.20
Exhibition: *Between Transcendence and Brutality: American Sculptural Drawings from the 1940s and 1950s*, organized by Tampa Museum of Art. Exhibited at The Parrish Art Museum, Southampton, N.Y., September 24–November 7, 1994 // *David Smith: Drawings of the Fifties*, Anthony d'Offay Gallery, London, July 13–August 12, 1988
Publication: Douglas Dreishpoon, *Between Transcendence and Brutality: American Sculptural Drawings from the 1940s and 1950s*. Tampa, Fla.: Tampa Museum of Art, 1994, p. 21, no. 8, illus. // *David Smith: Drawings of the Fifties*. London: Anthony d'Offay Gallery, 1988, pl. 8 // Krauss, cat. 750
Provenance: [Anthony d'Offay Gallery, London, July 27, 1988]

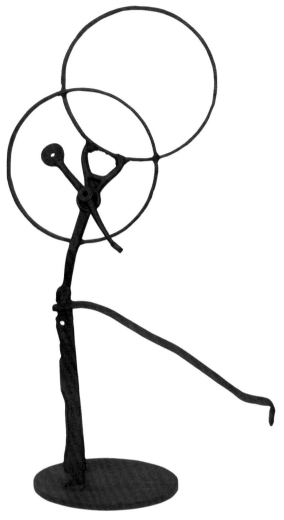

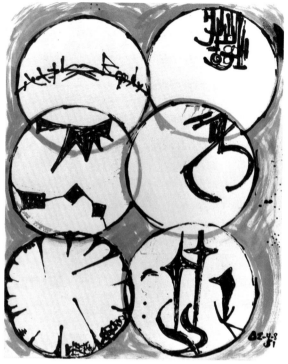

51.8
Untitled, 1951
Ink and watercolor on paper, 22³/₄ x 18 in.
Initialed in Greek and dated RLR: ΔΣ 4–8–51
Exhibition: *David Smith: Drawings of the Fifties*, Anthony d'Offay
Gallery, London, July 13–August 12, 1988
Publication: *David Smith: Drawings of the Fifties*. London: Anthony
d'Offay Gallery, 1988, pl. 6
Provenance: [Anthony d'Offay Gallery, London, January 10, 1994]

51.7
Untitled, 1951
Steel, 32 x 16³/₄ x 9¹/₄ in.
Exhibition: *David Smith*, Knoedler Contemporary Art, New York, October 5–26, 1974
Publication: Krauss, cat. 263, illus. // *David Smith*. New York:
Knoedler Contemporary Art, 1974, illus. n.p.
Provenance: [Anthony d'Offay Gallery, London, July 27, 1988]

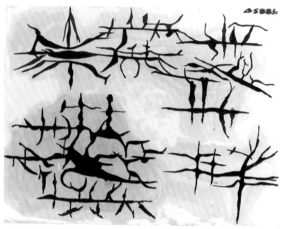

51.9
Untitled, 1951
Black egg ink, orange, green, and white tempera on paper, 19³/₄ x
26 in.
Initialed in Greek and dated RUR: ΔΣ 8851
Photo: Gavin Ashworth
Estate 73.51.44
Provenance: [M. Knoedler, London, October 14, 1986]

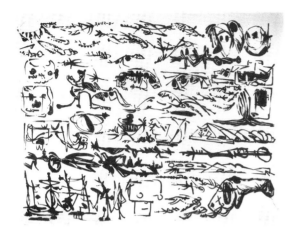

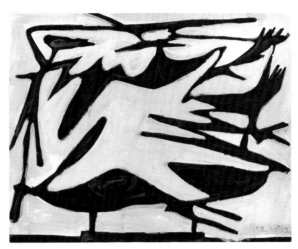

51.10
A Letter, 1952
Lithograph, 17 x 13 in.
Initialed and dated in the upper center stone: ΔΣ–52–8; Signed and inscribed in ink RLL: David Smith Ed–13 1952
Edition of 13; only 6 known impressions signed and dated. Produced at Margaret Lowengrund's workshop in Woodstock, N.Y. with Michael Ponce de Leon
Photo: André Grossmann
Exhibition: *David Smith: The Prints,* The Pace Gallery, New York, February 27–March 21, 1987
Publication: *David Smith: The Prints.* Catalogue raisonné by Alexandra Schwartz and essay by Paul Cummings. New York: The Pace Gallery, 1987, cat. 34, illus.
Provenance: [Susan Sheehan, New York, March 14, 1989]

51.12
Untitled, 1952
Blue ink and gray tempera on paper, 18 x 23 in.
Initialed in Greek and dated LR: ΔΣ 3/5/52
Photo: Ken Cohen
Estate 73.52.160
Exhibition: *David Smith: Sculpture, Painting, and Drawing of the Fifties,* M. Knoedler, New York, November 17–December 6, 1984
Publication: *David Smith: Sculpture, Painting, and Drawing of the Fifties.* New York: M. Knoedler, 1984, p. 7, illus.
Provenance: [M. Knoedler, New York, December 3, 1984]

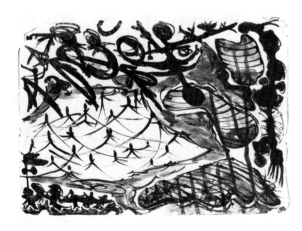

51.11
Tent, 1952
Lithograph, 14 x 19³⁄₈ in.
Signed and dated LL margin in black ink: David Smith E10 1952
Edition of 10; only one known impression signed and dated
Photo: John Black
Estate 76.52.1
Exhibition: *David Smith: The Prints,* The Pace Gallery, New York, February 27–March 21, 1987
Publication: *David Smith: The Prints.* Catalogue raisonné by Alexandra Schwartz and essay by Paul Cummings. New York: The Pace Gallery, 1987, cat. 31, illus.
Provenance: [The Pace Gallery, New York, March 12, 1987]

51.13
Untitled, 1952
Black egg ink, tempera wash on paper, 20³⁄₈ x 15³⁄₄ in.
Initialed in Greek and dated UR: ΔΣ 4/16/52
Photo: Douglas M. Parker
Estate 73.52.164
Exhibition: *David Smith: Works on Paper,* Margo Leavin Gallery, Los Angeles, January 6–February 10, 1990
Publication: *David Smith: Works on Paper.* Los Angeles: Margo Leavin Gallery, 1990, p. 17, color illus.
Provenance: [Margo Leavin Gallery, Los Angeles, February 1, 1990]

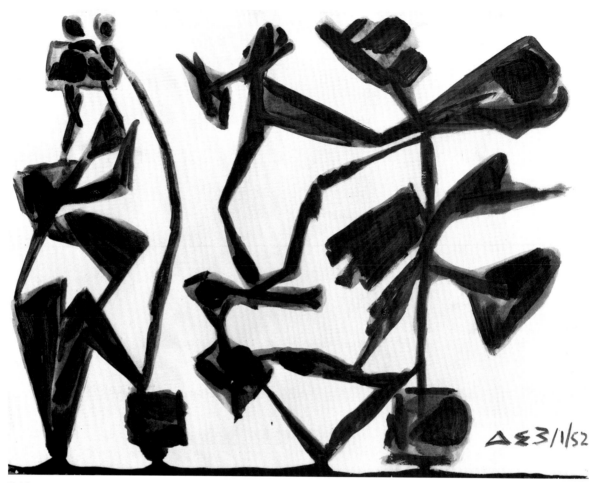

51.14
Untitled, 1952
Black and purple ink on paper, 18¼ x 23⅜ in.
Initialed in Greek and dated LR: ΔΣ 3/1/52
Photo: Douglas M. Parker
Estate 73.52.111
Exhibition: *David Smith: Works on Paper*, Margo Leavin Gallery, Los
Angeles, January 6–February 10, 1990
Publication: *David Smith: Works on Paper.* Los Angeles: Margo Leavin
Gallery, 1990, p. 15, color illus.
Provenance: [Margo Leavin Gallery, Los Angeles, February 1, 1990]

51.15
Untitled, 1953
Brush and black ink on paper, 15¾ x 20½ in.
Initialed in Greek and dated UL: ΔΣ 9/5/4/53
Provenance: (Christie's, New York, February 20, 1988, lot 7)

51.16
Untitled (Page 6 of April 1954 sketchbook), 1954
Ink and pencil on paper, 10⅝ x 8¼ in.
Dated LL: 4/28/54
Estate 73.53.93
Exhibition: Storm
Publication: Storm, p. 6, cat. 3, illus.// E. A. Carmean, Jr., *David Smith*. Washington D.C.: National Gallery of Art, 1982, p. 78, no. 8, illus.
Provenance: [Mekler Gallery, Los Angeles, March 25, 1987]; ex coll. Gloria Gil

51.17
Untitled, 1953
Rose and black egg ink on paper, 15½ x 20¼ in.
Initialed in Greek and dated RLR: ΔΣ 6/5/3/53
Exhibition: *New Dimensions in Drawing // Smith Drawings*
Publication: *Smith Drawings*, p. 82, no. 70, illus.
Provenance: [M. Knoedler, New York, January 2, 1980]

51.18
Untitled (Page 7 of April 1954 sketchbook), 1954
Ink and pencil on paper, 10⅝ x 8¼ in.
Exhibition: Storm
Publication: Storm, p. 6, cat. 4, illus.
Provenance: [Mekler Gallery, Los Angeles, March 25, 1987]; ex coll. Gloria Gil

51.19
Untitled (Page 27 of April 1954 sketchbook), 1954
Ink and pencil, 10⅝ x 8¼ in.
Unsigned, Exhibition: Storm
Publication: Storm, p. 15, cat. 17, illus.
Provenance: [Mekler Gallery, Los Angeles, March 25, 1987]; ex coll. Gloria Gil

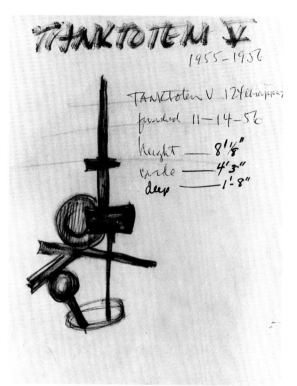

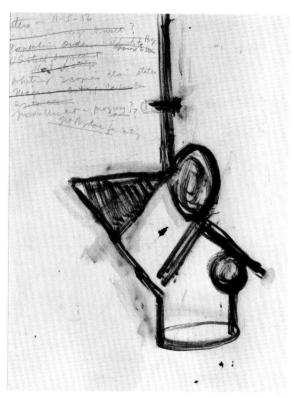

51.20
Untitled (Tanktotem V; Page 112 of 1954 sketchbook), 1954
Ink and pencil on paper, 10⅝ x 8¼ in.
Unsigned
Exhibition: Storm
Publication: Storm, p. 35, cat. 52, illus.
Provenance: [Mekler Gallery, Los Angeles, March 25, 1987]; ex coll.
Gloria Gil

51.21
Untitled (Page 107 of April 1954 sketchbook), 1954
Ink and pencil on paper, 10⅝ x 8¼ in.
Unsigned
Provenance: [Mekler Gallery, Los Angeles, March 25, 1987]; ex coll.
Gloria Gil

51.22
Untitled (Page 101 of April 1954 sketchbook), 1956
Ink and pencil on paper, 10⅝ x 8¼ in.
Dated with undecipherable inscription RLL: 9/1/56
Exhibition: Storm
Publication: Storm, p. 31, cat. 47, illus.
Provenance: [Mekler Gallery, Los Angeles, March 25, 1987]; ex coll.
Gloria Gil

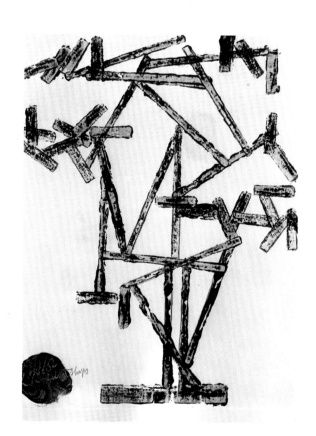

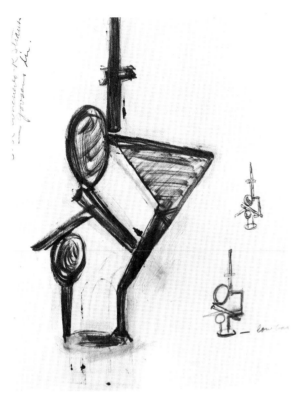

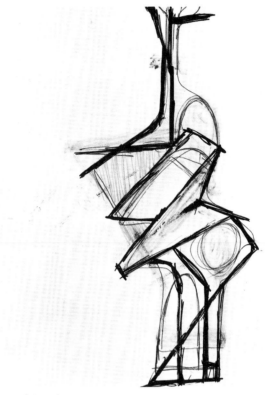

51.23a (recto)
Untitled (Page 108 of April 1954 Sketchbook), 1954
Ink and pencil on paper, 10⁵/₈ x 8¹/₄ in.
Unsigned drawing: abstract construction with 2 smaller constructions to
the right, writing along UL edge and LR quadrant
Exhibition: Storm
Publication: Storm, p. 34, cat. 50, illus.
Provenance: [Mekler Gallery, Los Angeles, March 25, 1987]; ex coll.
Gloria Gil

51.23b (verso)
Untitled (Page 109 of April 1954 sketchbook), 1954
Ink and pencil on paper, 10⁵/₈ x 8¹/₄ in.
Unsigned
Exhibition: Storm
Publication: Storm, p. 34, cat. 50, illus.
Provenance: [Mekler Gallery, Los Angeles, March 25, 1987]; ex coll.
Gloria Gil

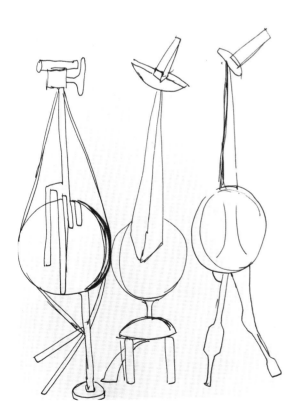

51.24
Untitled (Page 75 of April 1954 Sketchbook), 1954
Ink and pencil on paper, 10⁵/₈ x 8¹/₄ in.
Unsigned
Exhibition: Storm
Publication: Storm, p. 22, cat. 32, illus.
Provenance: [Mekler Gallery, Los Angeles, March 25, 1987]; ex coll.
Gloria Gil

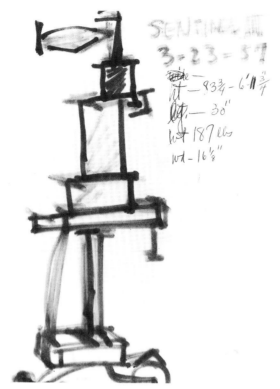

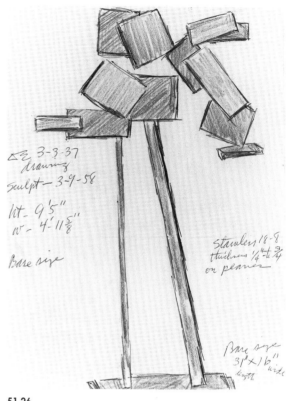

51.25
Untitled (Sentinel III, Page 129 of April 1954 sketchbook), 1954
Ink and pencil on paper, 10⅝ x 8¼ in.
Unsigned
Exhibition: Storm
Publication: Storm, p. 39, cat. 60, illus.
Provenance: [Mekler Gallery, Los Angeles, March 25, 1987]; ex coll.
Gloria Gil

51.26
Untitled (Page 139 of April 1954 sketchbook), 1957
Blue ballpoint pen and colored crayons on paper, 10⅝ x 8¼ in.
Inscribed left at center: ΔΣ
3–3–37/drawing/Sculpt–3–9–58/ht–9'5"/w–4'–11⅝"/base size;
LRC: Base size/31' x 16" length/width; t center: stainless 18–8/thick-
ness¼" to¾/on planes
Unsigned
Exhibition: Storm
Publication: Storm, p. 40, cat. 64, illus.
Provenance: (Christie's East, New York, May 8, 1993); [Zabriskie
Gallery, New York]

51.27
Untitled, 1954
Blue and rust tempera on paper, 30 x 42½ in.
Initialed in Greek and dated UC: ΔΣ 2/27/54
Photo: Gavin Ashworth
Estate 73.54.5
Exhibition: The Art Dealer's Association of America Art Fair, New York,
February 14–19, 1989 // *Smith Drawings*
Publication: *Smith Drawings*, p. 55, pl. 74
Provenance: [M. Knoedler, New York, February 28, 1989]

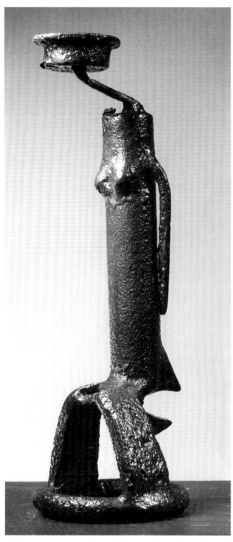

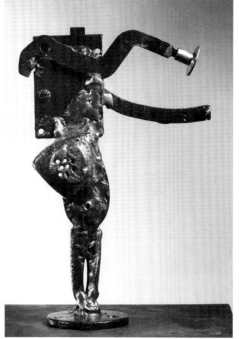

51.29
Untitled, ca. 1956
Steel, lemon juicer, lock, solder, 11⅝ x 7¾ x 3¼ in.
Archive: FNP80
Photo: O. E. Nelson
Publication: Krauss, cat. 309, illus.
Provenance: [Marlborough-Gerson Gallery, New York,
May 26, 1967]

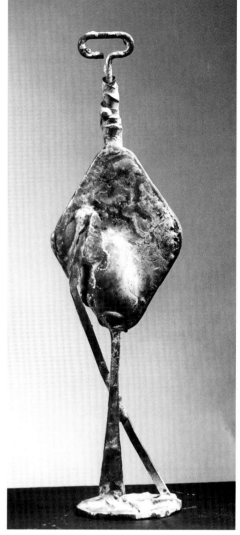

51.28
Untitled, ca. 1956
Steel, candle snuffer, tool, solder, 10 x 4 x 3⅜ in.
Photo: O. E. Nelson
Publication: Krauss, cat. 310, illus.
Provenance: [Marlborough-Gerson Gallery, New York,
May 26, 1967]

51.30
Untitled, ca. 1956–1959
Steel, sardine can, silver solder, 10¼ x 3 x 2 in.
Photo: O. E. Nelson
Publication: Krauss, cat. 311, illus.
Provenance: [Marlborough-Gerson Gallery, New York,
May 26, 1967]

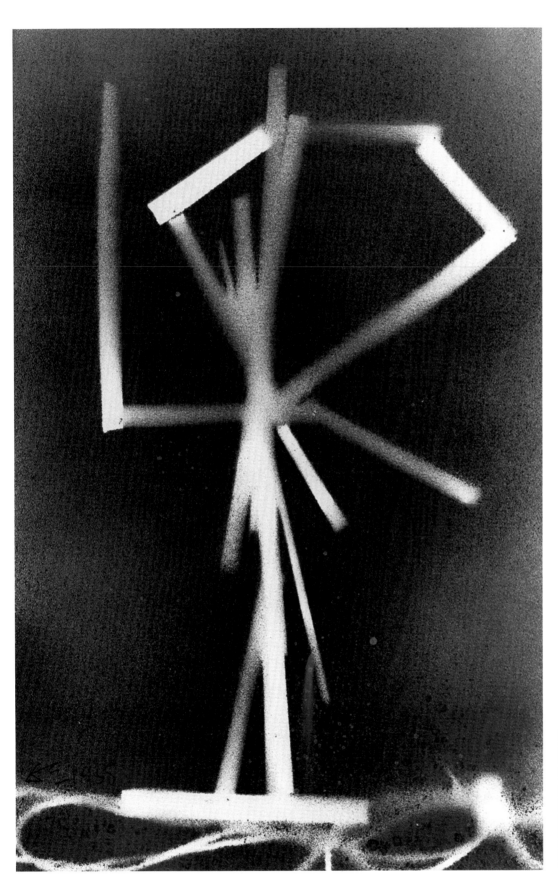

51.31
Enamel Spray, 1958
Enamel spray colored red drawing, 11½
x 17⅜ in.
Initialed in Greek and dated LL: ΔΣ 1958
Photo: Gavin Ashworth
Exhibition: *New Dimensions in Drawing*
Publication: Hilton Kramer, "David Smith:
Stencils for Sculpture," *Art in America* 50,
no. 4 (Winter 1962), p. 38, illus.
Provenance: [Balin-Traube Gallery, New
York, May 31, 1963]

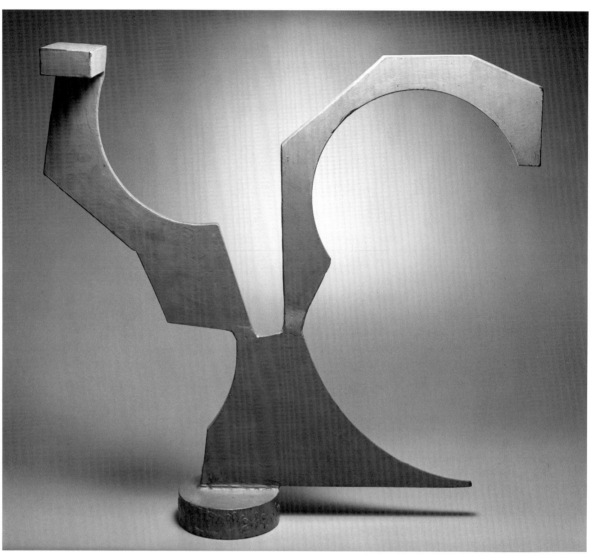

51.32
Albany VIIB, ca. 1959
Steel, yellow paint, 28¼ x 31½ x 8 in.
Signed and titled on base: Albany VIIB (illegible date) David Smith
Photo: Gavin Ashworth
Publication: Krauss, cat. 545, illus.
Provenance: [Marlborough-Gerson Gallery, New York, May 26, 1967]

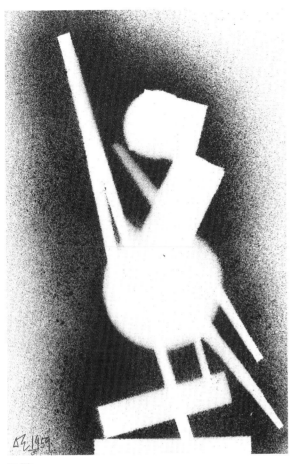

51.33
Untitled, 1959
Spray paint on paper, 17$\frac{1}{2}$ x 11$\frac{1}{2}$ in.
Initialed in Greek and dated LL: ΔΣ 1959/5
Photo: Prudence Cuming Assoc.
Estate 73.59.137
Exhibition: *Smith Sprays*
Publication: *Smith Sprays*, cat. 20, illus. // Hilton Kramer, "David Smith: Stencils for Sculpture," *Art in America* 50, no. 4 (Winter, 1962), p. 34, illus.
Provenance: [Anthony d'Offay, London, January 6, 1986]

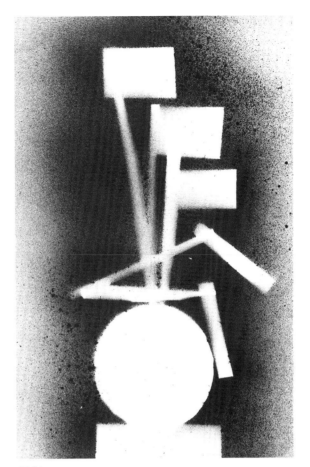

51.34
Untitled, 1961
Spray paint on paper, 17$\frac{1}{2}$ x 11$\frac{7}{16}$ in.
Estate 73.CA.61.43
Exhibition: *Smith Sprays*
Publication: *Smith Sprays*, cat. 27, illus.
Provenance: [Anthony d'Offay, London, November 12, 1985]

51.35
Untitled, 1962
Spray paint on paper, 15$\frac{1}{2}$ x 20$\frac{1}{2}$ in.
Photo: Gavin Ashworth
Estate 73.62.236
Exhibition: *David Smith: Spray Paintings and Works on Paper*, M. Knoedler, New York, November 21–December 12, 1981, no. 23
Provenance: [M. Knoedler, New York, December 3, 1981]

51.36
Untitled, 1962
Spray paint on paper, 13 x 19 in.
Estate 73.62.231
Exhibition: *Smith Sprays*
Publication: *Smith Sprays*, cat. 51, illus.
Provenance: [Anthony d'Offay, London, November 12, 1985]

51.38
Untitled, ca. 1962
Spray paint on paper, 19⅞ x 26 in.
Estate 73.62.209
Exhibition: *Smith Drawings*
Provenance: (Christie's, New York, November 13, 1991, lot 228); [M. Knoedler, New York]

51.37
Untitled, 1962
Spray paint and gesso on paper, 26 x 19 in.
Photo: Gavin Ashworth
Estate 73.62.216
Exhibition: *Smith Drawings*
Publication: *Smith Drawings*, cat. 135
Provenance: (Christie's, February 22, 1995, lot 23) [M. Knoedler, New York

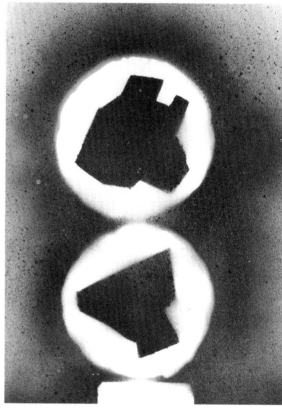

51.39
Untitled, 1963
Spray paint on paper, 17½ x 11⅝ in.
Estate 73.63.91
Exhibition: *Smith Sprays* //
Publication: *Smith Sprays*, cat. 53, illus. // Hirshhorn, p.123, pl. 109 // Krauss, cat. 775, illus.
Provenance: [Anthony d'Offay, London, April 15, 1986]

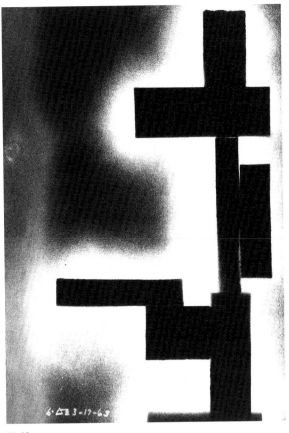

51.40
Untitled, 1963
Spray paint and gouache on paper, 16 3/8 x 11 5/8 in.
Initialed in Greek and dated LL: 6.ΔΣ 3–17–63
Photo: Gavin Ashworth
Estate 73.63.174
Exhibition: *Smith Sprays*
Publication: *Smith Sprays*, cat. 63, illus.
Provenance: [Anthony d'Offay, London, May 19, 1986]

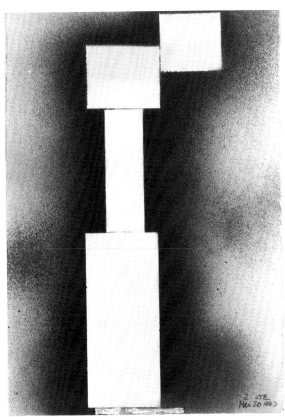

51.41
Untitled, 1963
Spray paint on paper, 16 3/8 x 11 5/8 in.
Initialed in Greek and dated LR: 2 ΔΣ Mar 20 1963
Estate 73.63.170
Exhibition: *Smith Sprays*
Publication: *Smith Sprays*, cat. 64, illus.
Provenance: [Anthony d'Offay, London, October 21, 1985]

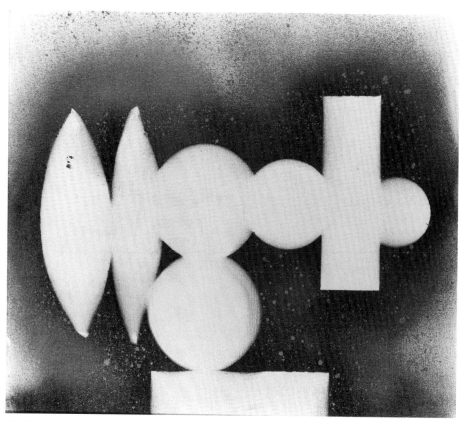

51.42
Untitled [related to Albany I], ca. 1963
Spray paint on canvas, 18 x 20 in.
Estate 75.63.29
Exhibition: Hirshhorn
Publication: Hirshhorn, cat. 130, p. 141, not illus.
Provenance: [M. Knoedler, New York, December 11, 1982]

52 TONY SMITH
(American, 1912–1981)

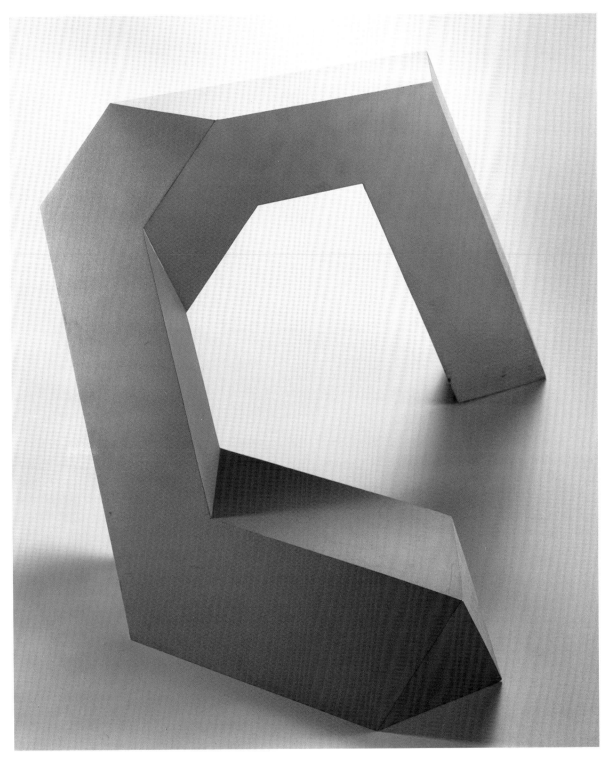

52.1
Cigarette, 1962
Stainless steel, 13½ x 21 x 16 in.
Edition: 5/5 (and two artist's proofs)
Provenance: [Fischbach Gallery, New York, November 29, 1967]

52.2
Untitled, ca. 1962
Blue ballpoint pen on white paper, 9¼ x 6⁵⁄₁₆ in.
Unsigned
Photo: Geoffrey Clements
Provenance: [Paula Cooper Gallery, New York, June 1993]

53.1
Ricerca su di una scultura, **1963**
Ink on gray paper, 12¼ x 9½ in.
Signed at bottom, left of center: Francesco Somaini 1963
Photo: Gavin Ashworth
Provenance: [Galleria Odyssia, New York, February 15, 1964]

54 RICHARD STANKIEWICZ
(American, 1922–1983)

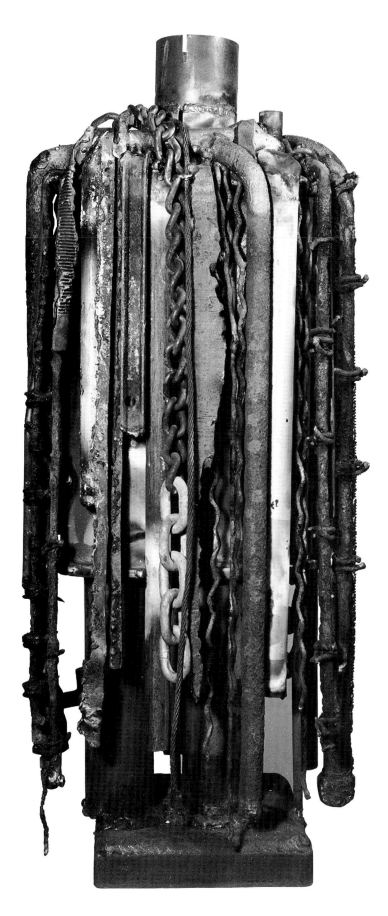

54.1
Chain People, **1960**
Steel, 23$\frac{1}{2}$ x 10$\frac{1}{2}$ x 8 in.
Exhibition: *International Exhibition, VI Bienal, Sao Paulo,* Brazil, September-December 1961 // *Annual Survey of Contemporary American Sculpture and Drawing,* Whitney Museum of American Art, December 7, 1960–January 22, 1961
Publication: *International Exhibition, VI Bienal, Sao Paulo,* Brazil, 1961, cat. 104, illus.// *Annual Survey of Contemporary American Sculpture and Drawing.* New York: Whitney Museum of American Art, 1961, p. 38, illus.
Provenance: Whitney Museum of American Art, December 21, 1960

55 JOHN STORRS
(American, 1885–1956)

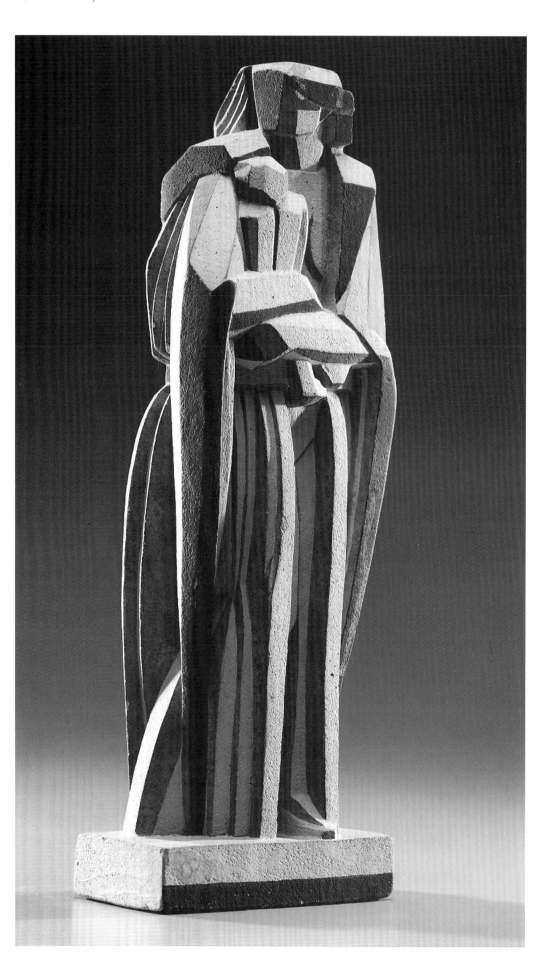

55.1
***Modern Madonna,* 1918**
Polychrome terracotta, 11¼ in. H.
Signed with initial S
Photo: Gavin Ashworth
Exhibition: *Storrs* (did not travel with
exhibiton)
Publication: *Storrs*, p. 21, no. 8, illus.
Provenance: (Parke-Bernet Galleries,
New York, May 16, 1973)

55.2
Industrial Forms (Auto Tower), 1920
Pen and black ink on paper, 12$\frac{1}{8}$ x 9 in.
Initialed and dated LL: J.S. 5–2–20
Photo: John D. Schift
Exhibition: *Storrs*
Publication: *Storrs*, p. 51, no. 49, illus.
Provenance: [Robert Schoelkopf Gallery, New York, February 1, 1971]

55.3
Mandarin, 1931
Oil on canvas, 18 x 12 in.
Signed LL in paint: STORRS
Photo: Gavin Ashworth
Provenance: [Michael Owen, New York, February 20, 1992]; Mrs. Titleman, Florida (1967); [Downtown Gallery, New York

55.4
Abstract Drawing, 1936
Pencil on paper, 10⅝ x 8¼ in.
Dated LR: 10–17–36
Provenance: [Robert Schoelkopf, New York, February 27, 1986]

55.5
Study for a Sculpture, 1936
Pencil on paper, 10⅝ x 8¼ in.
Dated LR: 10–12–36
Provenance: [Robert Schoelkopf, New York, February 27, 1986]

55.6
Study for Sculpture (Personages), 1937
Silverpoint on paper, 9 1/4 x 5 7/8 in.
Dated LL: 10-1-37
Exhibition: *Storrs*
Provenance: [Robert Schoelkopf Gallery, New York, February 1, 1971]

55.7
Walking on the Grass, 1937
Oil on canvas, 12 x 18 in.
Photo: John D. Schiff
Exhibition: *Storrs*
Publication: *Storrs*, p. 98, no. 117, illus.
Provenance: [Robert Schoelkopf Gallery, New York, February 1, 1971]

189

I had aheart,

55.8
Sculpture Studies, 1939
Pencil on typewriter paper, 11 x 8 7/8 in.
Dated in LL quadrant: 3–11–39
Exhibition: *Storrs*
Provenance: [Robert Schoelkopf Gallery, New York, February 22, 1989]

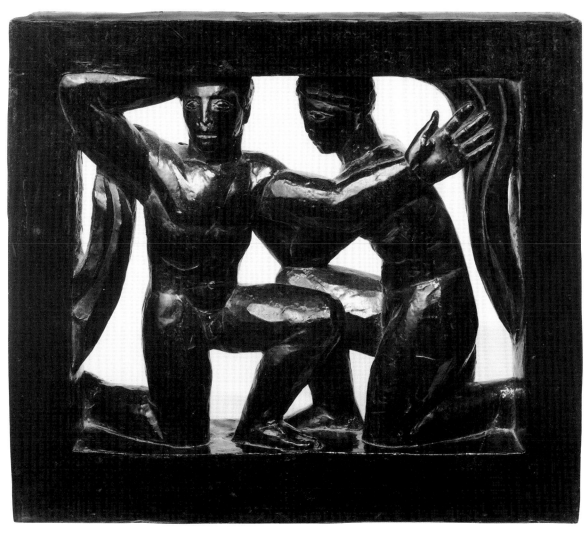

55.9
Open Window with Figures, ca. 1939
Bronze, 10½ x 12⅜ x 2⅜ in.
Signed ULL: STORRS; foundry mark at bottom left side:
Valsuani/Cire/Perdu
Exhibition: *Storrs*
Provenance: [Robert Schoelkopf Gallery, New York, February 22, 1989]

56 GEORGE SUGARMAN
(American, b. 1912)

57 JEAN TINGUELY
(Swiss, 1925–1991)

56.1
***Dance*, 1953**
Ink and watercolor on paper, 11 x 8¾ in.
Signed and dated LL: Sugarman 1953
Photo: Gavin Ashworth
Provenance: [Stephen Radich Gallery, New York, February 26, 1963]

57.1
Untitled (No. 3), 1965
Black ink on paper, 12⅞ x 9¾ in.
Signed and dated LR: Jean Tinguely 1965
Provenance: [Gimpel Fils, London, May 11, 1972]

58 TOM WESSELMANN
(American, b. 1931)

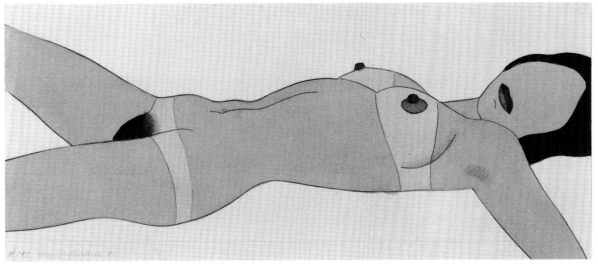

58.1
Open Ended Nude #147, **1981**
Watercolor and graphite on Bristol board, 3 3/4 x 8 7/8 in.
Signed and dated in pencil LR: #147 Wesselmann 81
Photo: Gavin Ashworth
Provenance: (Christie's, New York, May 8, 1990, lot
246); [O.K. Harris Works of Art, New York]

58.2
Drawing for Amy Reclining, **1984**
Pencil on Bristol board, 9 3/4 x 19 1/2 in. image
Signed and dated LL: Wesselmann 1984
Provenance: [Sidney Janis Gallery, New York, January
21, 1986]

58.3
Drawing for Amy Reclining, **1984**
Pastel, pencil on rag paper, 23 x 28 in.
Signed and dated LL: Wesselmann 84
Photo: Gavin Ashworth
Provenance: [Sidney Janis Gallery, New York, March 1, 1988]

58.4
Study for Steel Drawing/Amy Reclining, 1984
Felt-tip pen on paper, 32 x 75 in.
Signed
Provenance: [Sidney Janis Gallery, New York, January 21, 1986]

58.5
Steel Drawing/Reclining Nude Edition (Steel Drawing Edition/Amy Reclining), 1985
Laser-cut stainless steel, 13 x 33 in.
Signed, numbered, and dated front LR in engraving: Wesselmann 5/50 85
Edition: 5/50
Photo: Gavin Ashworth
Provenance: [Sidney Janis Gallery, New York, November 29, 1985]

59 FRITZ WOTRUBA
(Austrian, 1907–1975)

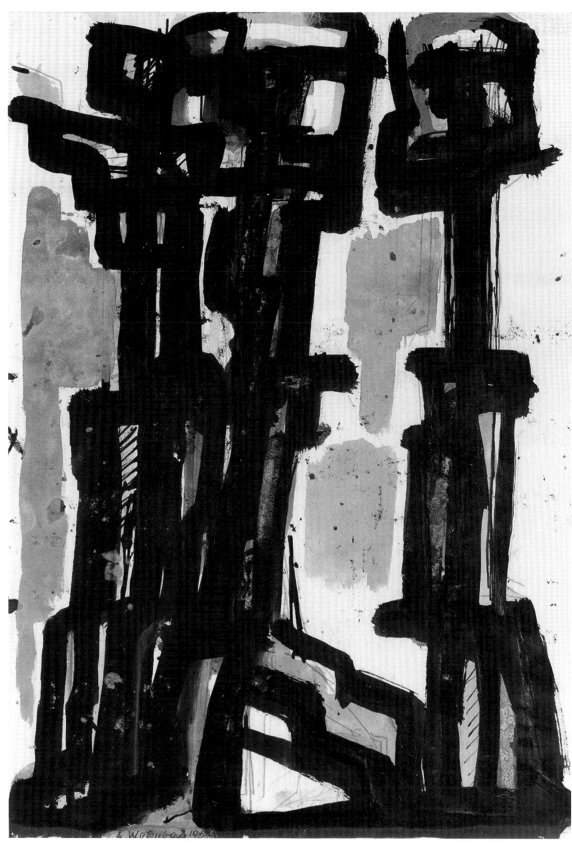

59.1
***Standing Figures*, 1958**
Watercolor and pencil on paper, 16¼ x 11½ in.
Signed and dated in black paint LL: F. Wotruba 1958
Provenance: [Otto Gerson Gallery, New York, September 18, 1962]